WATERFOWL ART

THE WATERFOWL ART OF MAYNARD REECE

Text by Maynard Reece

Introduction by Roger Tory Peterson

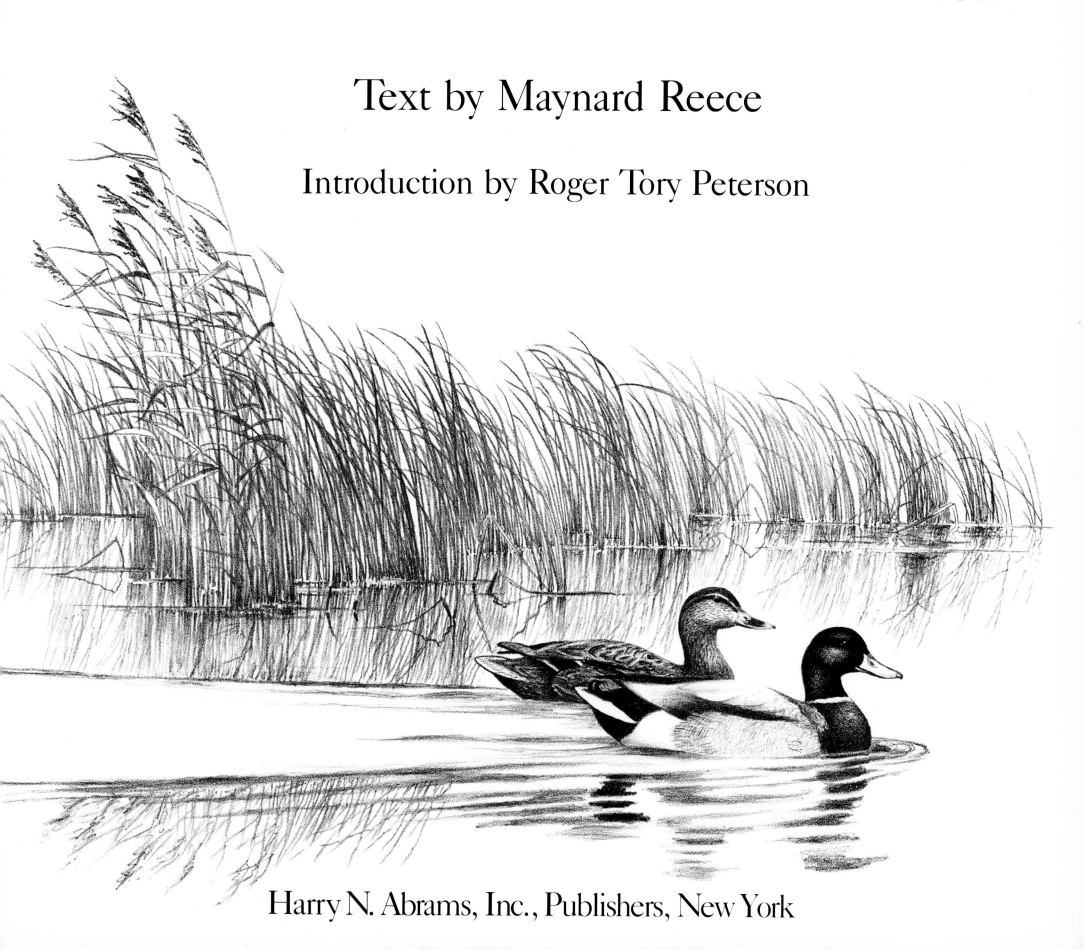

Harry N. Abrams, Inc., Publishers, New York

Editor: Patricia Egan
Designer: Carol Robson

Library of Congress Cataloging in Publication Data

Reece, Maynard
 The waterfowl art of Maynard Reece.

 1. Reece, Maynard. 2. Waterfowl in art. I. Title.
ND237.R255A4 1985 598.4′1′0222 85–6019
ISBN 0–8109–1797–1

Deluxe edition published in 1984 for Mill Pond Press
Copyright © 1984, 1985 Maynard Reece
Published in 1985 by Harry N. Abrams, Incorporated, New York
All rights reserved. No part of the contents of this book may be
reproduced without the written permission of the publishers

Printed and bound in Japan

2. *Flight: Canada Geese.* 1976, watercolor
A study of the flight patterns of geese
demonstrates the powerful sweep of the
large wings that lift and propel the birds
forward. Feathers, muscles, and bones
work in complex coordination to perform
this flight.

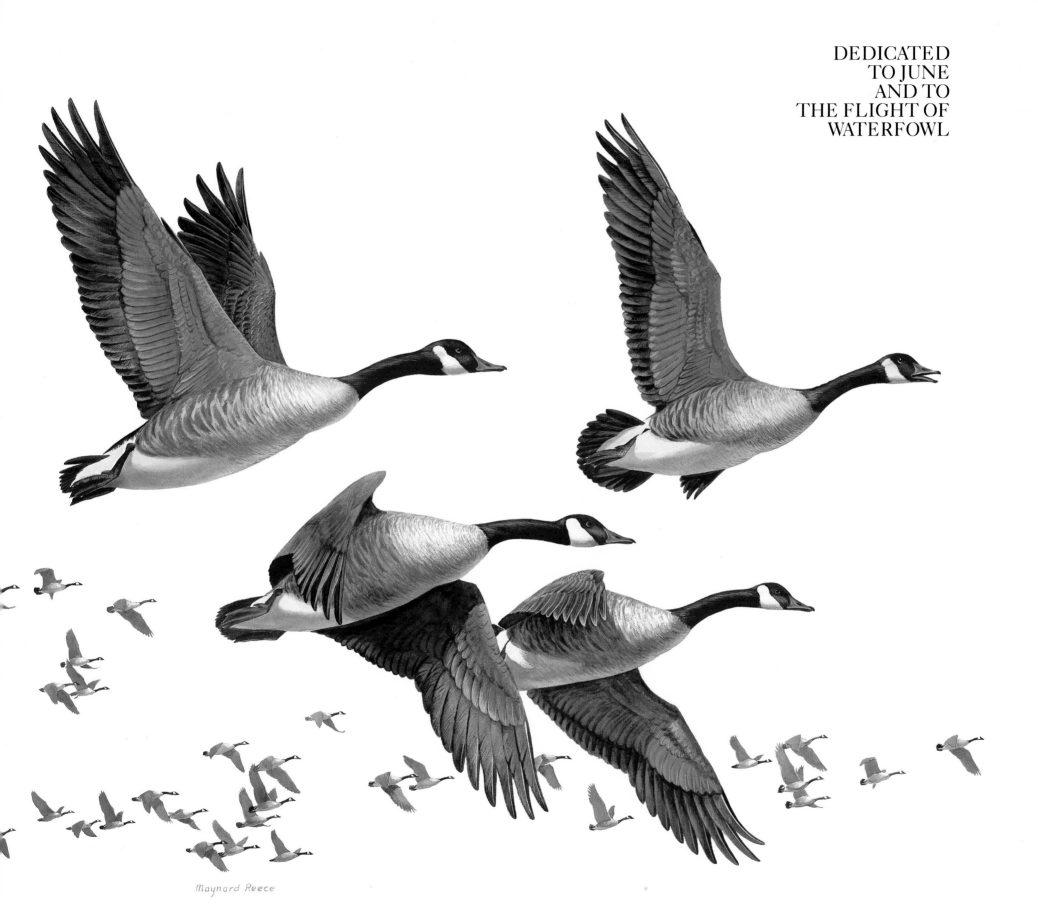

Maynard Reece

CONTENTS

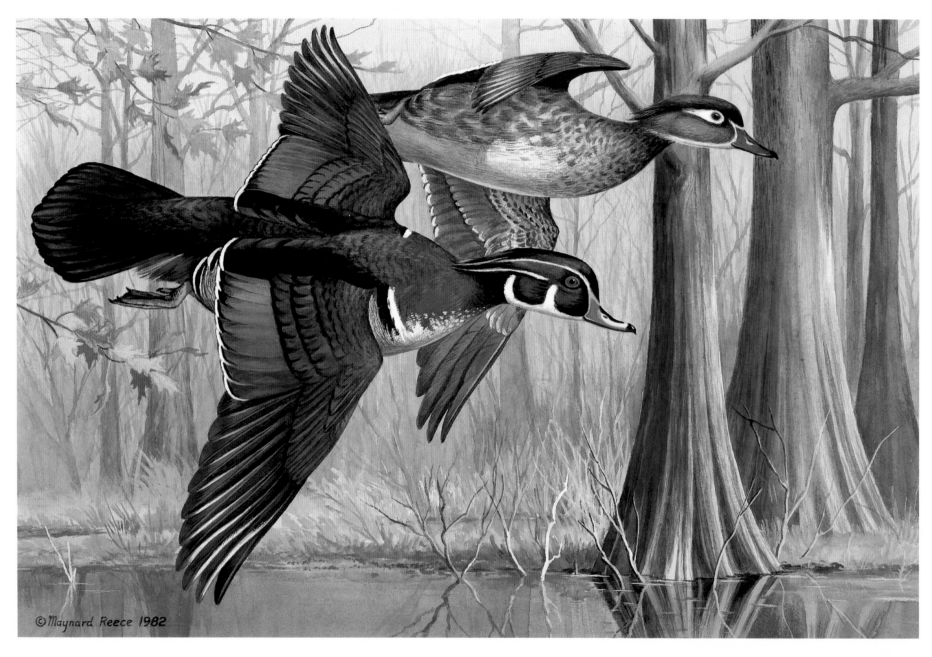

©Maynard Reece 1982

3. *Wood Ducks*. 1982 Arkansas Duck Stamp Design, watercolor

Wood ducks are darting through a stand of bald cypresses in the Big Lake Refuge of eastern Arkansas.

INTRODUCTION

INTRODUCTION

The Mississippi Valley is still the greatest flyway for waterfowl in the world, even though vast acreages of wetlands in the upper Midwest have been drained and turned by the plow.

Fortunately, choice parts of this watery heartland have been set aside in federal and state refuges to insure that the hordes of ducks and geese that travel between their northern nesting grounds and the Gulf states will always have resting places. In this avian paradise Maynard Reece was born and there he has spent most of his life painting his beloved wildfowl. In 1933, at age thirteen, he won first prize at the Iowa State Fair for a drawing of mallards. He still has the ribbon.

It is no coincidence that most of the premier painters of American waterfowl have lived and painted in the Mississippi flyway, undoubtedly imprinted by their environment. The late Francis Lee Jaques, whose dioramas and decorative canvases grace half a dozen major museums, was born in the prairies of Illinois and lived out his later years in Wisconsin. Owen Gromme of Wisconsin, now in his eighties, is another versatile museum preparator who turned his talents to waterfowl art.

Indeed, that seems to be the way to go, believes Maynard Reece, who has followed a similar pattern after working as a preparator, taxidermist, and artist at the Iowa Museum of Natural History in Des Moines. He states, "You can get in the front door or the back door, but you have to get training somewhere—in both natural history and art. I have always been interested in painting wildlife. At the museum I learned taxidermy and began to study in the field."

Very few wildlife artists ever start as full-fledged freelancers. They usually take one of three routes: as commercial artists with some formal art training; as museum preparators; or as academics with degrees in wildlife or ornithology. Their gallery painting is usually initiated as a sideline. Commercial artists or museum preparators can make the switch later, if their canvases are bringing prices that guarantee a living, but academics are usually trapped. They risk losing tenure and the security that has accrued over the years.

It was during the late 1960s when the market for sporting art and limited-edition prints blossomed that Maynard Reece really took off. He was already well known to Robert Lewin, a master printer and publisher, with whom he had worked in connection with the National Wildlife Federation's stamp program. So, when Bob and Katie Lewin launched Mill Pond Press in Venice, Florida, Maynard became their first artist. The fine printing was evident to collectors from the start, but the most positive reaction came from the midwestern sportsmen themselves, who recognized in Maynard a kindred spirit: "their kind of man," who knew their marshland environment

intimately, with all its moods and ever-changing quality of light, and who knew the ways of the waterfowl they hunted.

This intuitive knowledge did not come without years of apprenticeship. But Maynard must have known what he wanted from the start, or perhaps he became hooked when he won that first prize at age thirteen. When he graduated from high school he was irresistibly drawn to the Museum of Natural History in Des Moines where he met one of the most legendary wildlife conservationists of our time, J. N. "Ding" Darling, the powerful political cartoonist who was to become chief of the U.S. Fish and Wildlife Service; a man who was instrumental in saving vast acreages of waterfowl habitat. Darling advised Maynard, "If you religiously make five or six sketches every day for five years, you will become an artist." Maynard took this advice, but felt that field sketches alone were not enough if he did not know anatomy. After a two-year stint with Meredith Publishing Company in Des Moines, where he learned some of the secrets of commercial art— paste-ups, spot drawing, and airbrush—he returned to the museum as staff artist and assistant museum director. There he learned taxidermy —"how a bird is put together." His first book—*Waterfowl in Iowa*, with eight colorplates depicting thirty-six species in various plumages—was published in 1943. This was followed by a book on the fishes of Iowa. Because of his expertise in painting fishes, I

recommended Reece to the editors of *Life* magazine, for whom I had been painting birds. Maynard devoted two years to his portraits of *Fresh Water Fish* and *Salt Water Fish* which graced the pages of that magazine in 1955 and 1957. Later, because of his proficiency with fishes, my publisher, Houghton Mifflin, approached Reece to illustrate *A Field Guide to Freshwater Fishes* in my series of field guides; but by then the demands for his superb waterfowl canvases and prints left him little time for more mundane and functional illustration.

Maynard was evolving from a painstaking delineator to a more "painterly" painter. The detail became less important than the fall of light and shade, the movement in space, and the three-dimensional activity that the top wildlife artists now strive for. Representational painting, in the academic manner if you will, is the only honest approach for the naturalist, who cannot be other than a realist; it is as valid a statement as any devised by the avant-garde fraternity.

Although Reece has painted everything from insects to botanical subjects, waterfowl have always been his main thrust. In 1948 he won the first Federal Duck Stamp Contest and has won that contest four times since. This is an extraordinary achievement when we consider that now as many as fifteen hundred artists annually enter this "waterfowl sweepstakes."

Although Maynard Reece continues to make his home in Iowa, he is by no

means provincial. A museum buff, he has spent innumerable days studying the works of the masters at the Metropolitan Museum in New York and at the Louvre in Paris, as well as in the galleries of a dozen other art centers.

During his months of army training in the Signal Corps at Red Bank, New Jersey, during World War II, he spent his leaves and weekends at the American Museum of Natural History in New York. It was at this venerable institution that he met Francis Lee Jaques, the great museum dioramist, with whom he established immediate rapport because both were from the prairies and both were more obsessed with waterfowl than they were with lesser birds. Perry Wilson, another fine museum artist, also took Maynard under his wing, as did Robert Cushman Murphy, James Chapin, and other ornithological giants. How could he miss? Obviously he couldn't.

Maynard Reece spends half his time in the field, much of it in his familiar Iowa wetlands; but, aware that there is "a big world out there," his travels have taken him to the arctic tundra, the South American tropics, the African veldt, and even to Antarctica. The penguins captivated Maynard but did not divert him from the stately icebergs which he sketched in oil on small pieces of canvasboard. After a cruise on the Lindblad *Explorer* he showed me several of these sketches. "I can't get the turquoise, cobalt, and ultramarine from photographs," he explained. "Photos don't pick up the refraction of light going through glacial ice."

The innumerable tranparencies which Reece exposes are used as a memory jog, not as a crutch. He depends more on his field sketches which tend to reinforce his highly trained visual memory. Some may be scarcely more than a few lines or a swatch of color, but enough to catch the essence of the subject.

This handsome book, a celebration of the art of Maynard Reece, is a delight to the eye and will make us all more sensitive to the pageantry of waterfowl.

Roger Tory Peterson

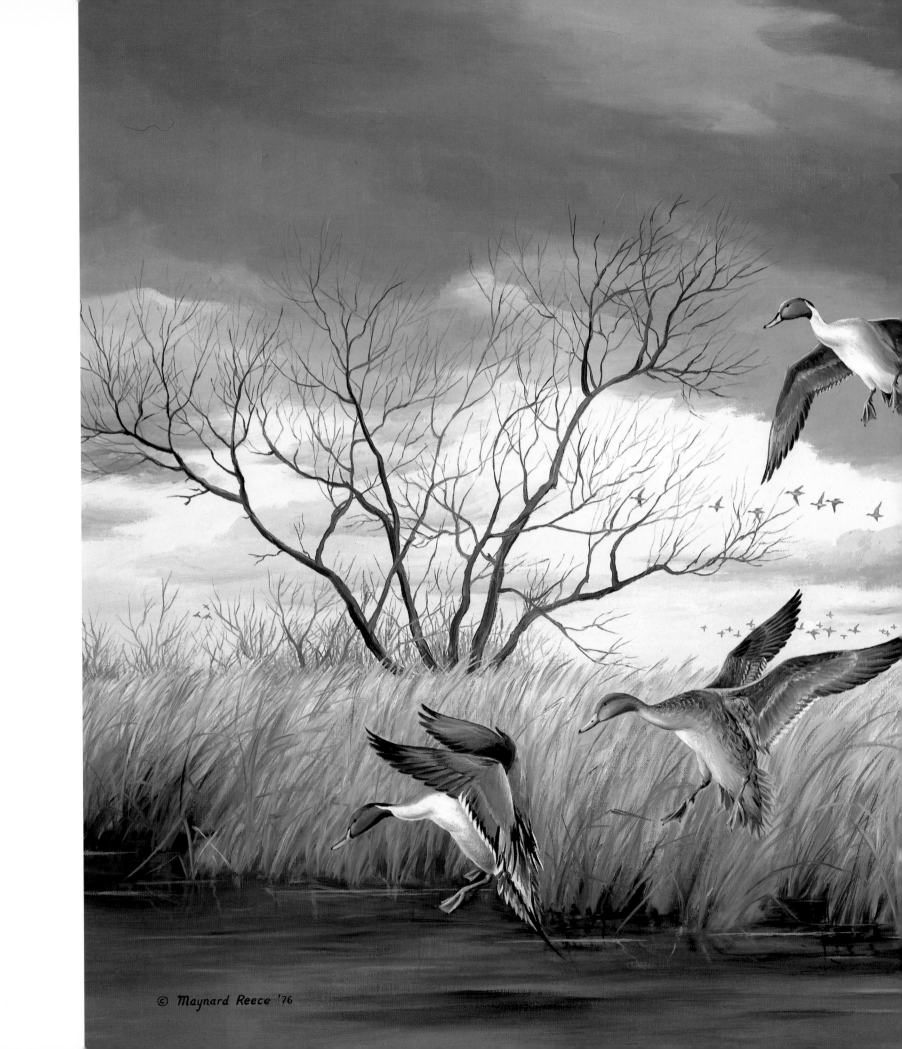

© Maynard Reece '76

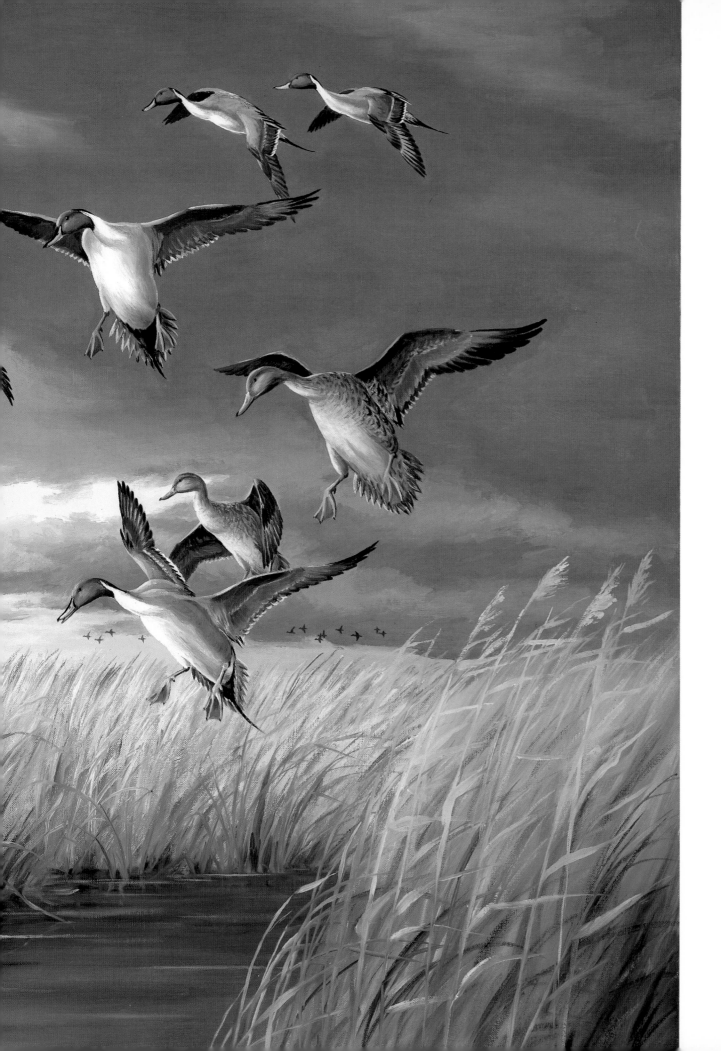

4. *Easy Landing: Pintails*. 1976, oil on canvas

Pintails, so adept at landing in marshes, put on a fascinating performance of balance and graceful maneuvering as they twist down through the reeds and onto the water. Pintails are sleek and streamlined.

(overleaf)

5. *Diamond Island: Mallards*. 1980, oil on canvas

A flock of mallards is funneling into an oxbow which has formed an island along the Mississippi River. Oxbows are water areas trapped by a river changing its course as it flows toward the ocean. High water at floodtime kills some of the trees, but others survive with the plants and weeds, affording food and shelter for waterfowl. By evening thousands of ducks will be resting here and all will be quiet except for the occasional quack and chuckle of contented mallards.

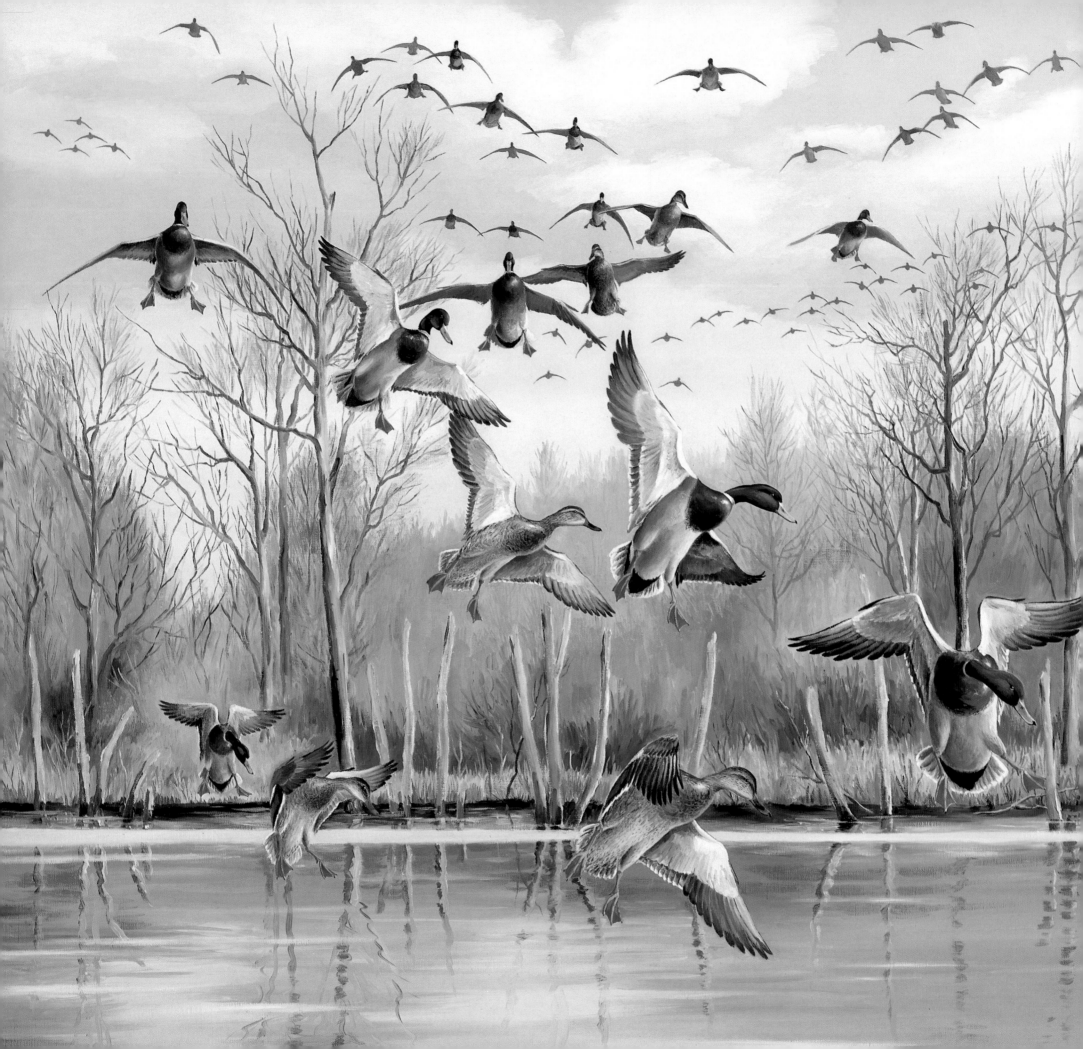

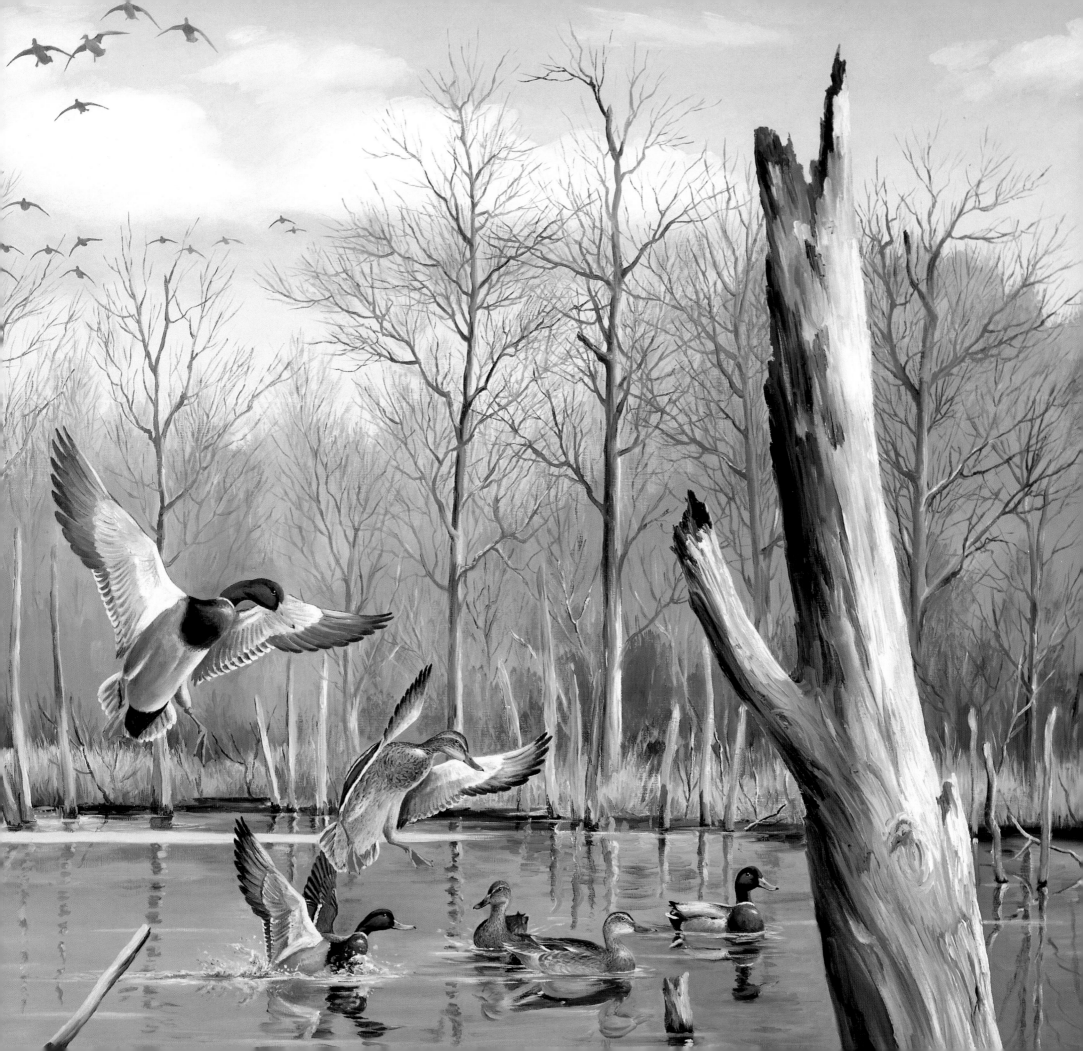

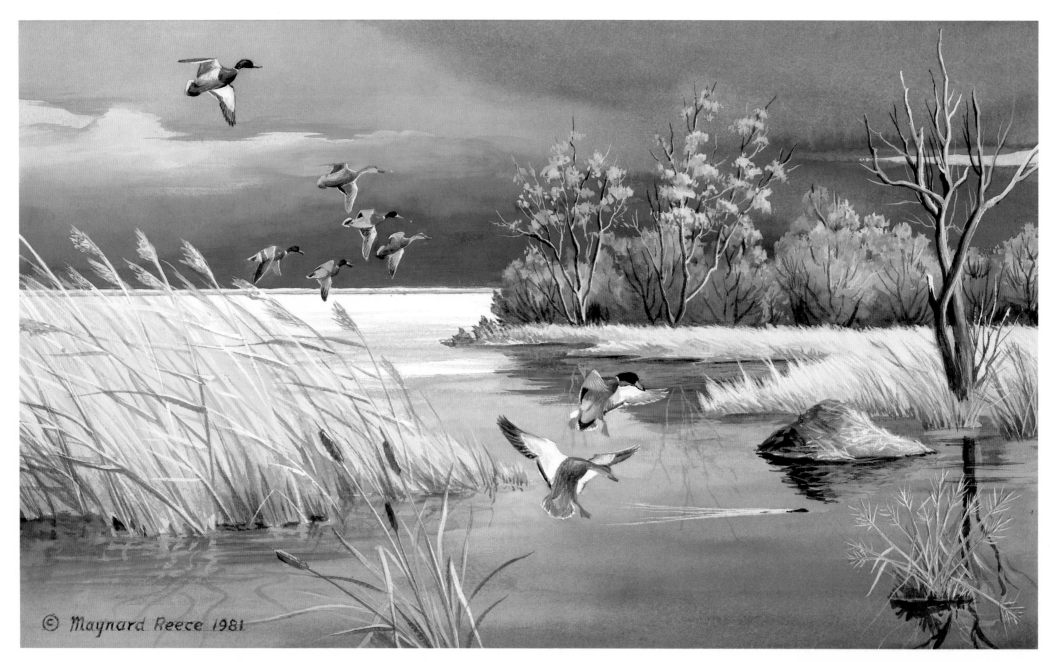

© Maynard Reece 1981

6. *Tranquil Marsh: Mallards*. 1981, watercolor

A muskrat streaks the still water as he
swims past clumps of wild rice, cattails,
and phragmites. Mallards are drifting in
for the night.

THE HABITAT

CHAPTER I

THE HABITAT

MARSHES

It is dark. You settle down in the canoe, remembering to wipe the water off the seat from the early morning fog. In the blackness you search for some little reflection on the water to guide your progress through the weeds. The stagnant water has a pungent smell as you paddle quietly, sensing the water more than seeing it. A talkative mallard quacks intermittently. More noises. The ducks are getting restless.

Suddenly, ahead in the darkness, comes a roar of wings beating against weeds, water, and air as the frightened ducks take off. After the brief commotion the marsh returns to silence, only to have the commotion repeated again and again as you paddle deeper into the maze of water paths winding past dense patches of cattails or phragmites. Familiar sounds are muted but constant. Frogs, coots, and a bittern are becoming vocal. As it begins to lighten, the blackbirds, crows, swallows, terns, and marsh wrens are awake and on the move.

The water now can be seen, reflecting the light of the sky. Across the smooth surface a muskrat throws a sharp "V" as he swims toward his house, somewhere still in darkness. He sees the gliding canoe and dives underwater without the large splash or plop of a beaver—you can barely make out the muskrat's vertical flattened rat tail as he submerges.

You pull your canoe over the heavy tangle of cattails, sliding almost out of the water—with cattail fluff in your mouth and down your neck. You are quiet, hidden, and blending with nature, with solid vegetation beneath your canoe. Standing, you can see over the cattails, and you look toward shore as the first rays of light hit the willows. Low-hanging clouds take on a glow of color as the sun steadily climbs over the horizon, bathing the marsh with sunlight.

This scene can be found across North America in thousands of marshes, from tiny bogs you can jump across to vast expanses of water and weeds that stretch to the horizon. Our marshes are necessary to our existence. Without water trapped on the land, our environment would be in danger.

Marshes are natural flood plains, slowing water runoff and soil erosion. It is nature's purifying water system and even may become the sewage treatment plant of the future, for cattails and bulrushes have the capacity to turn raw sewage into desirable organic material that is rich in minerals. Saltwater marshes are hatcheries for many beginning forms of marine life. The wetlands, both fresh and salt, are complex systems of water and vegetation that have produced homes and food for all kinds of animal life, including man. Marshes improve the water table for agriculture and human needs, and in them grow edibles— wild rice and cranberries. These simple water areas hide an amazing number of diversified benefits.

Marshes are a part of nature known to all of us, and a fitting beginning for the fascinating story of the free and romantic group of birds called waterfowl.

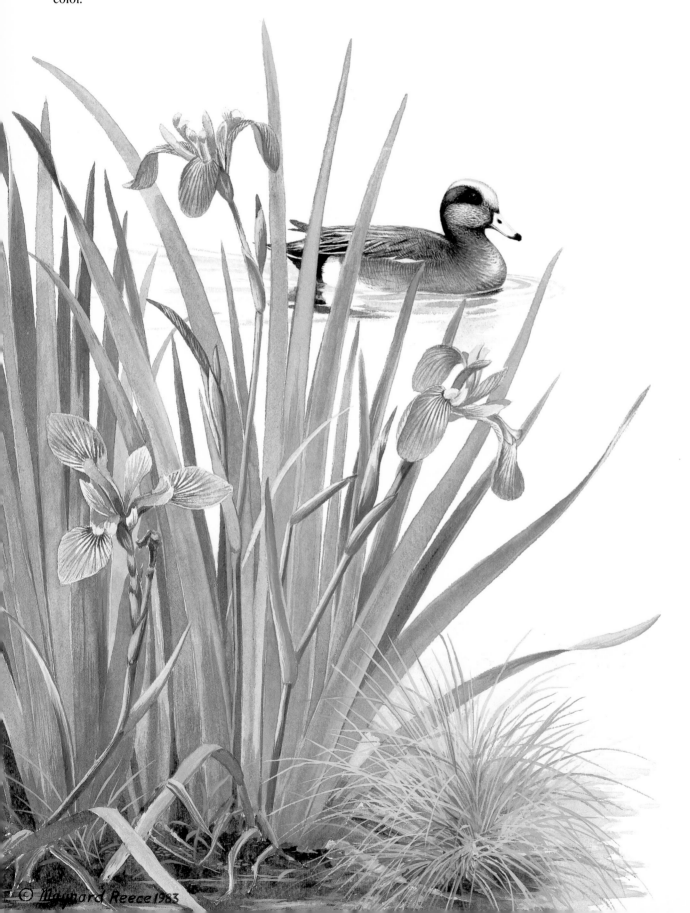

7. *Blue Flags and Wigeon*. 1983, watercolor

Iris or "flags" grow in bogs and marshes of the north country. In spring they turn the shallow shorelines into a purple blaze of color.

SOLITUDE OF MARSHES

Besides water, marshes also provide an abundance of solitude. No angry waves here; heavy winds blow unheeded; you duck your head behind the dense, tall weeds and it is quiet, for the wind slides across the top of weeds that bend and dance but never break.

It is soothing to sit in your boat in a marsh with the movement and sound of water gently lapping against the sides. In the muted voices of frogs and birds is the therapy of restful sounds.

The colors of the marsh are always muted. Flowers bloom. Swallows dip and dive back and forth over the water in search of insects. Terns, marsh hawks, and now and then a crow winging across this flat expanse of water and weeds give you a sense of solitude in the form of oneness with nature.

Marshes can look immense with seemingly endless vistas of weeds all uniform in height: the dense, upright growth of cattails; the flowing, graceful waves of phragmites; the bending, neat appearance of bulrushes. But move in closer and you will find a multitude of coves of water forming small ponds of every shape and size.

Marshes offer sheltered resting spots for the millions of waterfowl that wing back and forth each year over our vast continent.

8. *Late Afternoon: Mallards*. 1969, oil on canvas

Marshes in late afternoon take on warm colors from the setting sun. Shadows deepen and the water quiets to reflect both weeds and sky. Ducks return to the marsh in small groups, settling down before dark. It is a peaceful time of day.

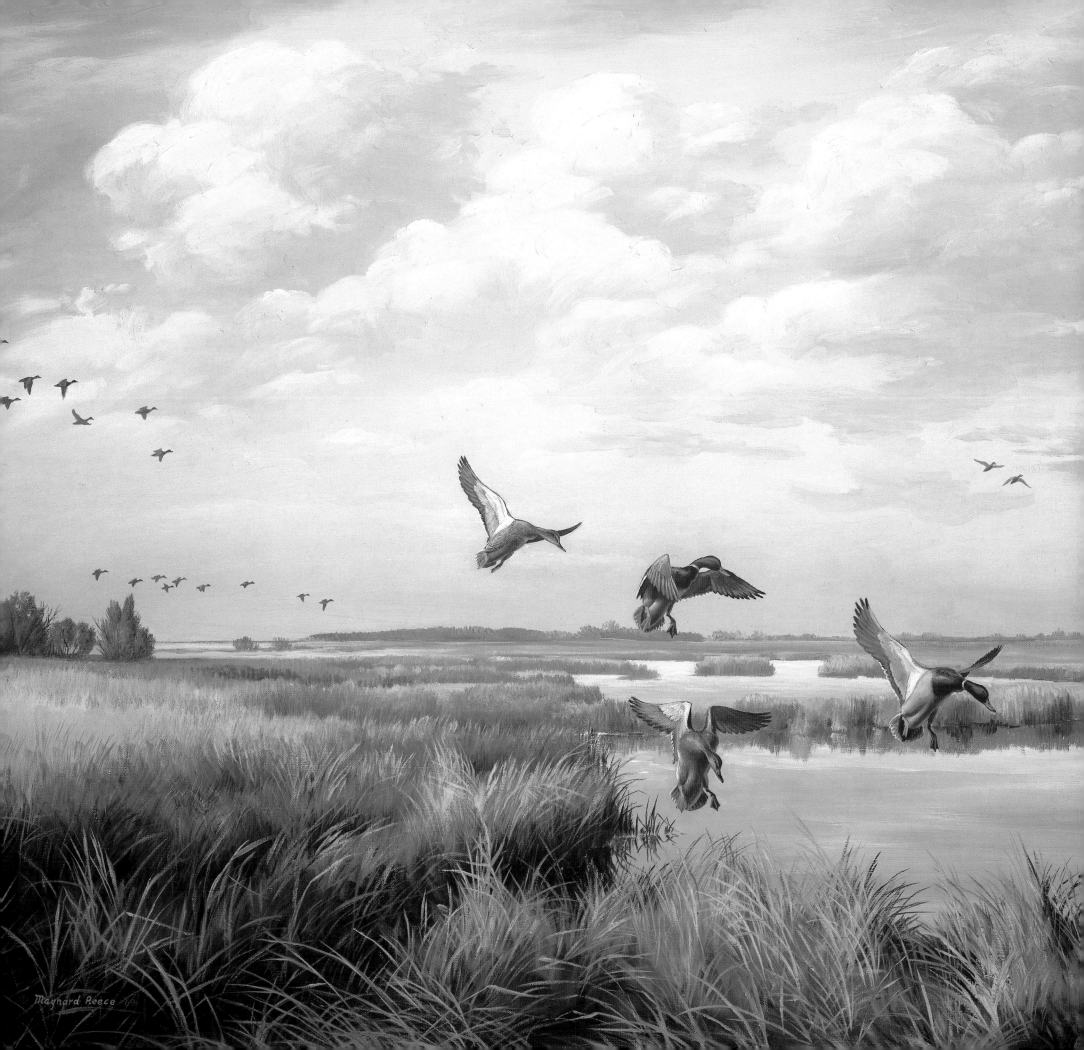

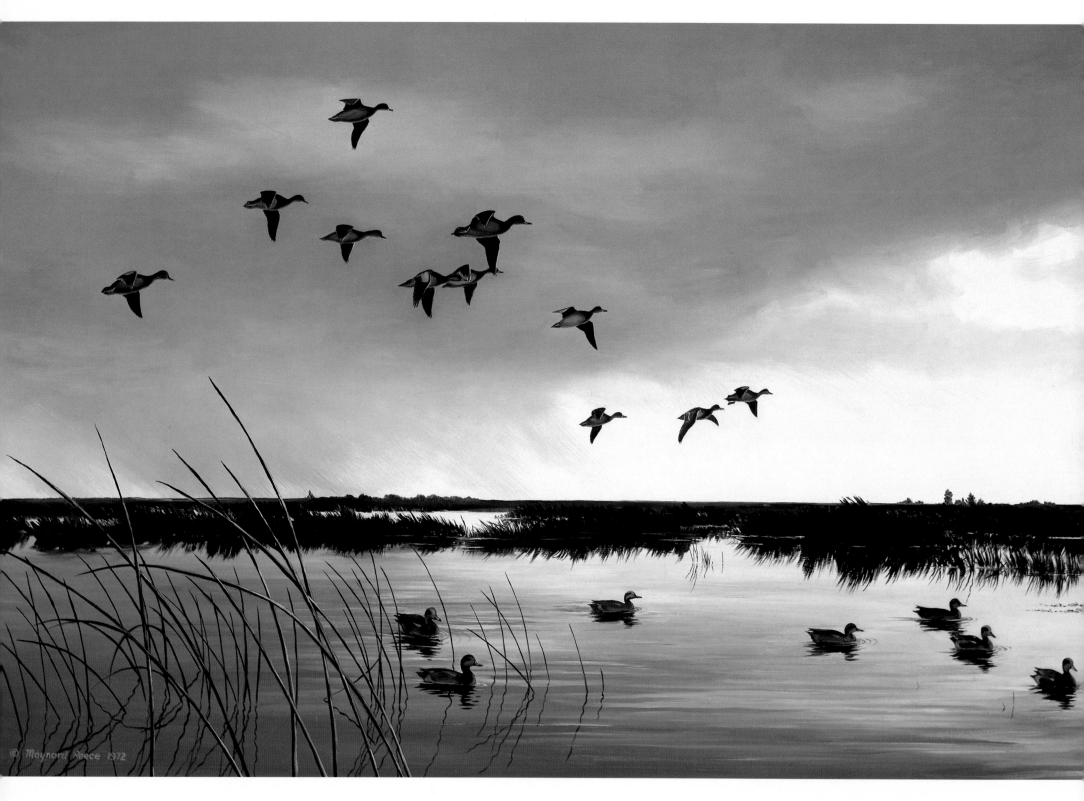

9. *Twilight: American Wigeon.* 1972, oil on canvas

The sky suddenly darkens with an approaching storm, and the fading light is almost gone. Some wigeons have already landed, and another flock is dropping into the marsh, silhouetted against the sky. In a few minutes the wind and driving sheets of rain will hit the marsh.

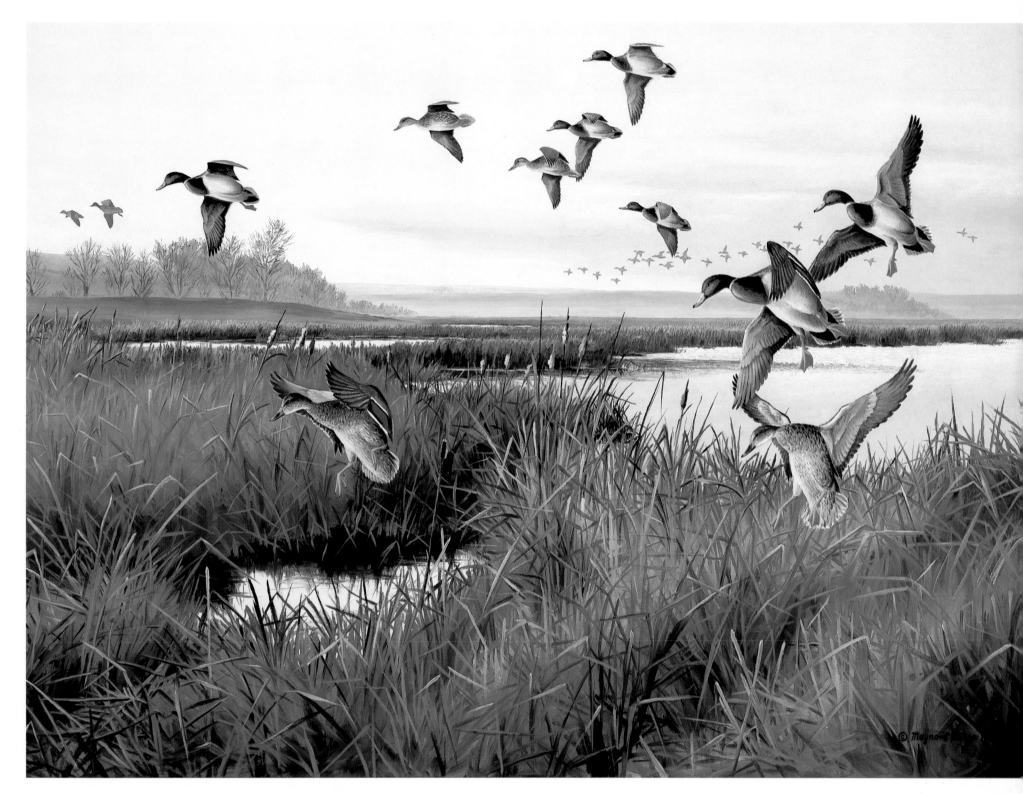

10. *Stony Lake: Mallards*. 1981, oil on canvas

It is early morning on the marsh. Fog still hangs across the low hills. The sun's first rays reach the top of the cattails and bathe the mallards with a warm glow.

Mallards will land and settle on any secluded pond offering a little privacy. Timber and brush are fine; even a small creek will do. They adapt well to civilization, sometimes nesting and living within large cities on park lagoons or private estates.

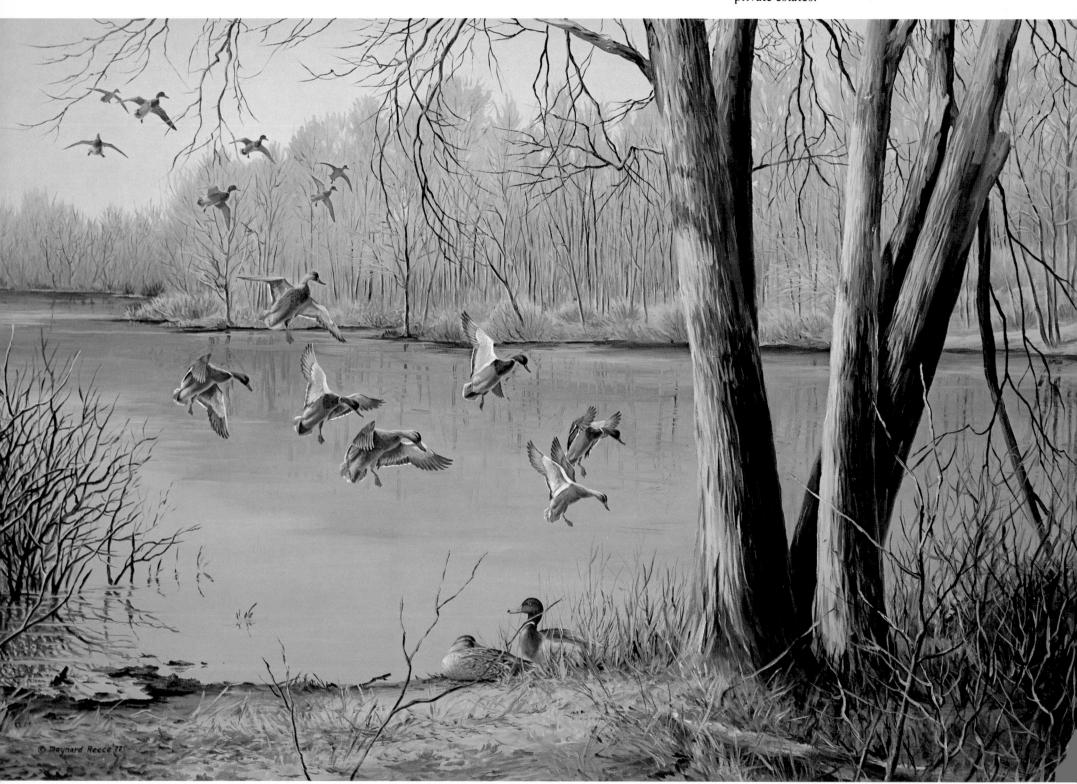

LAKES, STREAMS, AND RIVERS

While marshes provide havens for millions of waterfowl, lakes and streams are also homes for many species of ducks and geese. Canvasback, redhead, scaup, goldeneye, and most diving ducks prefer to rest and feed in wide-open, deeper waters: some ducks will dive as deep as sixty to eighty feet below the surface in search of food.

Diving ducks may raft up in immense flocks in the middle of the rivers and off the shores. They seem to enjoy companionship, for several species can often be found together in the same area. Heavy waves do not bother them; even in the surf along the coastline, they will bob about like corks.

Several methods can help you get close to waterfowl on lakes and streams. The unique water vehicle called a scull boat provides one way. Sculling, an art different from rowing, paddling, or poling, uses a single oar at the rear of a flat, low-profiled hull. You can lie down and control or propel the boat by twisting and swinging the oar slowly back and forth. Such gentle motion goes unnoticed by the raft of waterfowl, since to them you look like a large floating log, and in the scull boat you can drift right in among the ducks or geese on the water.

Some ducks, such as mallards, can make use of any type of water area, resting on large lakes or settling into tiny streams or ponds. The rivers and coastlines along our continent provide natural migration routes for these waterfowl.

It is fascinating to watch diving ducks come into a lake where they are accustomed to feeding. Without trees, weeds, or grasses to worry about, they bore through at a fast speed like little jet planes on an approach landing, skidding along calm water or bouncing from wave to wave if it is rough. Coming to a stop, they collect in a loose group and start diving for food. Their smooth dives without a ripple are repeated time after time, the birds popping up in random fashion like bubbles from the bottom. The bobbing and bouncing action of ducks in the waves is hypnotic and therapeutic to watch, like flames in a campfire or waves on an ocean shore.

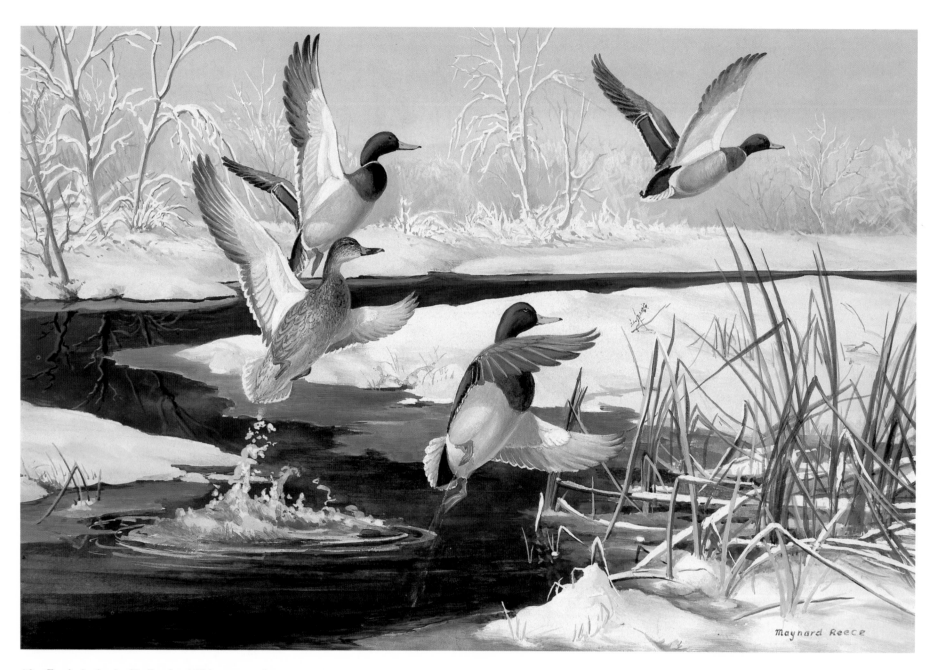

12. *Early Arrivals: Mallards*. 1974, watercolor

It is always interesting to come suddenly upon a few mallards already sitting on a small creek with banks still covered with snow. When you approach, they instantly lift off and speed away.

13. *Rough Water: Canvasbacks*. 1978, oil on canvas

Canvasbacks are strong, speedy fliers; on a windy day a flight of canvasbacks is an impressive sight winging over the heavy waves and driving across the lake through the rain squall.

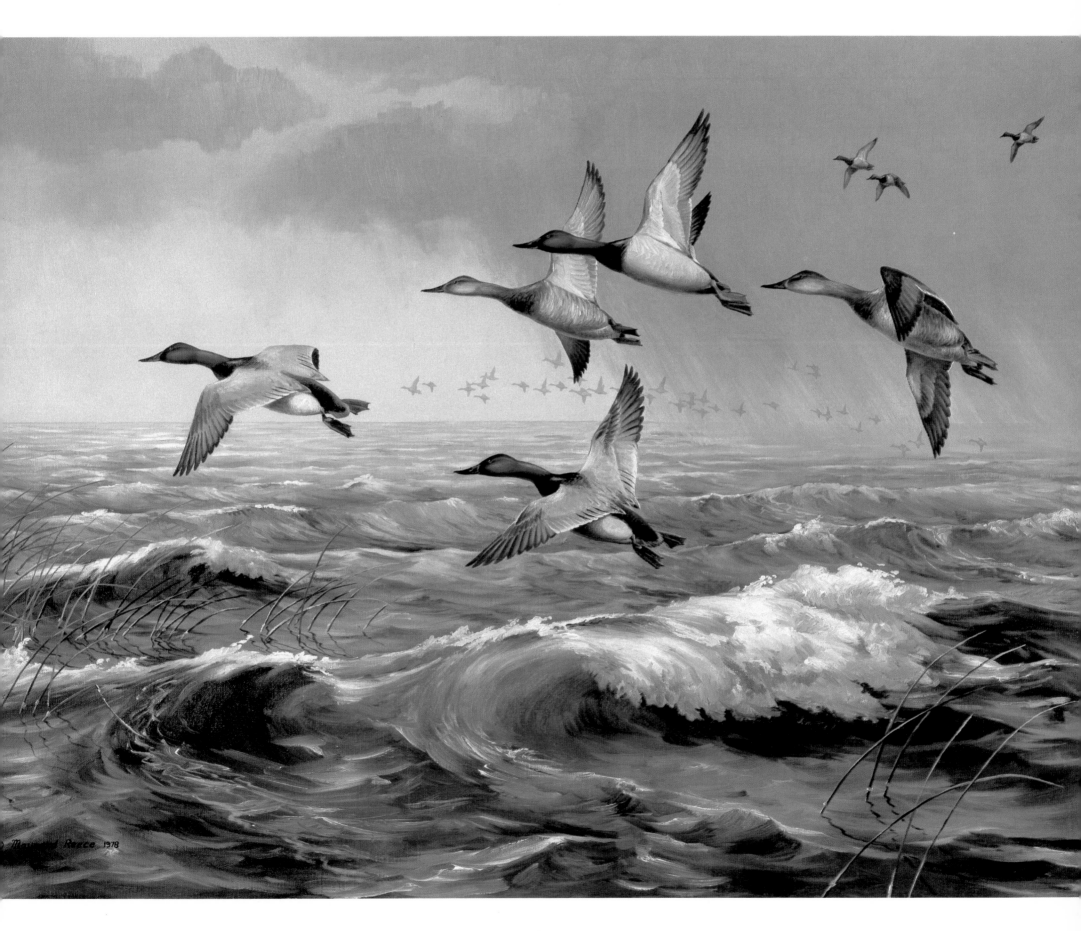

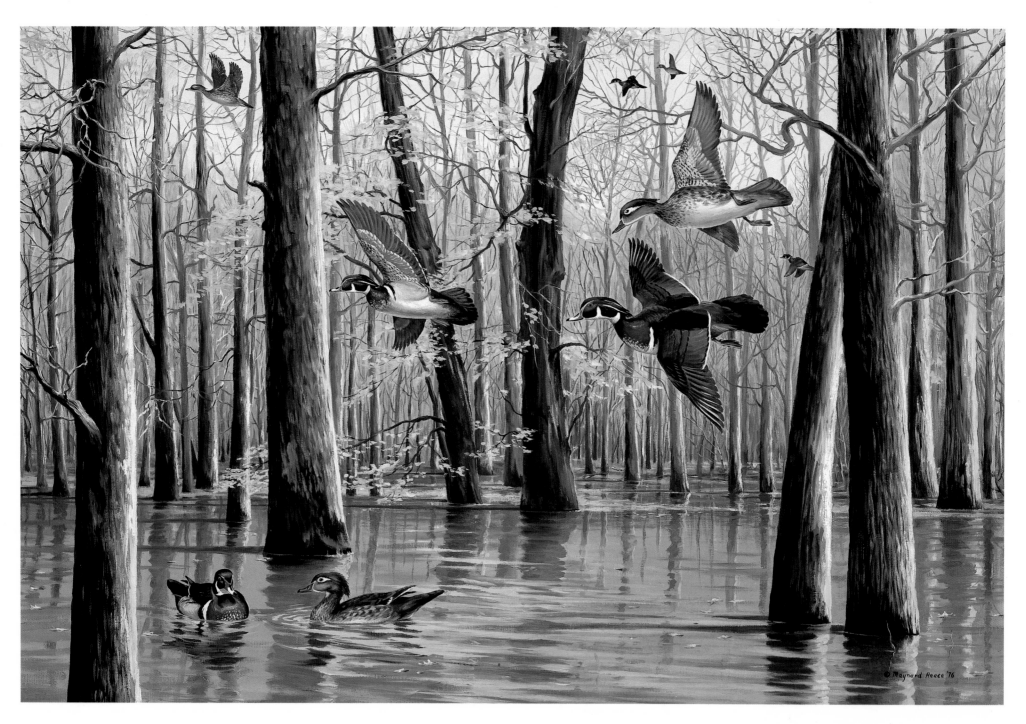

14. *Through the Trees: Wood Ducks.* 1977, oil on canvas

Wood ducks, aerial acrobats, do not land like other surface-feeding ducks. They dart through the timber at full speed and dive toward the water, braking at the last instant and skidding to a stop.

Many species of ducks love the water havens in flooded timberland, where they find weed seeds and acorns to eat, lots of water for protection and drinking, and shelter from wind. In the hollow cavities of its trees nest wood ducks and goldeneyes. Teal, wigeon, mallards, and occasionally such divers as ring-necked ducks also make use of flooded timber.

Yes, timber flooded with water is great for ducks, but not so good for us. Sometimes a boat can be navigated through the timberland, but the best way to observe these waterfowl is to stride along in waders or hip boots from one tree trunk to the next—it is like walking two-foot tall among the birds. But walking in waders is precarious, for a foot may get stuck in the mud or caught under a sunken log, and if you stumble or snag a hole in your boots you will find that a drenching in 33-degree water is an extremely cooling experience. Ducks keep warm with a layer of down insulating their skin from their oiled outer feathers; you too may be insulated by layers of clothing, but icy water

TIMBER AND FIELDS

will disastrously affect even your best protection. Should this happen, the best place to head for is dry land, leaving the flooded timber to animals better equipped to cope with cold water—like ducks.

The fields of waste grain or winter wheat are prime habitat for geese as well as ducks. Geese like places with ample room for spotting predators, and they also need plenty of space for taking flight. Though waterfowl may feed for considerable time in fields, they will go back to water areas to rest and drink. After cleaning up the nearby fields of available waste grain, the birds fly farther and farther each day in search of food. Ducks and geese will travel from fifty to a hundred miles to feed and still return to their resting areas each night. Today's combines for harvesting grain leave much waste grain for the waterfowl, but the birds do not always wait for the combines. Grain fields are an open invitation to hungry birds, and this can bring real trouble to the farmers whose crops are destroyed or reduced by feeding waterfowl.

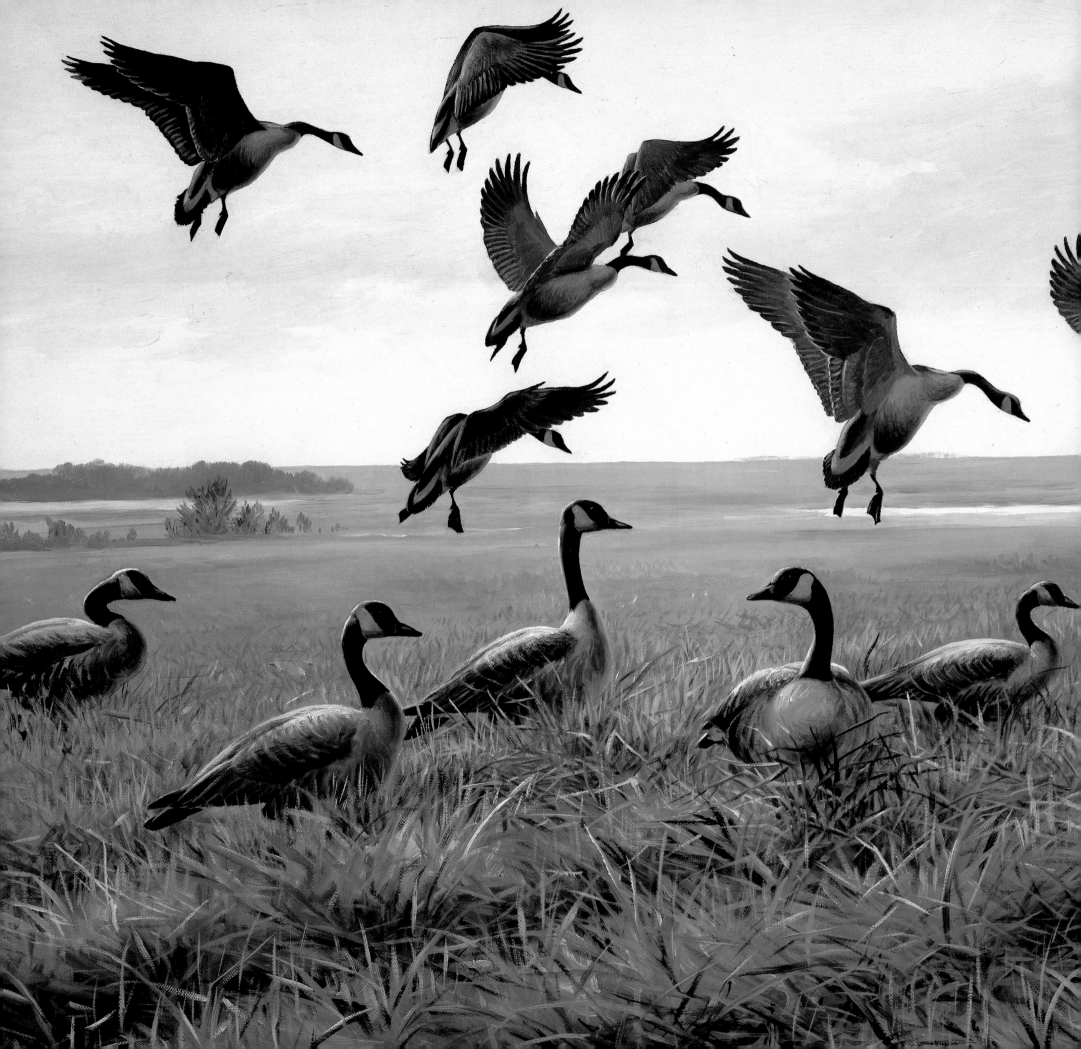

15. *Feeding Time: Canada Geese.* 1968, oil on canvas

These geese landing to join those already in the stubble field are nearly silhouetted against the lighter sky by the strong back light that accents the whole scene.

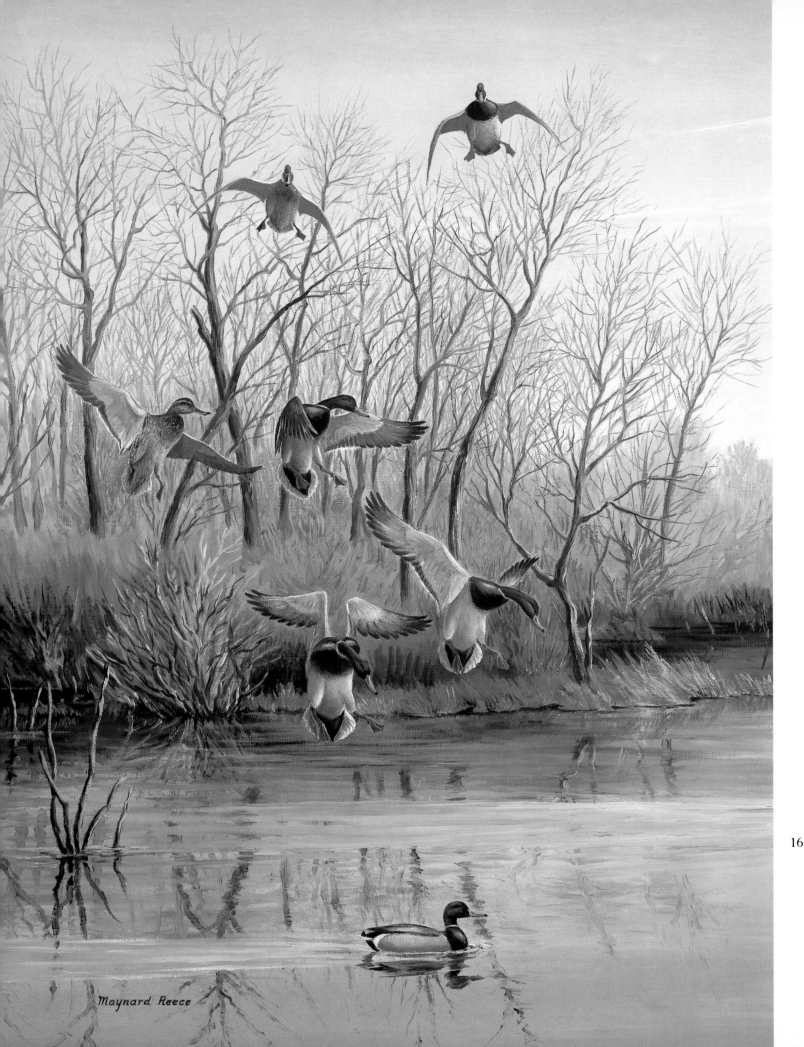

Maynard Reece

16. *Dropping In: Mallards.* 1974, oil on canvas

A flock of mallards drops into the quiet water with scarcely a sound. They appear from no-where and make their descent into the narrow water area with the competence of expert fliers.

17. *Coming In: Canada Geese.* 1976, oil on canvas

After circling once or twice and seeing other geese feeding on the ground, Canada geese set their wings and come in for a landing. Dropping their spread feet and tails as flaps, Canadas drift down against the wind, alighting easily among their companions.

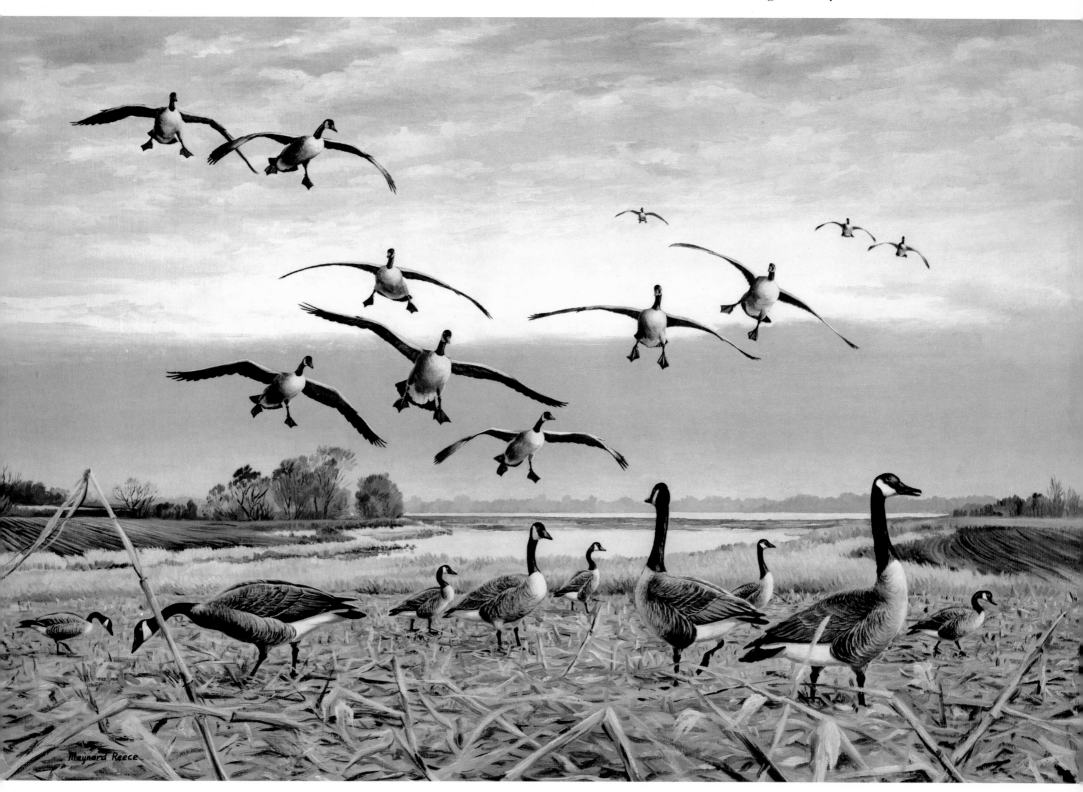

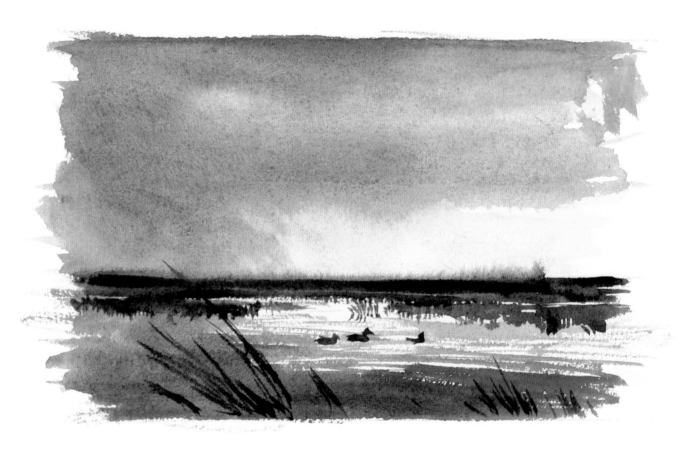

18. *The Marsh*. 1972, watercolor sketch

A preliminary watercolor sketch, dashed
off freely to catch an idea for a large
painting, sometimes has a spontaneity and
freshness that can never be recaptured.
This one is reproduced here with all its
flaws for your enjoyment.

THE SEASONS

CHAPTER II

THE SEASONS

SPRING

Clarion calls drift down from high overhead as long "V"s of Canada geese head north, heralding once again the age-old drama of migration. Everyone feels the strange stirrings of some early bond with nature as he looks skyward at this timeless flight. Spring is here! Nature has once again begun her relentless push against the winter ice and snow. Soon the barren ground will start to turn green as the land warms, and trees will burst from bud to leaf in a new growing season.

With this change have come the ducks and geese, anxious to return to their nesting grounds in the far north. Snow geese also fly in long lines, but not in the "V"s of the Canadas; the snows form loose, wavy series of overlapping strings that sometimes stretch beyond where the eye can see.

The ducks will keep moving as far north against the winter elements as they can still get food and water. The pintails and mergansers come first, along with the mallards, teal, and diving ducks. If a sudden blizzard makes them slide back south for a week, they will send scouts ahead to check the weather before traveling north again. Geese, ducks, and swans keep up this movement along the major flyways until they have again reached their old nesting areas in most of the northern states and northward to Alaska, across all of Canada, and on the islands in the Arctic Ocean.

Birds are pairing up as they migrate, mallards with mallards, pintails with pintails—no interbreeding. As they select mates, there is fierce competition for the eligible hens. The pintails do aerial maneuvers that show their graceful, slim bodies in full flight, with necks reared, heads upraised, and tails spread. Several drakes will fly after one hen, displaying their beautiful and colorful flight which seemingly arouses no interest in the hen, but she will finally choose a mate from this group of dazzling performers.

The red-winged blackbirds are busy selecting their nesting sites and territorial spaces with much courtship, fighting, and throaty song. They sway back and forth on last season's phragmites, the males displaying their bright red-and-yellow wing patches.

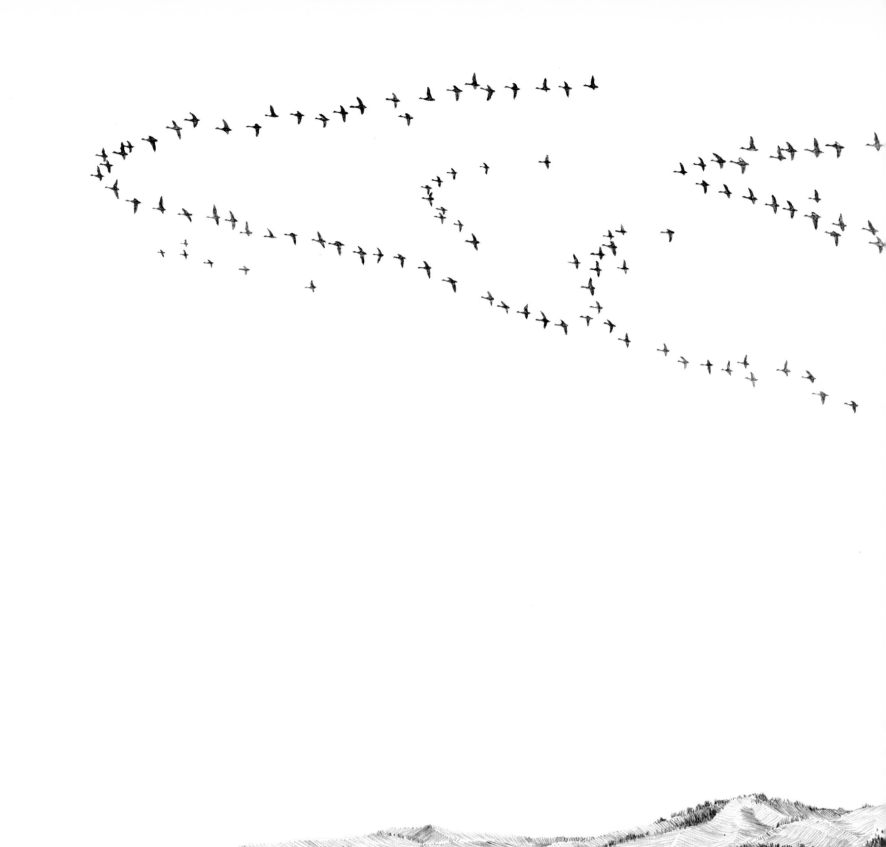

19. *Migrating Snow Geese*. 1983, pencil sketch
Snow geese form loose, wavy lines that
constantly change as they migrate. In the
background are the Waubonsie Hills in
Iowa along the Missouri River.

© Maynard Reece 1983

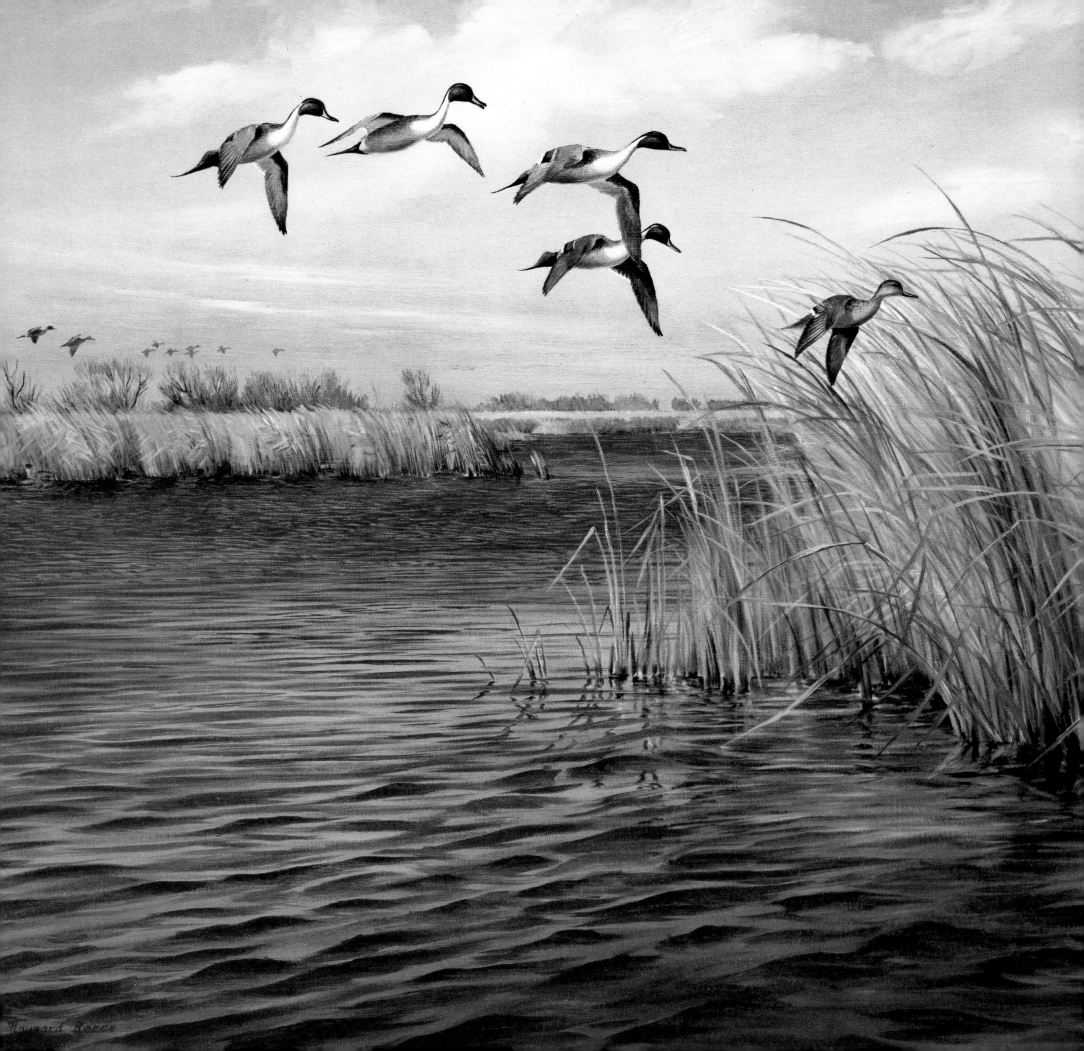

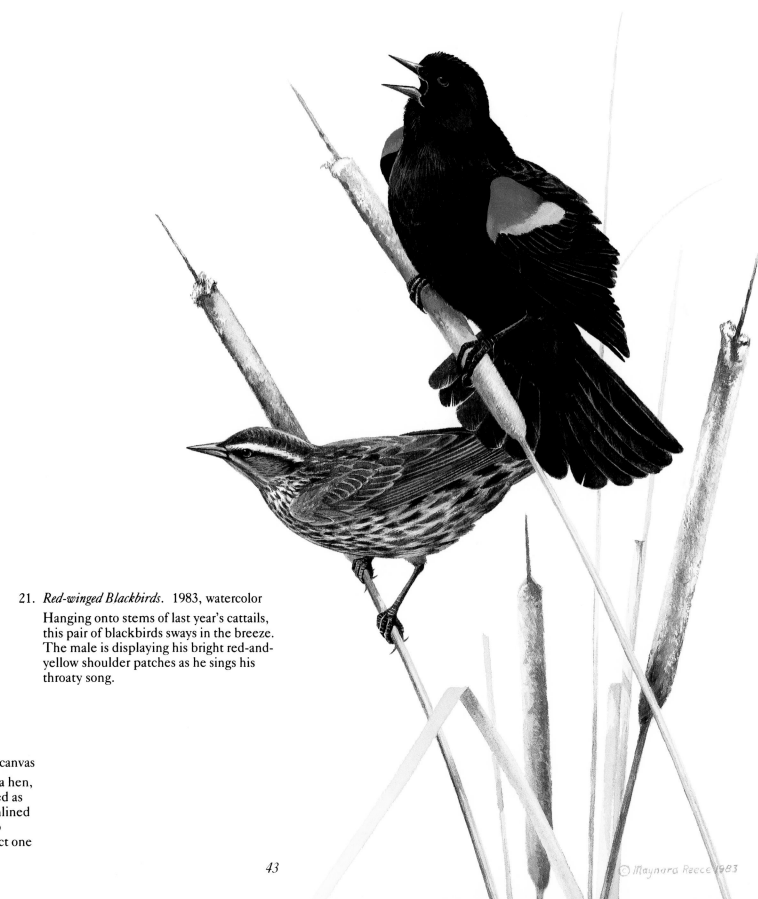

21. *Red-winged Blackbirds*. 1983, watercolor

Hanging onto stems of last year's cattails, this pair of blackbirds sways in the breeze. The male is displaying his bright red-and-yellow shoulder patches as he sings his throaty song.

20. *Courtship Flight: Pintails*. 1974, oil on canvas

Four pintail drakes are coasting past a hen, their necks arched and heads upraised as they show off their handsome streamlined bodies and spiked tails in a courtship display. Eventually the hen will select one drake for her mate.

© Maynard Reece 1983

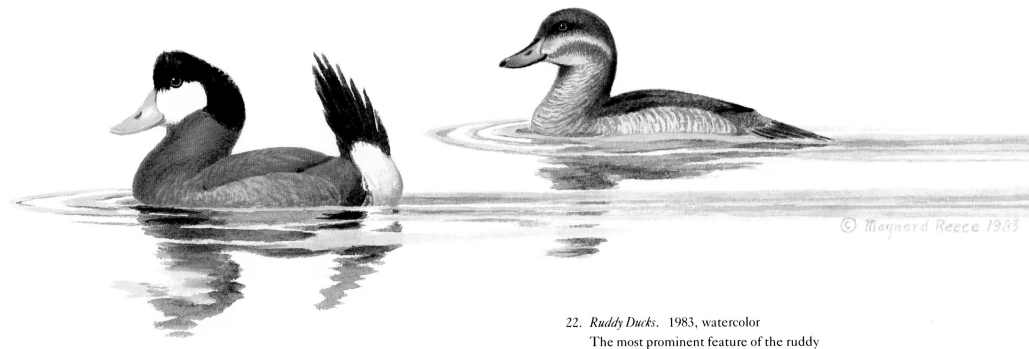

22. *Ruddy Ducks*. 1983, watercolor

The most prominent feature of the ruddy duck drake's courtship display is the erecting of his stiff, long tail to a ninety-degree angle, showing his white undertail coverts.

COURTSHIP

The gaudy colors of the drake's plumage are displayed during the courtship rituals, which take place during the spring migration and after arriving at the nesting grounds before actual nesting begins. Each species of waterfowl has a distinctive courtship ritual or style. The ruddy duck displays a swollen neck and two topknots, and holds his stiff tail up vertically to impress his female friend. Canvasbacks and redheads soon pair, though some males will be left aside as bachelors. A goldeneye bobs his head up and down, throwing his head back and then forward to the water as if he were gasping out his last breath.

Finally these formalities are over, and the birds settle down to the serious business of rearing a family.

23. *The Marsh*. 1972, oil on canvas

In this prime nesting area of southwestern Manitoba, these birds are selecting mates. The redheads behind are paired up; the canvasback hen in front has selected a drake, leaving a rejected suitor nearby. The yellow-headed blackbird prefers these freshwater marshes.

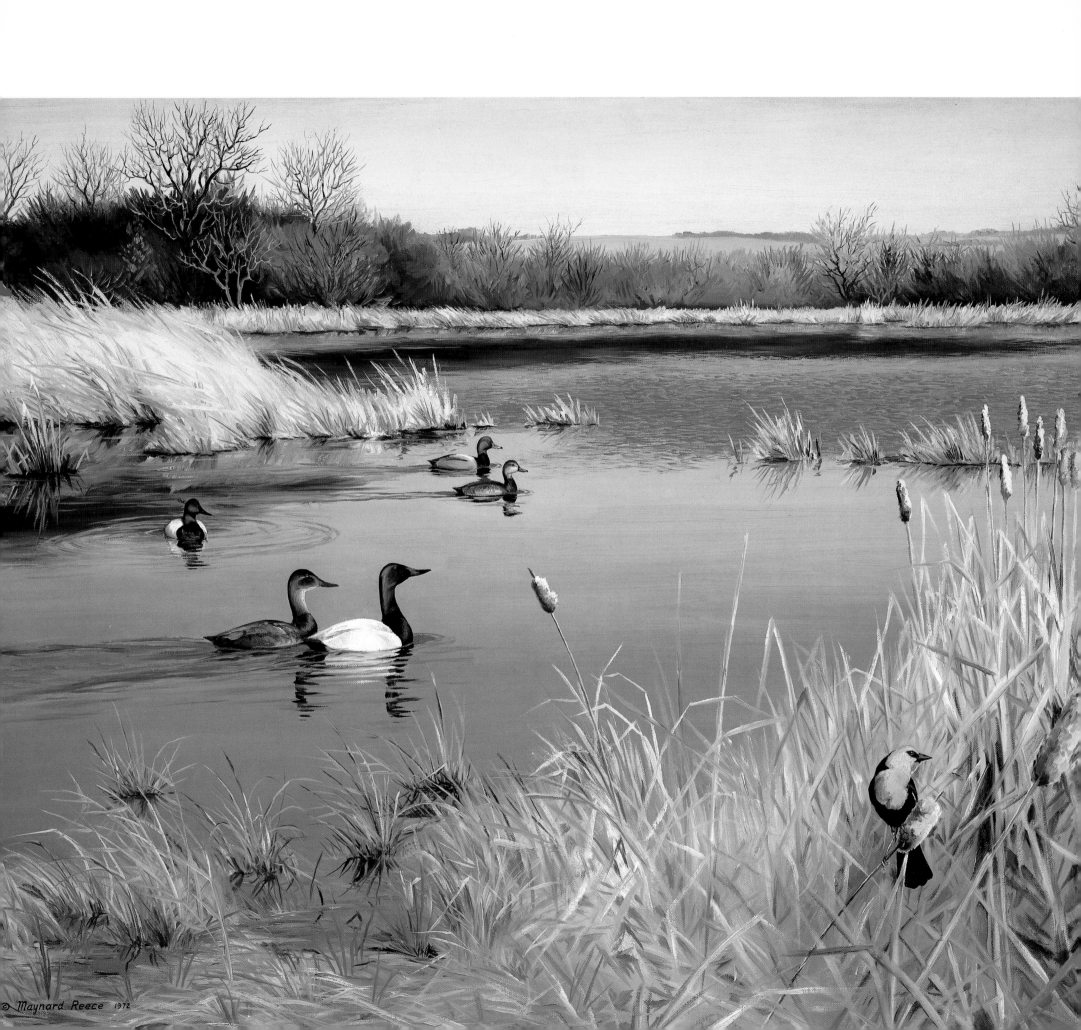

Maynard Reece 1972

24. *Blue-winged Teal with Ducklings.* 1971, oil on canvas

Once the hen has moved her brood from the nesting site to a secluded pothole, she will stay in this spot for some time. The drakes often leave their hens during incubation and join other drakes.

25. *Canvasback Nest.* 1983, pencil drawing

Canvasbacks build their nests where the water is a foot or two deep. This nest is made of cattails and was built more than a foot above the water.

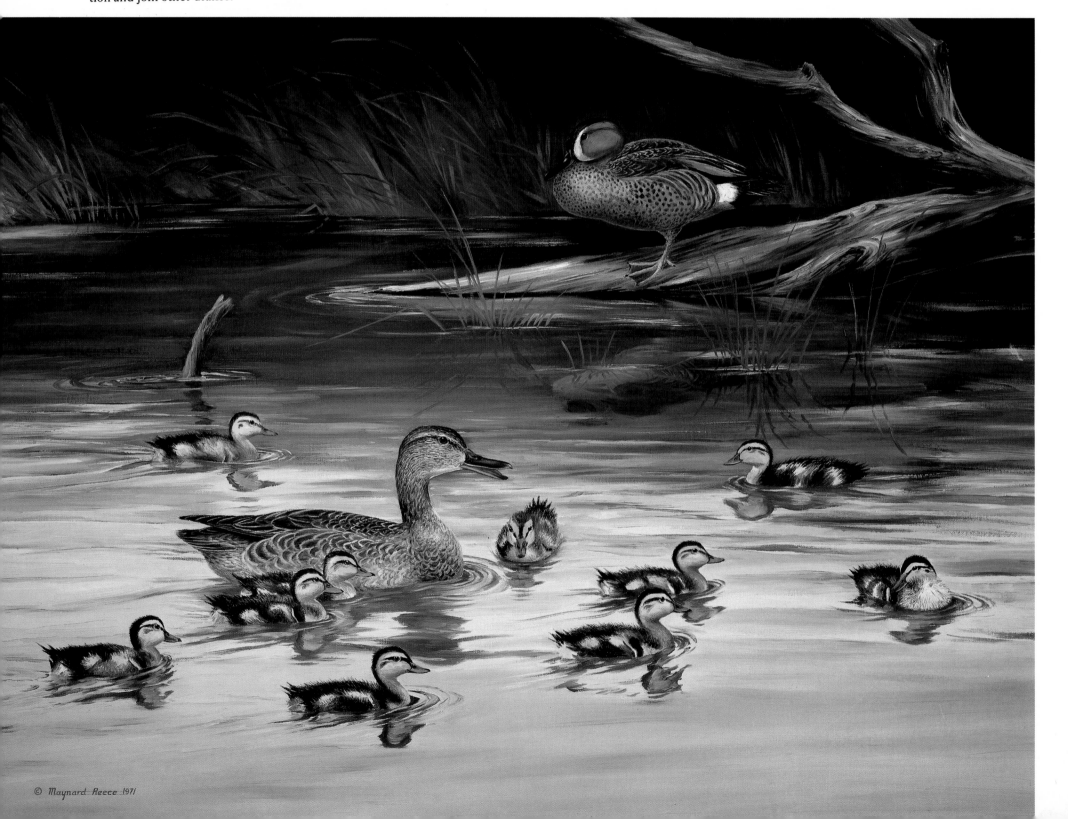

© Maynard Reece 1971

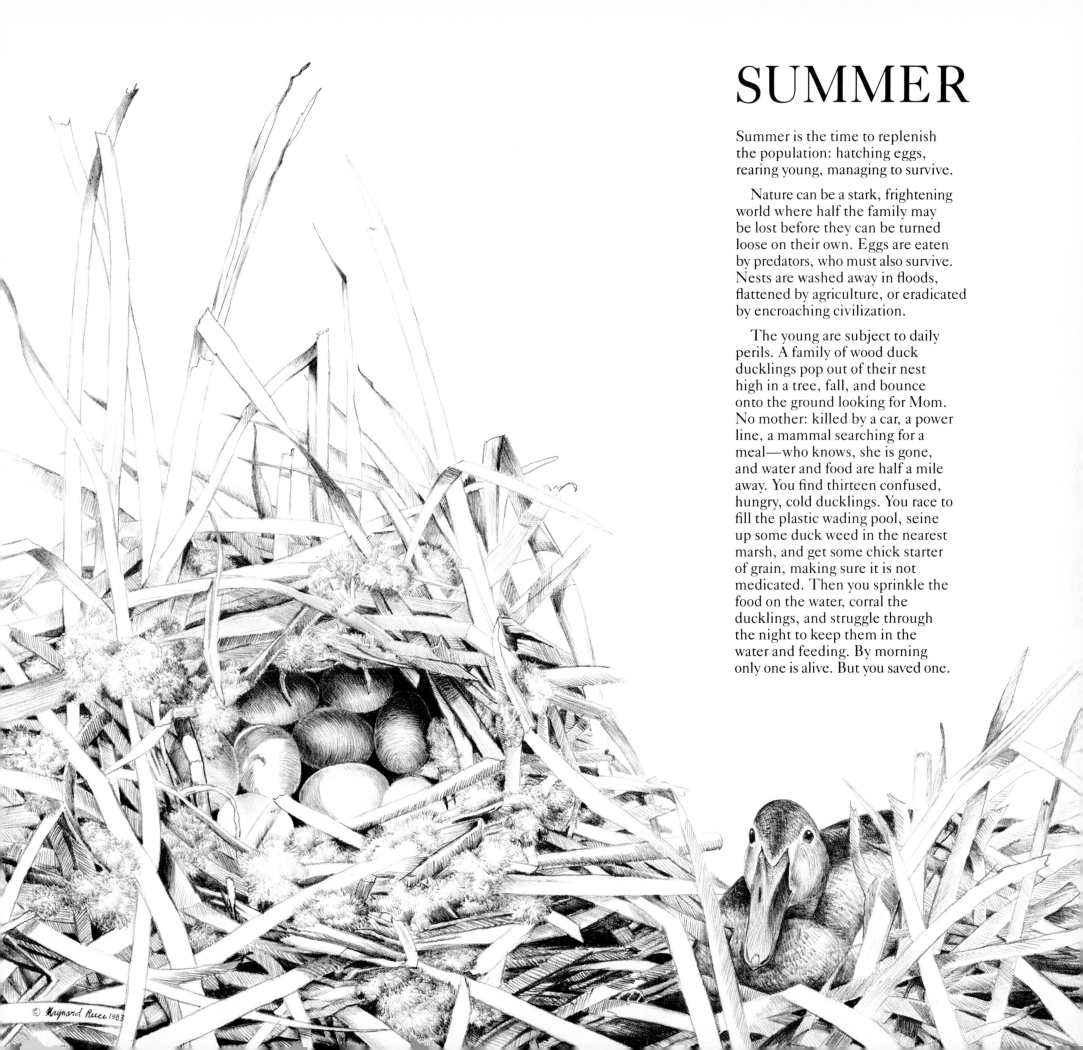

SUMMER

Summer is the time to replenish the population: hatching eggs, rearing young, managing to survive.

Nature can be a stark, frightening world where half the family may be lost before they can be turned loose on their own. Eggs are eaten by predators, who must also survive. Nests are washed away in floods, flattened by agriculture, or eradicated by encroaching civilization.

The young are subject to daily perils. A family of wood duck ducklings pop out of their nest high in a tree, fall, and bounce onto the ground looking for Mom. No mother: killed by a car, a power line, a mammal searching for a meal—who knows, she is gone, and water and food are half a mile away. You find thirteen confused, hungry, cold ducklings. You race to fill the plastic wading pool, seine up some duck weed in the nearest marsh, and get some chick starter of grain, making sure it is not medicated. Then you sprinkle the food on the water, corral the ducklings, and struggle through the night to keep them in the water and feeding. By morning only one is alive. But you saved one.

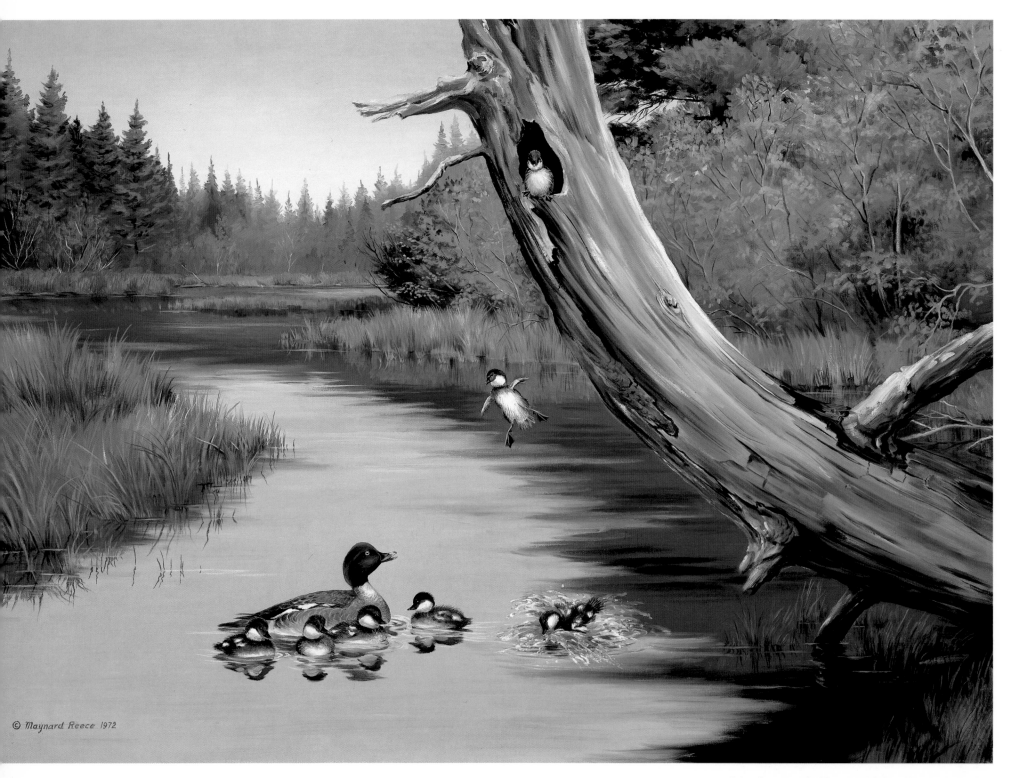

© Maynard Reece 1972

26. *Common Goldeneye with Ducklings.* 1972, oil on canvas

Goldeneyes nest in cavities of trees. The ducklings jump out of the nest and flutter down to the water when the mother hen calls to them.

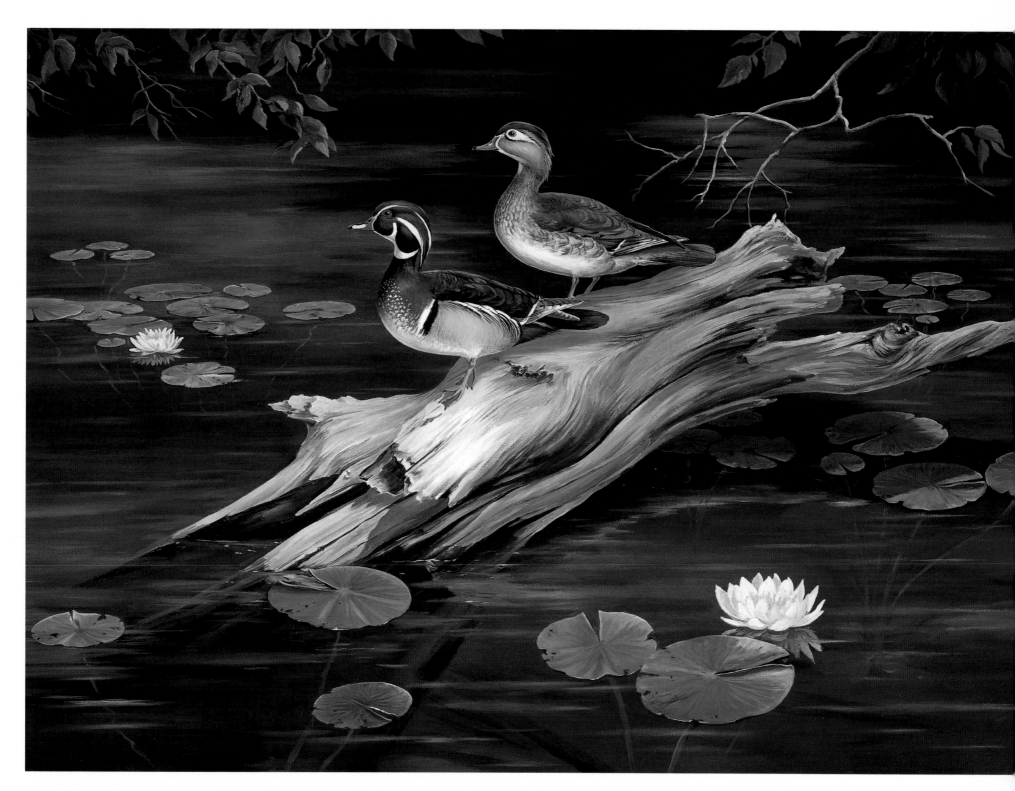

27. *Wood Ducks*. 1973, oil on canvas

Wood ducks like to rest in shaded, se-
cluded water spots hidden in timber,
swamps, or ponds. The white pond lilies
are in harmonious contrast with the dark
green water.

RAISING A FAMILY

With their parents alive, the young have better chances of survival. Swimming around in the marsh may be their home, but it is not necessarily safe; a duckling or gosling is one good bite for a northern pike or snapping turtle or a dozen other predators. Nature anticipates some loss, and the more vulnerable species hatch more young.

It is time for training. A mallard family is swimming along, the ducklings exploring every weed for bugs, spiders, and larvae, when suddenly the hen makes a startled quack and the ducklings scatter in all directions for hiding places under weeds, pond lilies, and dense vegetation. All is quiet now, no telltale ripple in the mirror-like water disclosing a hidden duckling. The hen quacks her all-clear signal after the danger is past, but play

or feeding is over now. Mother steams off followed by the ducklings in a close-knit group like a precision drill. Strict obedience; good team work; when you are fighting for survival, there is no time for argument.

The ducklings grow quickly and now begin to try flying—their second major step. They must be ready soon to fly away from the nesting area, for all the water and food will be frozen and covered with snow before long.

Summer is also the season for the adults to replenish their worn-out feathers. New feathers on the wings replace old ones, and the waterfowl are flightless until the new feathers grow long enough to enable the bird to fly again.

Finally, the population is healthy, strong, and eagerly awaiting the fall.

The mallard hen is a devoted mother to her brood. These young are just beginning to develop body feathers, outgrowing the downy stage. They are now thirty-four days old.

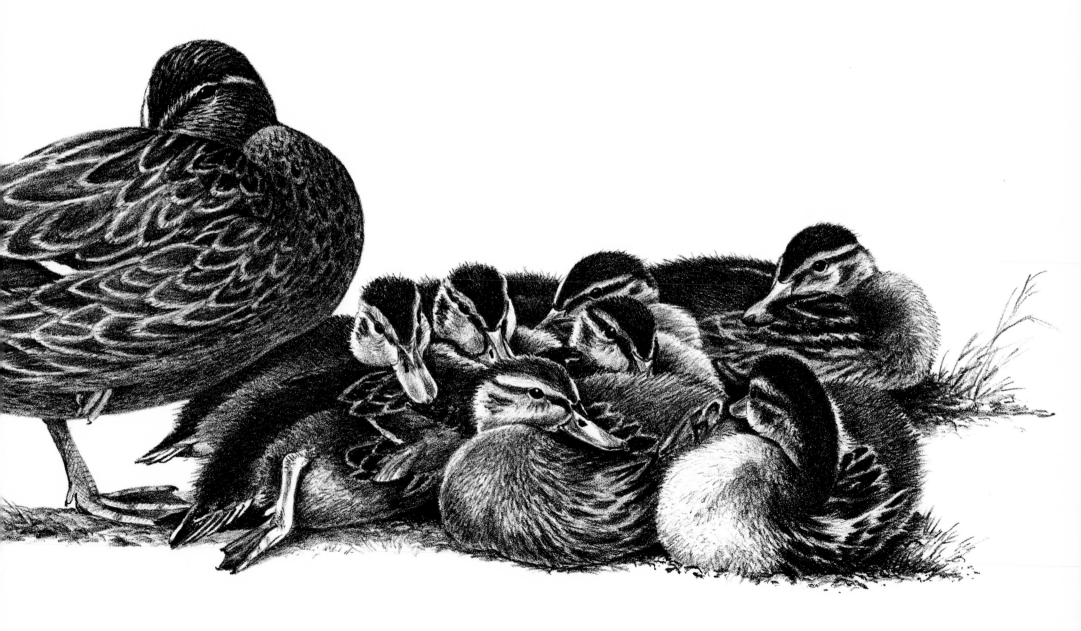

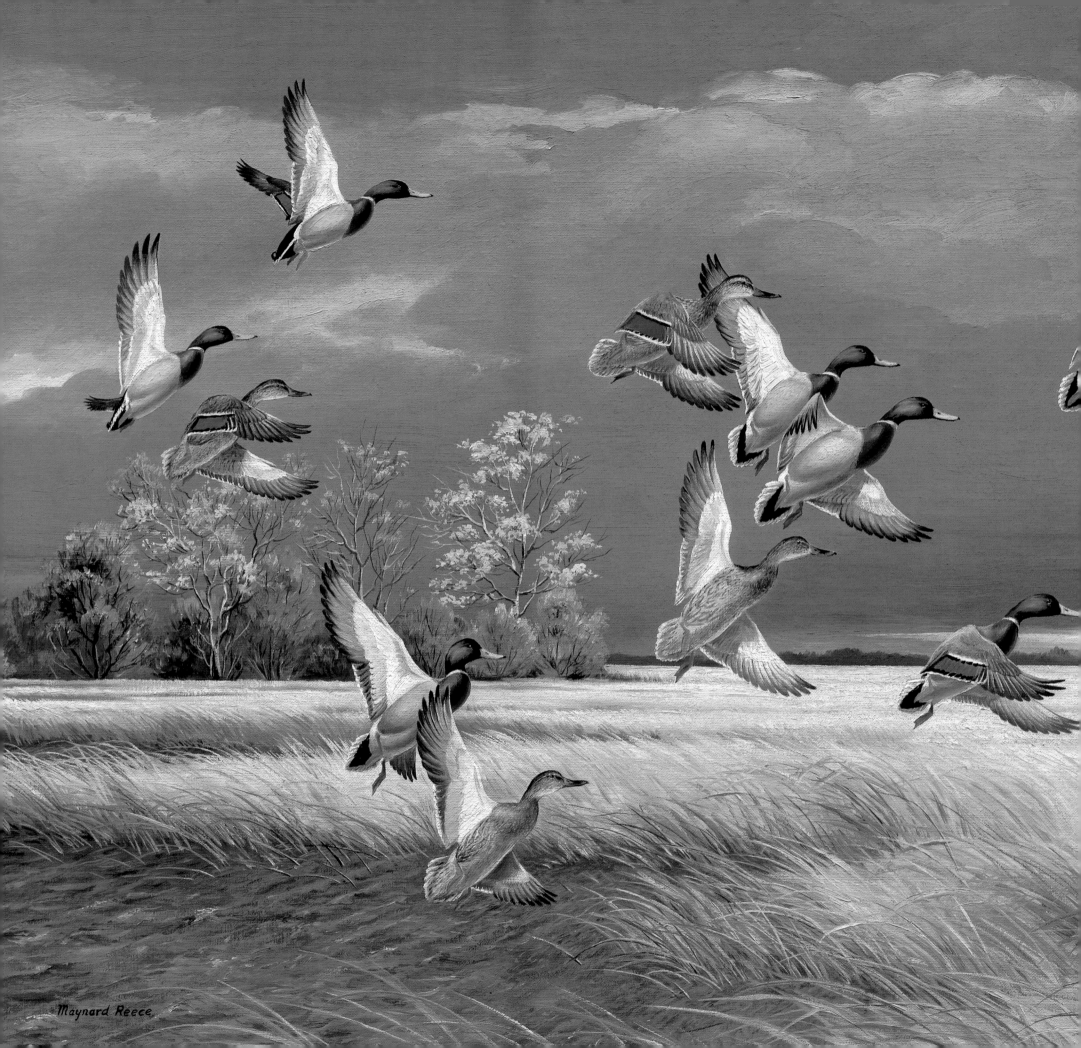

FALL

Fall is colorful. Nature puts on a brief and brilliant display before returning to the cool or somber colors that dominate the landscape for much of the year. The trees show a dazzling range of yellow, orange, and red. Oaks, maples, ash, sumac, and birch color the timber with their radiant leaves, both on the trees and covering the ground below. Even the water is dotted with bright fallen leaves, yellow and tan weeds, and red smartweed.

As the days grow shorter and frost forms on the lower areas of land, waterfowl start gathering together to begin their annual flight to their wintering areas farther south. Some species migrate by the calendar regardless of weather conditions. Others wait before moving south until water and food are no longer available. Diving ducks that find their food in the water are forced south as soon as the water freezes.

Migrating waterfowl like to ride a strong north wind which carries them long distances in comparative ease. Some water birds will migrate only at night. All waterfowl have a superb ability to detect major weather fronts and storms that will aid their migrating habits. Cold weather poses no problem to waterfowl since their perfect insulation keeps them warm.

When snow and ice begin to blanket the northern regions of North America, waterfowl filter down the flyways south to their traditional wintering grounds.

29. *Dark Sky: Mallards*. 1976, oil on canvas

The sunlit weeds and trees make a startling contrast of color with the dark sky of autumn. Mallards, lifting off the roughened water, flash their white underwings as they climb against the wind.

A large number of other birds use the same water areas as the waterfowl and migrate similarly. Coots look and act somewhat like ducks, and prefer marshes and lakes; they take off from the water like diving ducks but their flight is much slower. Flying low in fog or early morning light, they can sometimes be confused with ducks. A marsh may have no coots one day and be loaded with them the next, for they have nighttime migrating habits.

The grebe is another bird that can be mistaken for a duck. If you see a small, slim bird that rides low in the water and dives instead of flying away when you approach, you can be sure it is a grebe: only ruddy ducks and the female bufflehead resemble it. The cormorant is a large bird that sometimes frequents inland marshes; nearly the same size of a goose, it is slimmer, black, and has a longer tail, its narrow bill hooked for fishing.

You will have no trouble separating pelicans from geese, though they also migrate in large flocks and fly in long lines, sometimes spiraling around as they move forward. Pelicans hold their large bills tight against their chests in flight.

Other migrating water birds are herons, loons, rails, bitterns, and gallinules, along with many species of shore birds.

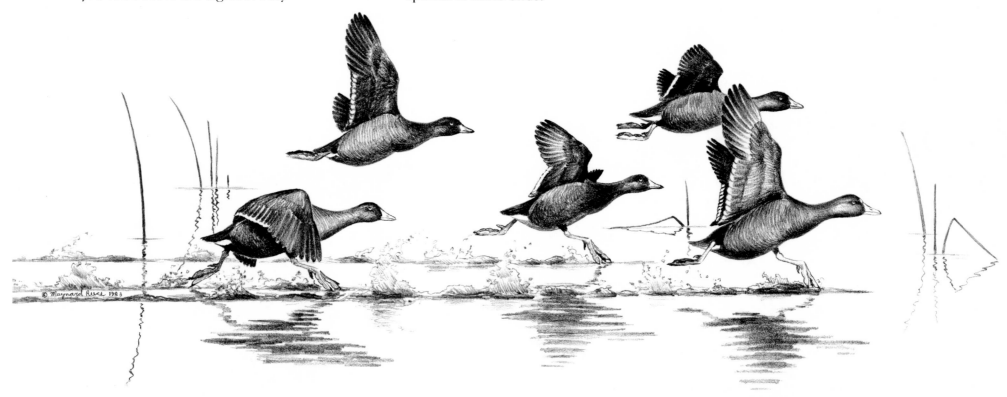

30. *Coots*. 1983, pencil sketch

Coots are dark water birds with white bills that frequent the same habitat as ducks and are often mistaken for them. They have trouble lifting off the water into flight, and first skitter over the surface.

31. *The Willow: Green-winged Teal*. 1979, oil on canvas

Green-winged teal are amazing bundles of energy and beauty. Being speedy fliers, greenwings swish past trees and may come sliding across the water for an abrupt landing nearly at your feet. In another minute, they have bounced off again, rocketing up in flight to climb past the willow in their swift surge toward another favorite water spot.

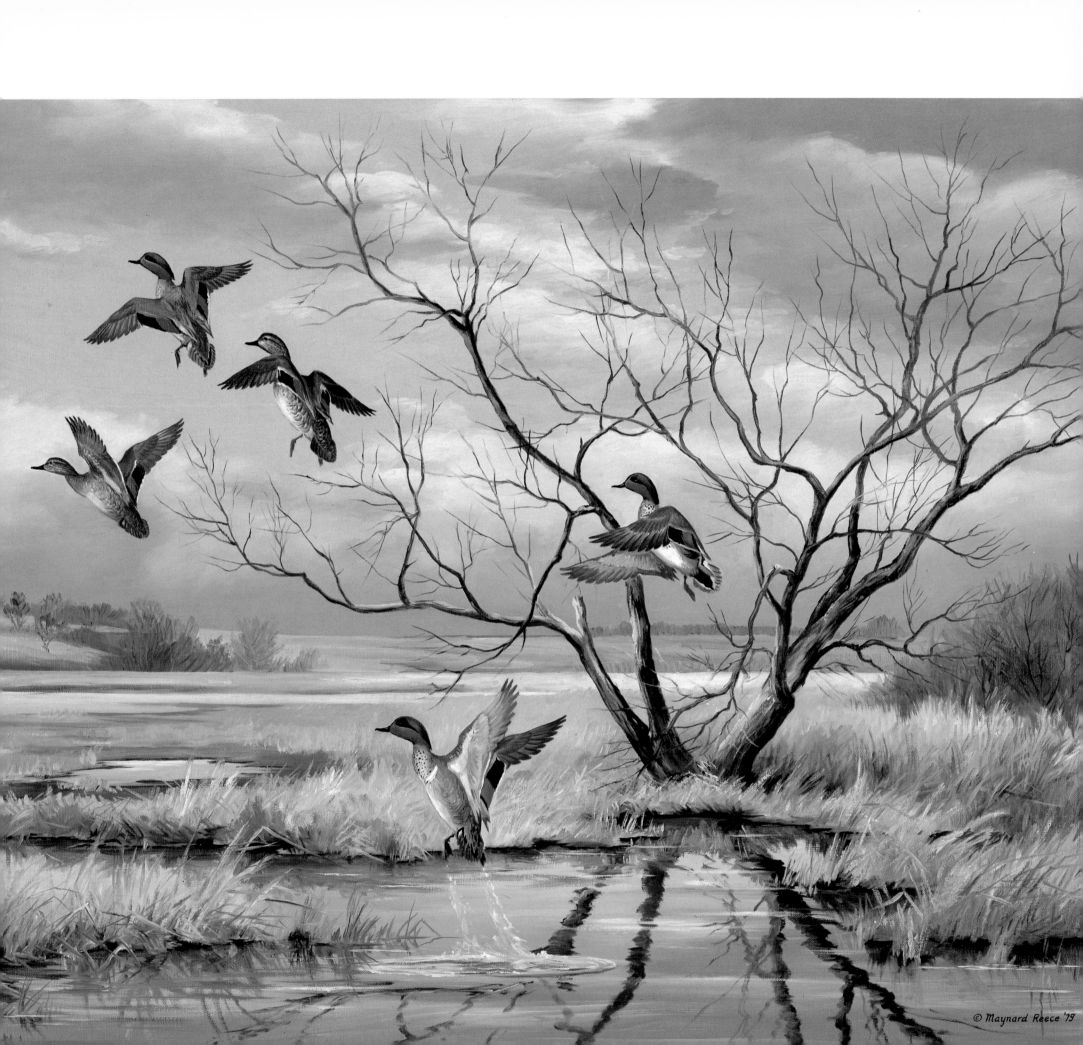

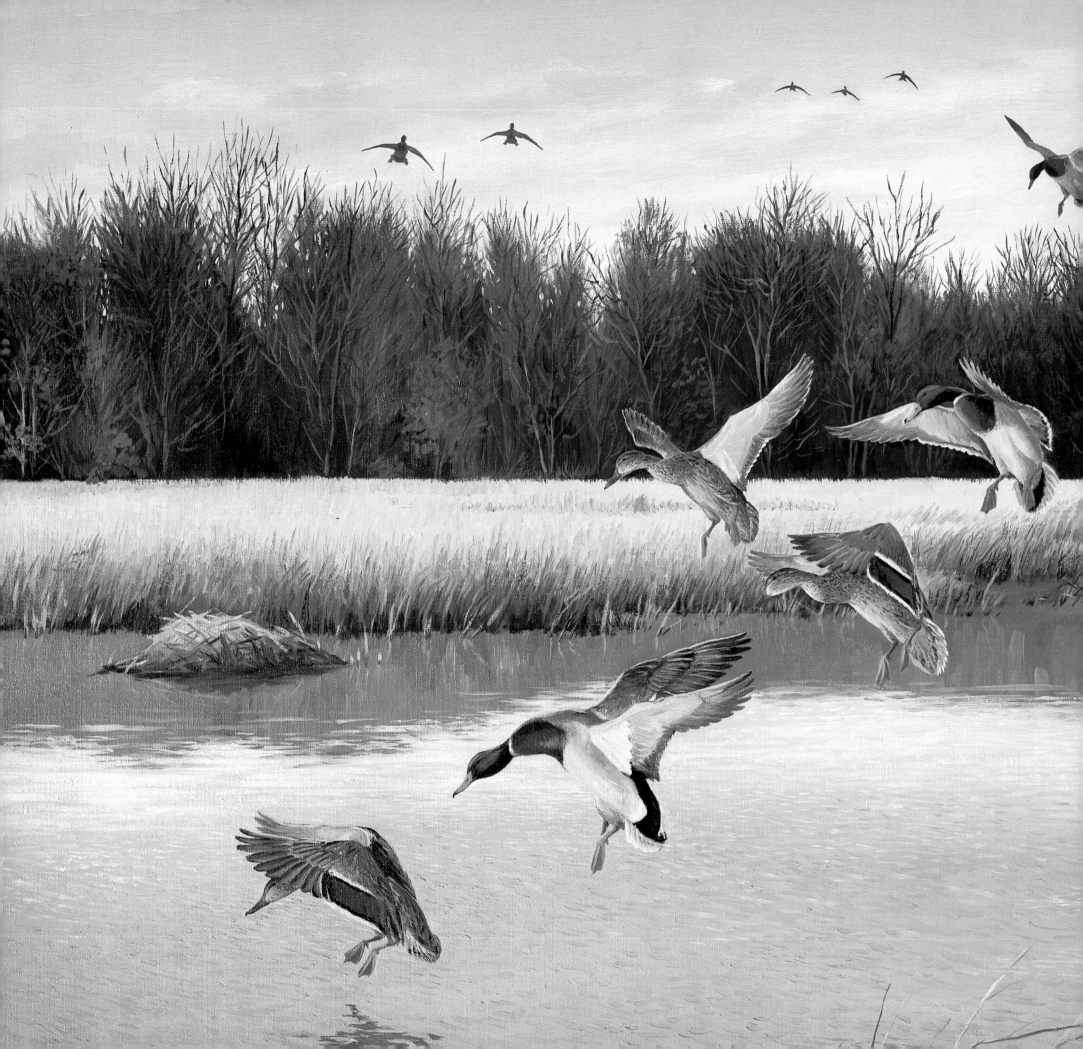

32. *Crescent Lake: Mallards.* 1977, oil on canvas
Small marshes nestled in the timber of old oxbows deserted by a river become water havens for mallards. The surrounding trees protect the waterfowl from the wind.

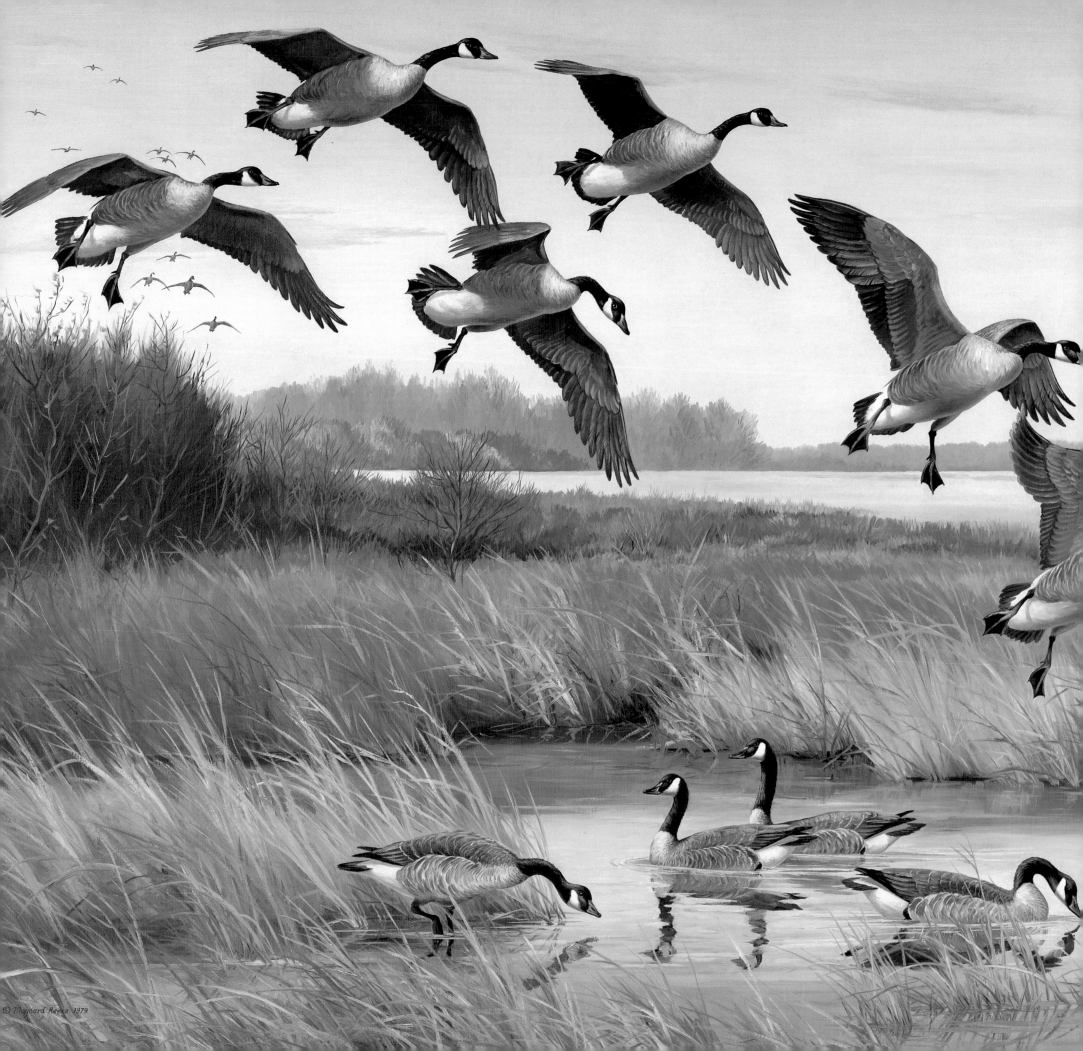

© Maynard Reece 1979

33. *The Quiet Place: Canada Geese.*
1979, oil on canvas

Canada geese are careful about
landing in a spot that might
contain danger, preferring the
unlimited visibility of open
country. But Canadas may drop
into a small area of water to
drink, feed, and rest, and once
the first group is safely on the
water, the next flock will readi-
ly approach and land without
suspicion.

WINTER

It is a day in early winter: November 11, and the weather here in the Midwest is unusually warm and humid. Normally there would already be snow on the frozen ground and ice in the ponds, but the river is still open and the day looks good for taking your small boat over to the island. It is so warm that you are perspiring even in your shirt, and you wonder why you brought along the heavy down jacket which Smoky, your dog, has curled up on in the front of the boat.

Reaching the island, you pull the boat into the brush along the water's edge, get Smoky into the blind with you, stow your gear, and settle down to wait for the ducks. It is eerie— for no reason the gray day seems foreboding. Smoky seems nervous and whines occasionally, though generally he is calm and quiet.

Suddenly the sky is full of ducks, more ducks, and still more ducks. Unbelievable! You have never seen so many ducks in your life. They fall from the sky within feet of your blind, totally exhausted as they drink and rest, and when you stand up they pay no attention to you. Soon come more ducks and the earlier arrivals take off to the south. Large flocks of geese tumble in too, only to leave after drinking and a brief rest.

The gray sky has darkened and it is beginning to drizzle, but still no wind. What is wrong? The waterfowl seem to be fleeing from some unseen monster. Imperceptibly a breeze begins to stir the few leaves on the oak trees, then little scuffs of wind roughen the surface of the water. The drizzle turns into sleet, and a few snowflakes are sticking to the cattails. The wind picks up, now blowing out of the north; you really should start home, but the chance of seeing this many waterfowl comes only once in a lifetime. Another five minutes, maybe—or ten.

But the weather has switched into a raging blizzard, and plainly it is too late to go. Fifty-mile winds churn the river into an impassable sea of treacherous waves, and the snow, driven nearly horizontal, is so thick that the trees right behind you are no longer visible. The ducks and geese are gone, and you can see what they were fleeing—a monster storm.

You thank God for that down jacket you didn't think you needed, and for Smoky. Squeezed tight together in the jacket for lifesaving warmth, the two of you spend a sleepless night during one of the worst blizzards of the century. By morning it is over, but now you have learned that the waterfowl know more about survival than you do.

In a normal winter, ducks and geese can keep a water area open for drinking by swimming about, agitating the water enough to prevent it from freezing over even at sub-zero temperatures. But the birds are forced to go farther south for food once the snow covers the waste grain in nearby fields. With the food buried, the water frozen, and the birds gone, the marsh is deserted until the coming of another spring.

34. *Snowy Creek: Mallards.* 1974, oil on canvas
Last night's blizzard has left snow packed on the trunk and limbs of the tree. The open water in the creek has melted the snow, giving the mallards a place to drink and rest. Mallards enjoy small creeks.

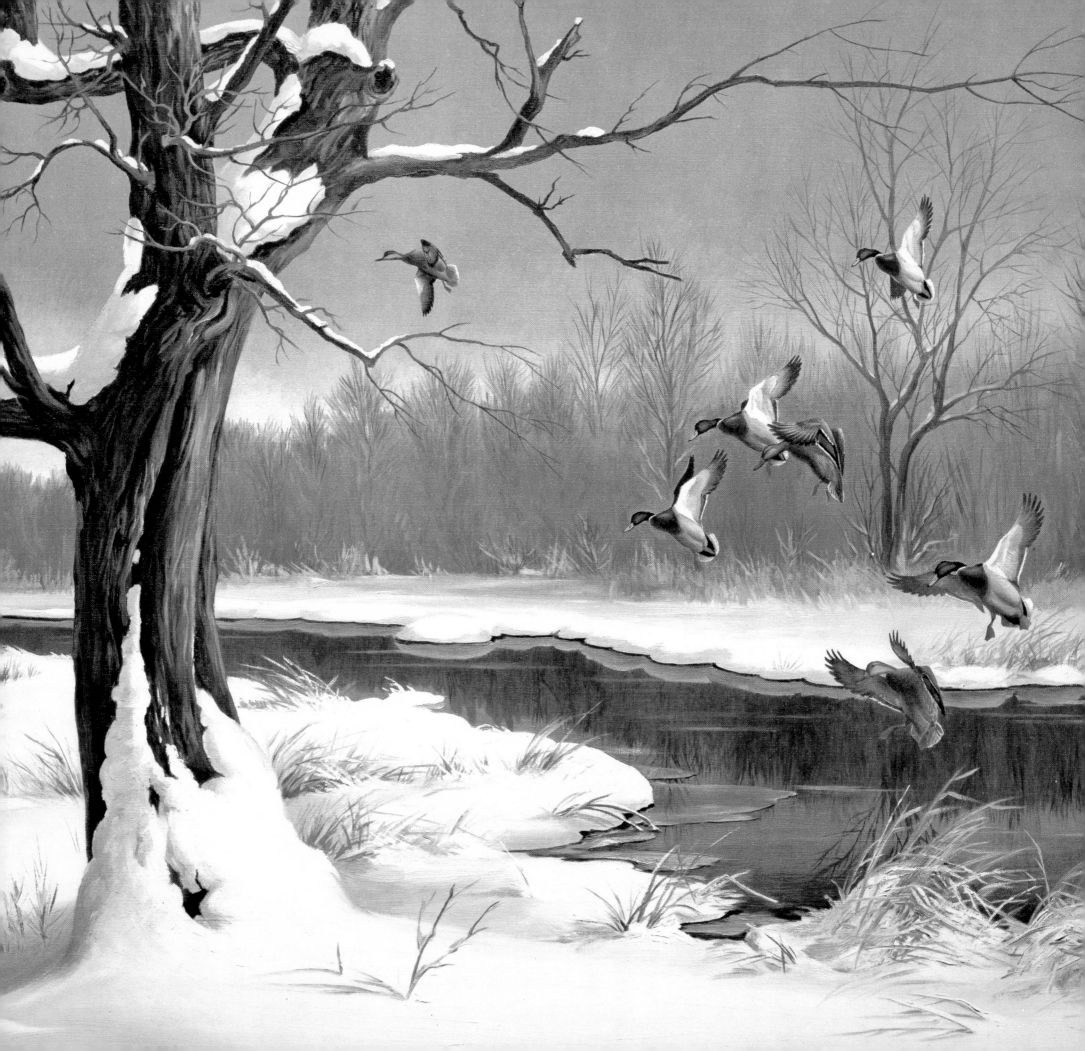

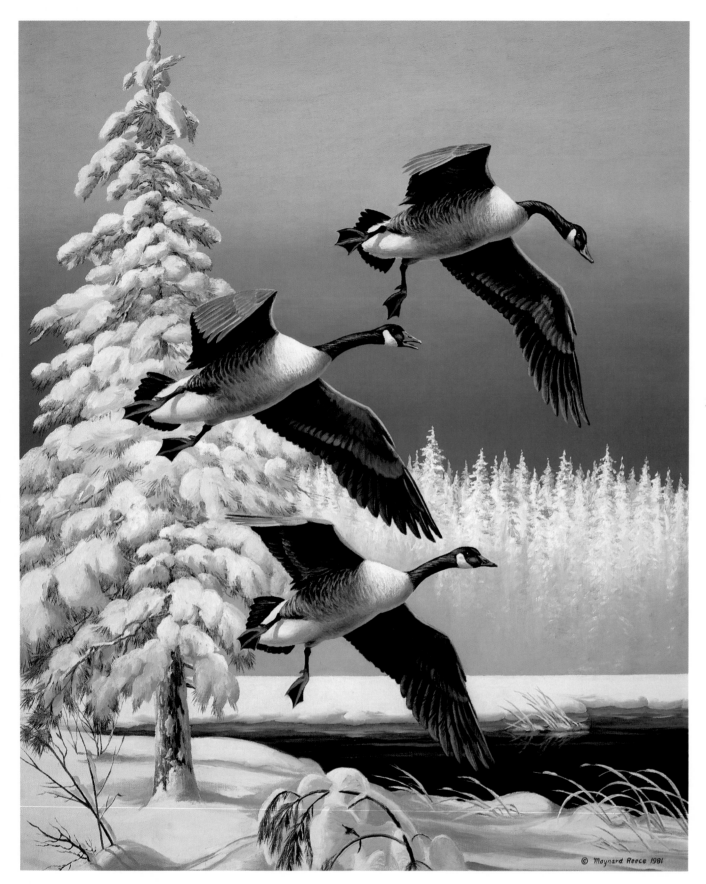

35. *Frosty Morning: Canada Geese*. 1981, oil on canvas

Canada geese will remain in snowy, ice-covered areas as long as they have food and water. They prefer open water, safe from predators on land. A cold morning with fog will produce frost on every tree and transform the pine branches into magical Christmas decorations.

36. *Cold Morning: Mallards*. 1980, oil on canvas

New arrivals drop into this gathering, returning from feeding in a field of waste grain which might be as far as fifty miles away. The morning fog has left bits of frost and snow on the trees and brush, but the sun, already trying to shine through, will soon melt it off. The birds welcome the warm rays of the sun as they rest, well insulated by their coats of down and feathers.

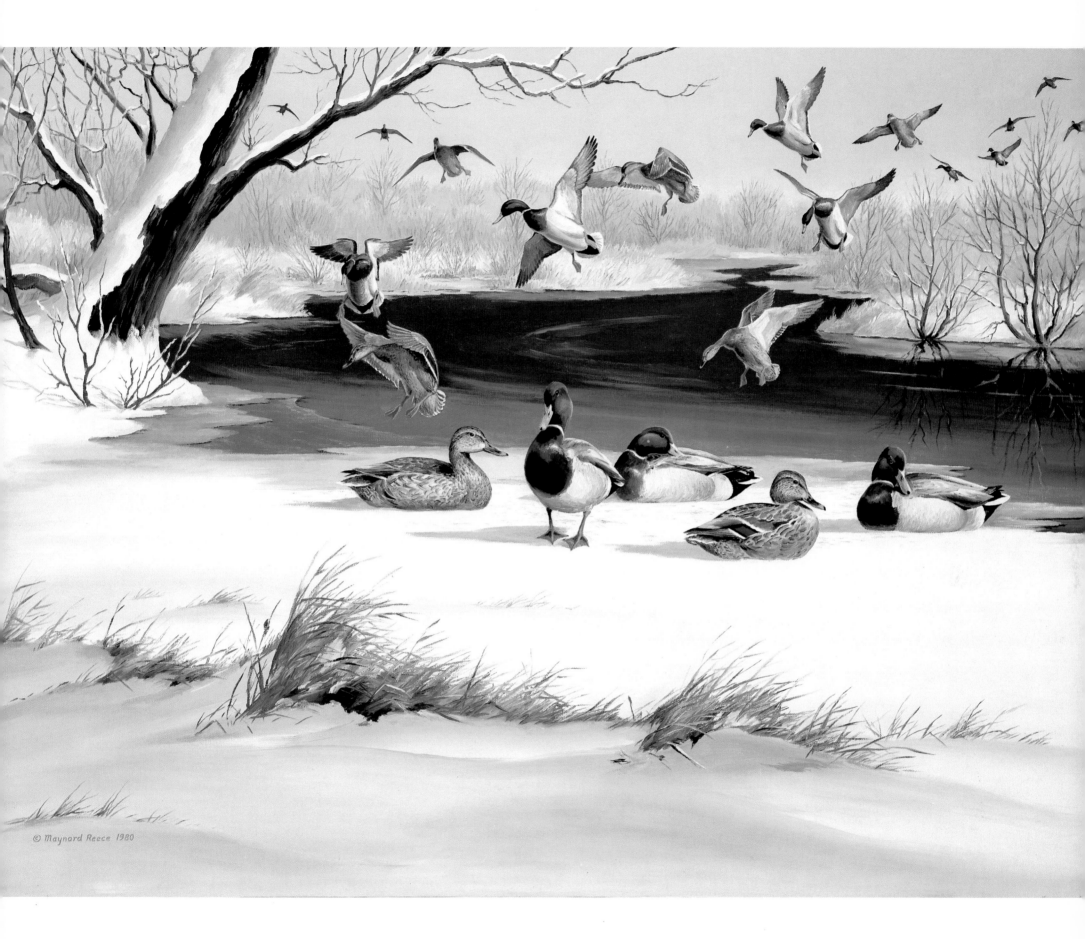

© Maynard Reece 1980

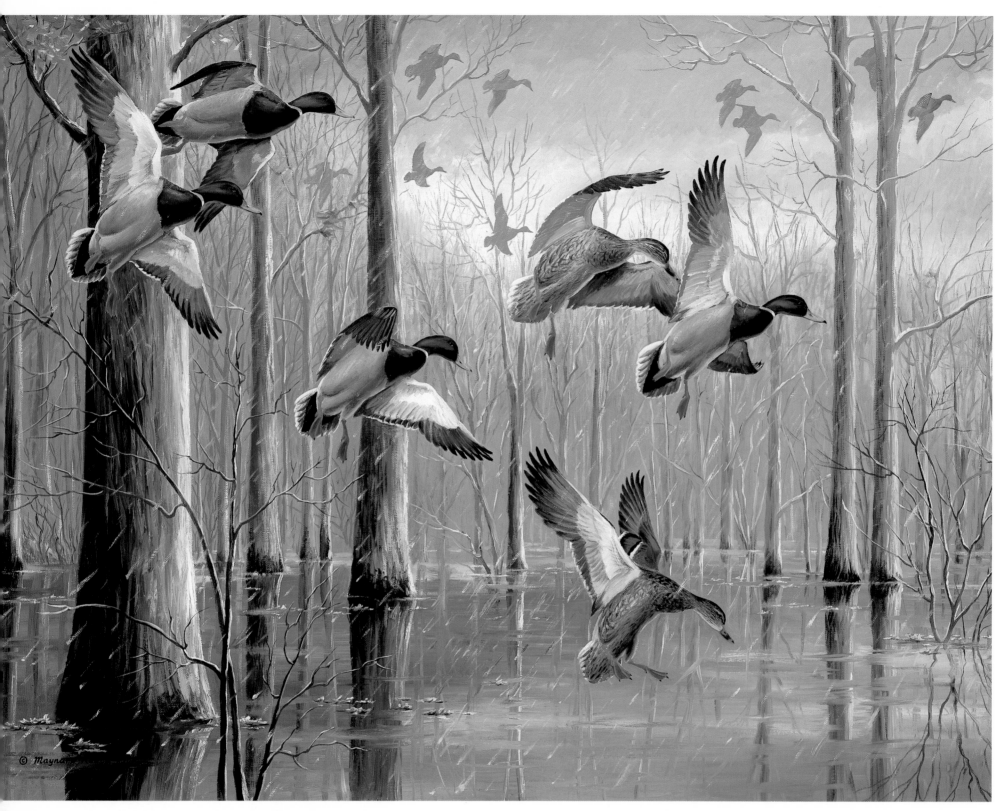

37. *The Snowstorm: Mallards.* 1967, oil on canvas

Snow does not generally reach flooded timber in the South, but an occasional cold snap can bring both snow and ice. Sheltered from the wind by the trees, the snowflakes drift down and melt at once on the water. A few flakes will stick to the floating leaves.

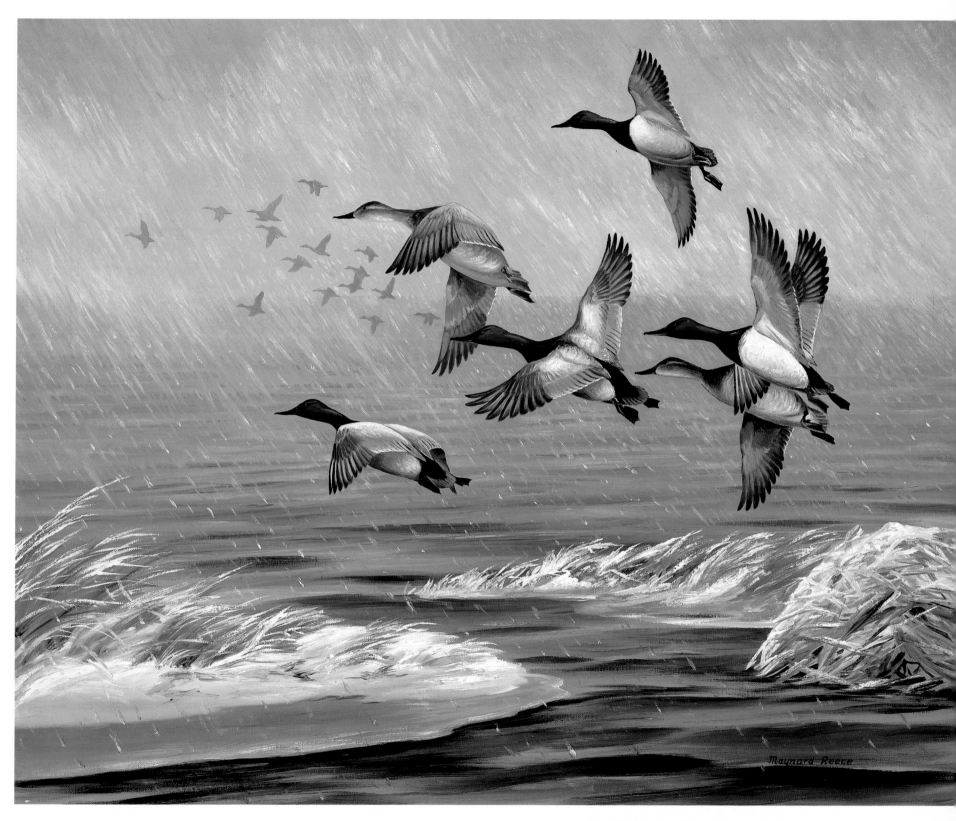

38. *The Muskrat House: Canvasbacks.* 1968, oil on canvas

When it is snowing over a marsh, the wind will drive the flakes at an angle that bites at the canvasbacks knifing their way through the snowstorm. The muskrat house will soon be covered with snow.

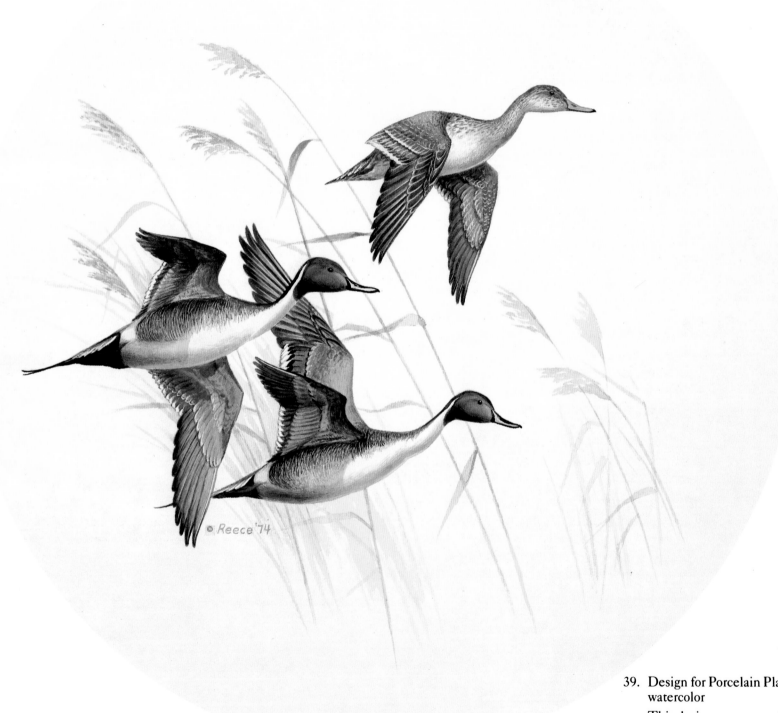

39. Design for Porcelain Plate: *Pintails*. 1974, watercolor

This design was created for a porcelain plate to be made in Limoges, France. To set off the beauty of the white porcelain, the white area was treated as an integral part of the design, not covered up by the painting.

THE WATERFOWL

CHAPTER III

THE WATERFOWL

SWANS, GEESE, AND DUCKS

The waterfowl belong to a unique family of birds, technically known as the family Anatidae. They are truly birds of the world, traveling back and forth across continents, and some are to be found everywhere on the globe. Waterfowl belong to no one place and live wherever they choose.

While North America was being settled these birds were a major source of our food, as they had been for the Indians before us. When the population of North America mushroomed, farmers cleared the land of forests and drained the wetlands for fields to provide food for the increasing number of people. Crops were grown and domestic birds and animals were raised, their meat gradually replacing the wild game.

But without marshes the wild birds had no place to nest or rear their young. The mistaken idea continued that the supply of birds was inexhaustible, as man cropped off this food source to below the level adequate for them to replenish themselves.

By the time man realized that he had cut too far into a natural resource by draining the marshes and destroying the birds' ability to reproduce, the waterfowl population had dropped dangerously low. Man the hunter became man the conservationist as well, pouring money and energy into preserving the marshes and the waterfowl. Millions were spent to save the nesting and feeding areas of his favorite birds, together with their wintering grounds. Biologists went into the field to study their habits and diseases, and the problems of waterfowl reproducing themselves worldwide.

With all this concern, waterfowl are no longer in danger of extinction, and no species has been totally lost for nearly one hundred years. The population of waterfowl is now managed so that the birds do not destroy too many crops, overpopulate too many crowded areas, or compete too strongly with man's artificial life-styles.

And thus far the birds are still free to nest in the far north, raise their broods, and fly anywhere they choose for the winter. This freedom is not shared by man, and it is the constant envy of all who dream of a nomadic life.

The future of waterfowl is not bright, in spite of the funds poured by conservation organizations and hunters into the saving of waterfowl and wetlands. The marshes of North America are still being drained for agriculture; estuaries along our coasts are steadily filled in for building sites for houses and industry; wetlands all across the country are continually eliminated for parking lots, city dumps, and the multitude of industrial uses that man devises in the name of progress.

The United States originally had 127 million acres of wetlands, but 45 million acres are gone already and the rest is being destroyed at the rate of nearly one-half million acres each year. This has already had a disastrous effect on the total population of waterfowl. Only by the concerted effort of all conservation organizations, hunters and nonhunters alike, can a common front be formed to stop this loss of wetlands. Without our wetlands our waterfowl are doomed.

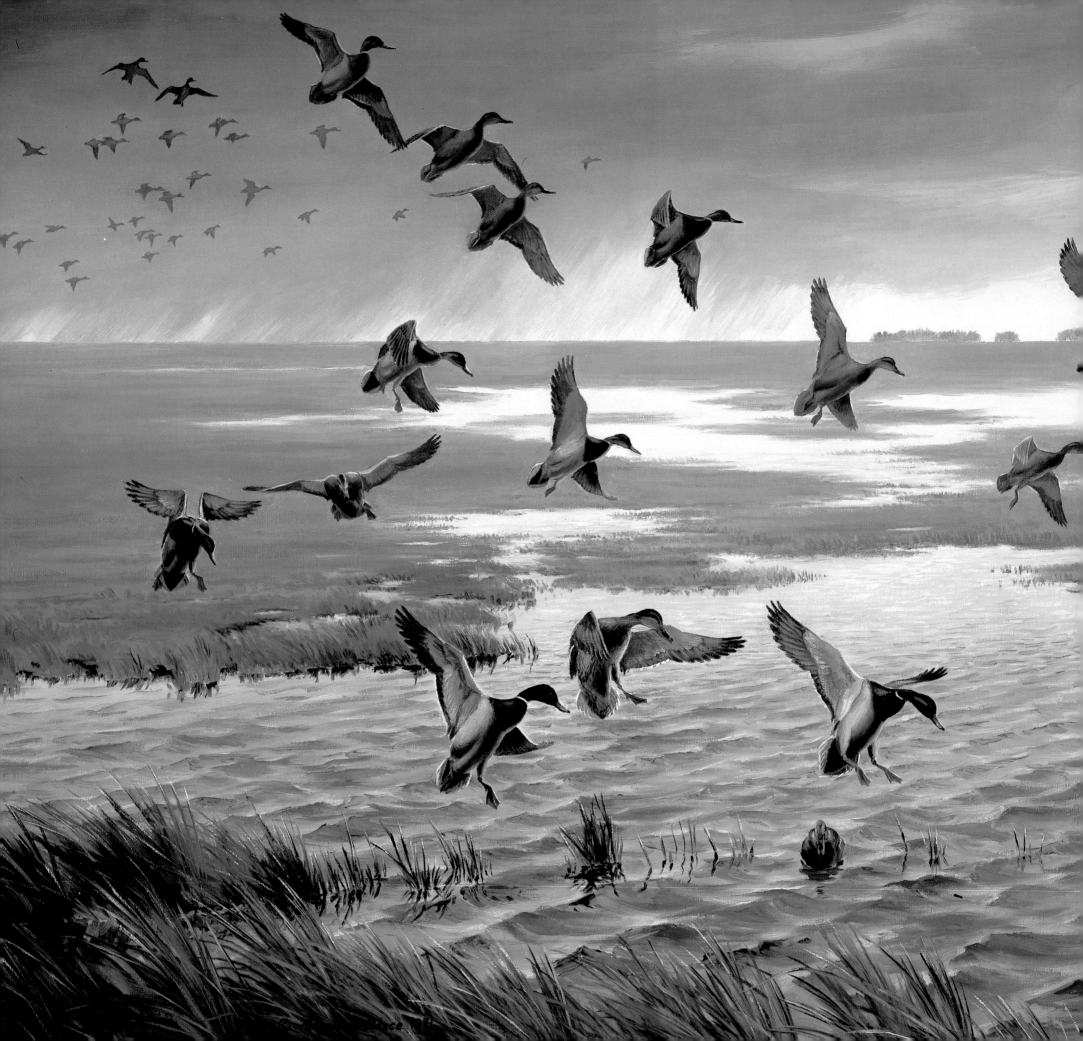

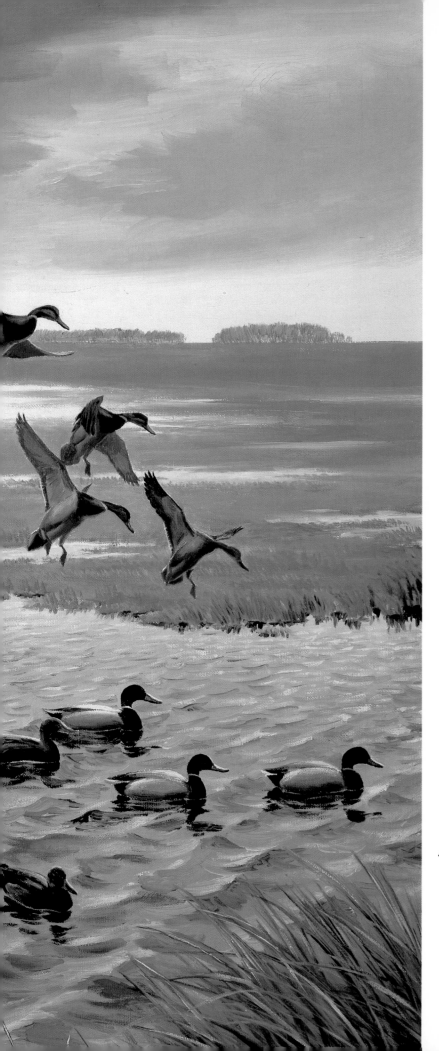

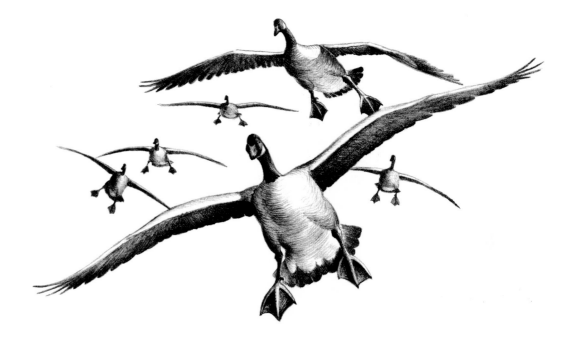

41. *Full Flaps: Canada Geese*. 1981, pencil sketch

Canada geese use their feet to slow down their flight speed before landing. Like letting down the flaps on an airplane wing, geese lower and spread their feet to brake against the wind. By combining their feet, spread tail, and wings held rigidly, they coast down to a gentle landing.

40. *Gloomy Day: Mallards*. 1971, oil on canvas

Near the Quill Lakes the flat wheat country of Saskatchewan changes to grass. Quite often it is flooded with heavy rains that leave standing water, a haven for mallards. This is a study of gray, somber colors on a gloomy wet day.

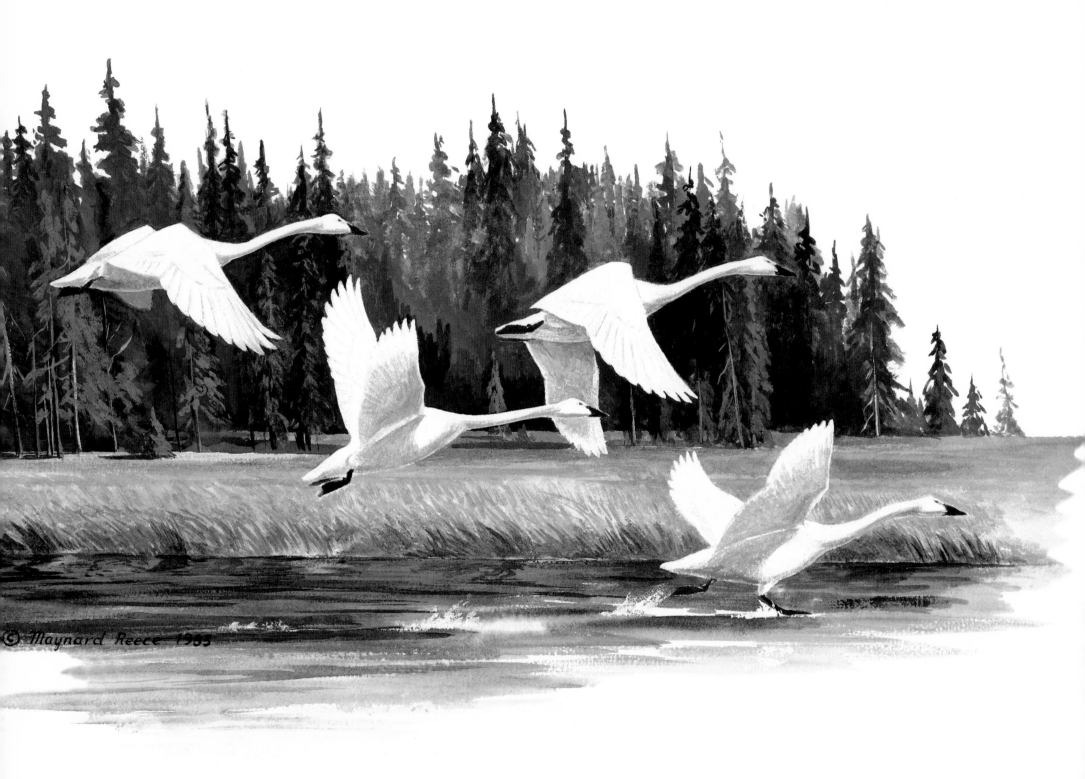

42. *Along the River: Trumpeter Swans.* 1983, watercolor

The Lewis River in Yellowstone Park is shallow and runs through heavy timber. Green water, green pines, and grass made a beautiful background for these white swans. Swans kick with their feet as they take off, making splashes of water.

THE SWANS

CHAPTER IV

THE SWANS

Flat country. Really flat. As far as you can see, there is nothing but flat tundra broken by small polygons of water with ice still floating on most of them. You and your son are in northern Alaska, only about a mile from the Arctic Ocean. The terrain is so desolate that it has a certain romance and attraction of its own.

Scattered waterfowl are nesting on the edges of these shallow ponds thirty to fifty yards wide—you can wade across them in hip boots. Now something white gleams prominently on a small knoll far out on the tundra: your son says it is a white oil drum left by some explorer, but with binoculars you identify it as a snowy owl. How could you mistake a bird for a fifty-gallon oil drum? Up here, with no trees, bushes, or objects to compare it with for size, something relatively small can look enormous —the willows at your feet are only six inches high.

Farther on you both see another white spot on the horizon, and by walking closer you find a whistling swan sitting on a nest built of moss, grasses, and down feathers. Nearby is her mate, guarding the territory.

You move in a little and both birds leave the nest area, swimming across the pond to the ice on the far side. Instantly a jaeger, a hawklike bird the size of a gull and with long central tail feathers, roars out of the sky toward its next meal of the eggs in the swan's nest.

You run for the nest, scaring away the jaeger. But now, what a mess! It was you who made the swans move off, and it will be your fault if the jaeger now gets the eggs. Your son runs around the pond, pushing the swans slowly back toward their nest; you back off to give the swans leeway, but the jaeger swoops down again. Running toward the nest as fast as you can on the spongy tundra, you chase the jaeger away. Finally, between jaeger attacks, you persuade the swans back to their nest. You sigh with relief and trudge on, vowing never to disturb nesting swans again.

Two species of swan are native to North America: the trumpeter swan and the whistling swan. A third species, the mute swan, was introduced from Eurasia into our parks and has since gone wild; it is found in good numbers along the East Coast and some now along the West Coast.

Swans have been honored since ancient times; there is even the constellation in the Milky Way called Cygnus, the Swan. Whether they are flying in the air or swimming in the water, swans are always an impressive sight.

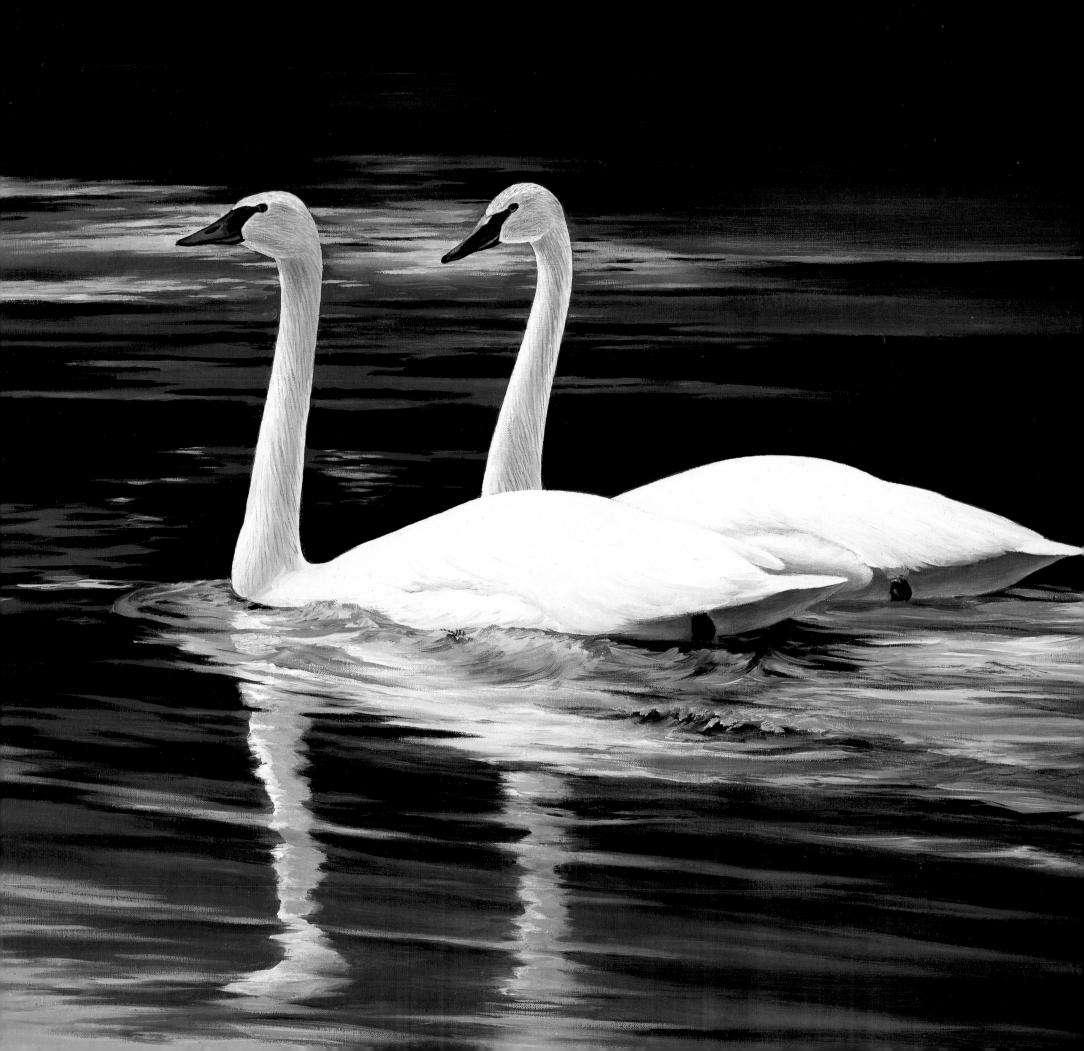

TRUMPETER SWANS

The replenishing of the trumpeter swan population from near extinction to an adequate number is one of the few success stories in man's association with the bird kingdom. By 1925 trumpeter swans were in danger of extinction, but with conservation and increasing knowledge of their habits, there are now more than ten thousand birds.

Largest of the swans, the trumpeter measures six feet from bill to tail when stretched out in flight, with an eight-foot wing span. In pioneer days it was found in the Midwest and the South, but now it stays in the western states and north to Alaska. A few birds are being introduced into Minnesota, with plans to help them spread even farther east and south. In 1935, J. N. "Ding" Darling managed to get the Red Rock Lakes Refuge established in Montana, which brought about the beginning of a comeback for these magnificent birds. In a few years, the original forty-six birds at the Red Rock Lakes multiplied to nearly five hundred.

Trumpeter swans are particular about where they nest and do not like to overcrowd their nesting grounds. Since they prefer to stay in family groups, some do not get around to their own nesting until their fourth or fifth year. They are also reluctant to leave their wintering lakes even in freeze-ups or hard winters: unable to find food or water, many starve or become too weak to fly, and these are eaten by predators.

Trumpeter swans do not migrate. Except for short flights of perhaps a hundred miles within an area, trumpeters remain in the same place where they nest.

43. *The Pair: Trumpeter Swans.* 1983, oil on canvas

Swans love to swim and feed on the Madison River. The current is swift, but swans have no trouble swimming with their large webbed feet. The water looks dark green, almost black.

© Maynard Reece 1983

WHISTLING SWANS

The most spectacular sight in nature is a flock of swans winging their way in formation across an evening sky. These all-white birds seem to be loafing along at a slow wingbeat but actually they are flying faster than ducks.

As the birds approach water, they brake with extended wings and feet. Their feet are so large that swans can actually skid along on them like water skis until their weight pulls them down into the water and they coast to a stop, throwing a large wake. Swans are so heavy that on takeoff they must run along the water, kicking their feet and beating their wings against it before they can clear the surface and pick up speed. Once in flight they are graceful fliers, their black feet folded up under their tails and their necks fully extended.

Most whistling swans may be identified by a yellow spot ahead of the eye. They raise an average of two or three cygnets each year, the young retaining their gray plumage through the first year.

Flocking together in the fall, they migrate south from the Arctic for long distances, sometimes covering over one thousand miles in continuous flight and occasionally flying at heights of five to six thousand feet. Whistling swans winter along the east and west coasts of the United States. During the winter the swans' favorite foods are wild celery, sago pondweed, redhead grass, and soft-shelled crabs. When these are not available, swans are quite capable of moving into a cornfield to feed on waste grain left by the combine harvesters or to graze on winter wheat.

44. *Regal Flight: Whistling Swans.* 1978, oil on canvas

During the breakup of ice and snow in early spring comes the call of the whistling swan. Penetrating, higher, and more musical than that of Canada geese, the call will drift through the morning sky even before the large white birds can be seen.

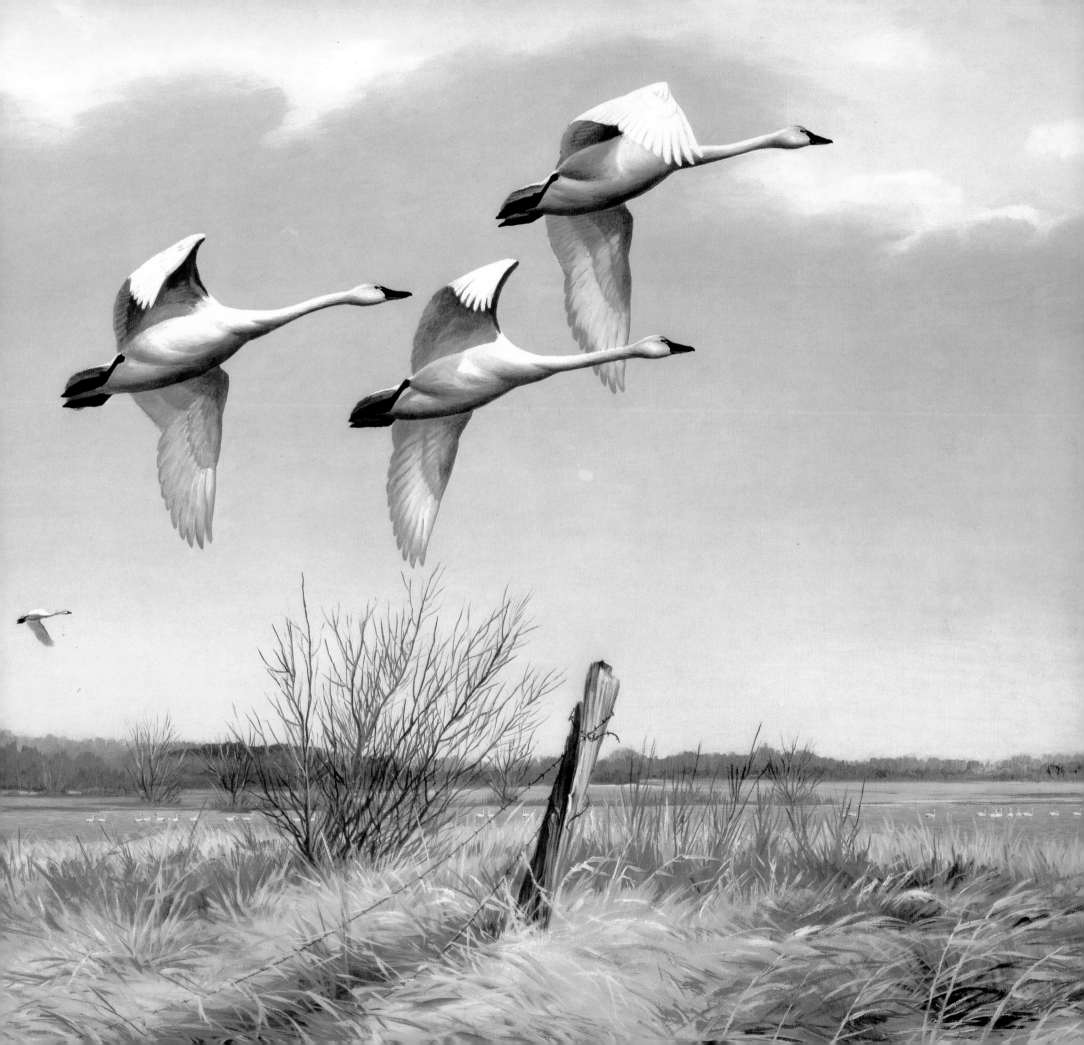

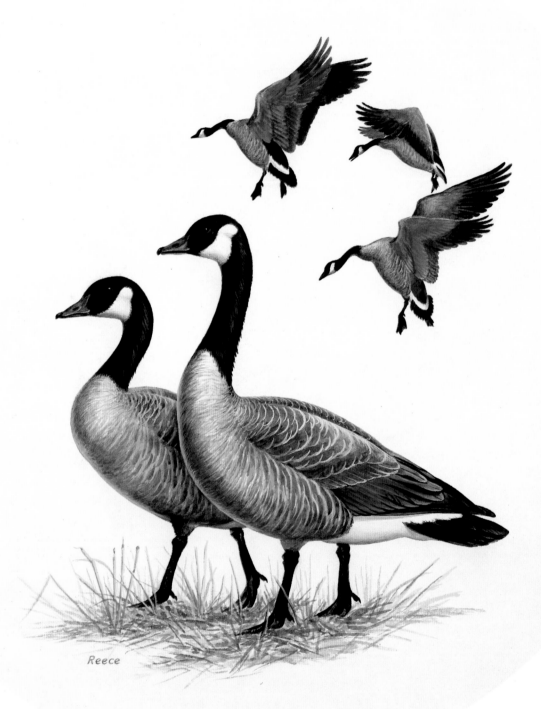

Reece

45. Design for Porcelain Plate: *Canada Geese*. 1975, watercolor

This design for a Limoges porcelain plate shows a pair of standing geese and other geese landing. Their gray, brown, and black colors make a powerful contrast against the white surface.

THE GEESE

CHAPTER V

THE GEESE

Geese. The word instantly brings back images of migrating geese —thousands of them, and in earlier years, millions.

You remember standing in spring along the wide, flat bottomland of the Missouri River in Iowa, where the loess hills bordering a strip about twenty miles wide run parallel to the winding river. All day you watched thousands of birds high in the sky flying north, and now you are driving along a gravel road to see if they are headed for some large concentration area. North and south there are geese as far as your eye can see, but ahead of you birds are circling in large spirals. Approaching them, you find the geese landing on the ice of Forney Lake, and others joining them by the thousands. The ice has melted around the shoreline but the center is still a frozen island at least a mile long and half a mile wide. Thousands more geese fly in, hour after hour, until they seem to be landing on top of each other.

Gradually you realize that the birds are not standing on the frozen lake, but are swimming in water. Their combined weight of millions of pounds has actually sunk the enormous mass of ice below the surface, forcing the birds to swim. What an amazing sight!

An airplane passes by, and the geese suddenly take flight. The sound of these thousands of geese honking and flapping makes a roar like the crowd cheering a touchdown at the Super Bowl. After the scare, the geese settle back down on the lake. Still more birds arrive all afternoon. The sun sets and against the evening sky, slightly lighter than the black earth below, dark shadows of geese are passing overhead so close you can almost touch them. Their forms vanish into the darkness, but their noise continues. Back at home you drop off to sleep, the roar of thousands of honking geese still sounding in your dreams.

This is the fascination of migrating geese. You never cease wanting to watch them, and they are with you in your memories forever.

Different species of geese do not like to mingle together. They all migrate at the same time, but you rarely see snow geese among Canadas or white-fronted geese. When all are landing in the same field to feed, the Canada geese will be off in a flock by themselves. White-fronts and snows are a little more sociable on the ground, but when flying they form separate flocks. And as they approach their nesting grounds, each species goes its individual way.

CANADA GEESE

On the ground, the Canada goose is a stately, dignified bird who takes his duties seriously. The female builds a sizable nest lined liberally with down feathers and lays from two to ten eggs, the average being five. The gander guards both goose and nest and will fight anything coming into the forbidden territory.

Like all geese, the family spends considerable time on land for they love plants, seeds, and insects, and grazing on grass or winter wheat provides a major source of food. But when the goslings are hatched the whole family must stay close to water, for the goslings cannot fly until late summer, after their flight feathers have grown and they have been well instructed in the art of flying. The parents remain highly protective throughout the summer, the young making tremendous growth each week until they are nearly as large as their parents and able to fly. The family stays together for the first year, joining other groups to migrate in large flocks to their wintering grounds.

Canada geese can adapt to changing environments, and they even nest in cities and towns when they find a suitable habitat. This versatility has led to an increasing population, but man has not always been happy with the outcome, for Canada geese like swimming pools and manicured lawns, and thus can raise problems in maintaining good public relations.

46. *Landing: Canada Geese.* 1972, oil on canvas

Canada geese are always wary before landing. The flat terrain of a wheat field, besides the attraction of waste grain left in the stubble, affords a broad view of possible danger spots. The plowed ground also holds shallow puddles for a good drink after eating.

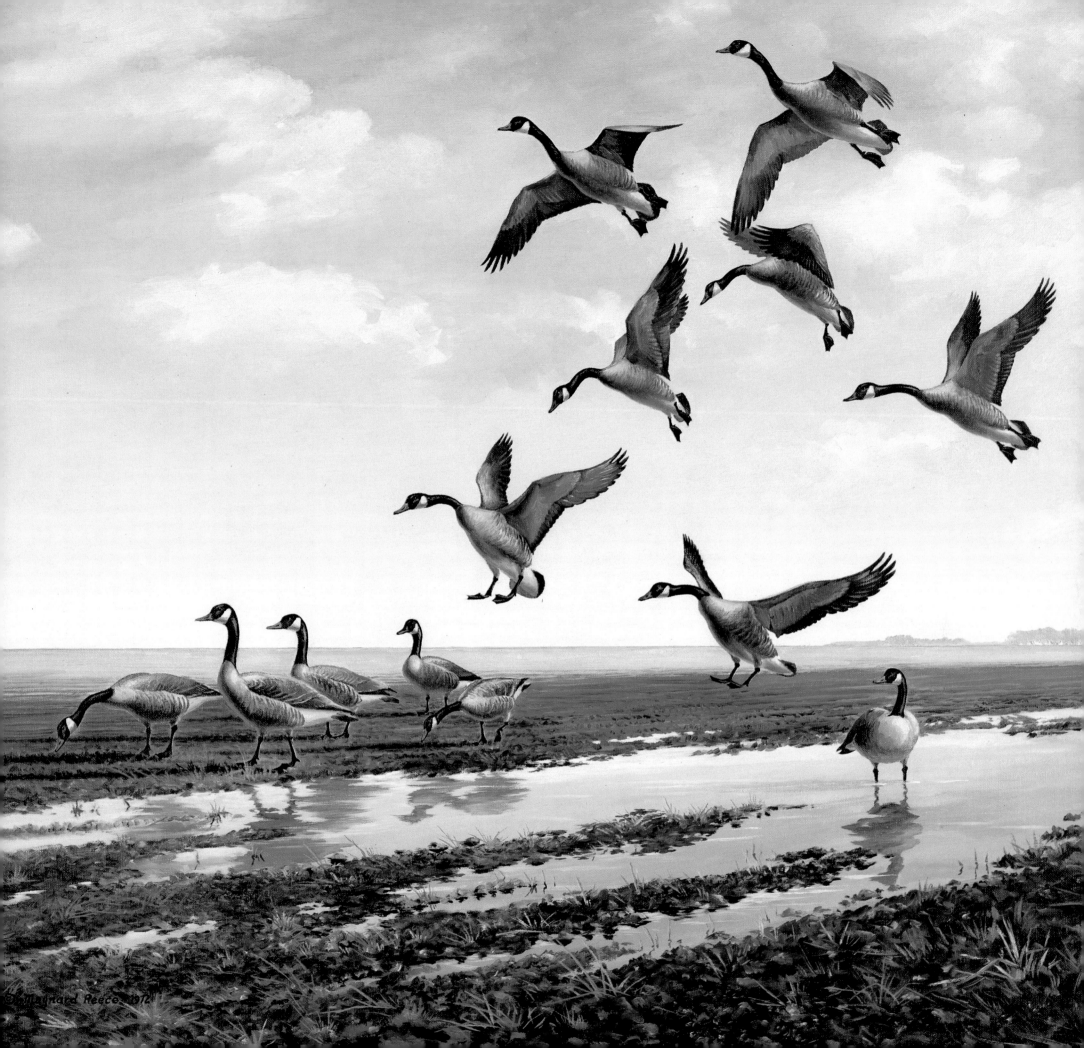

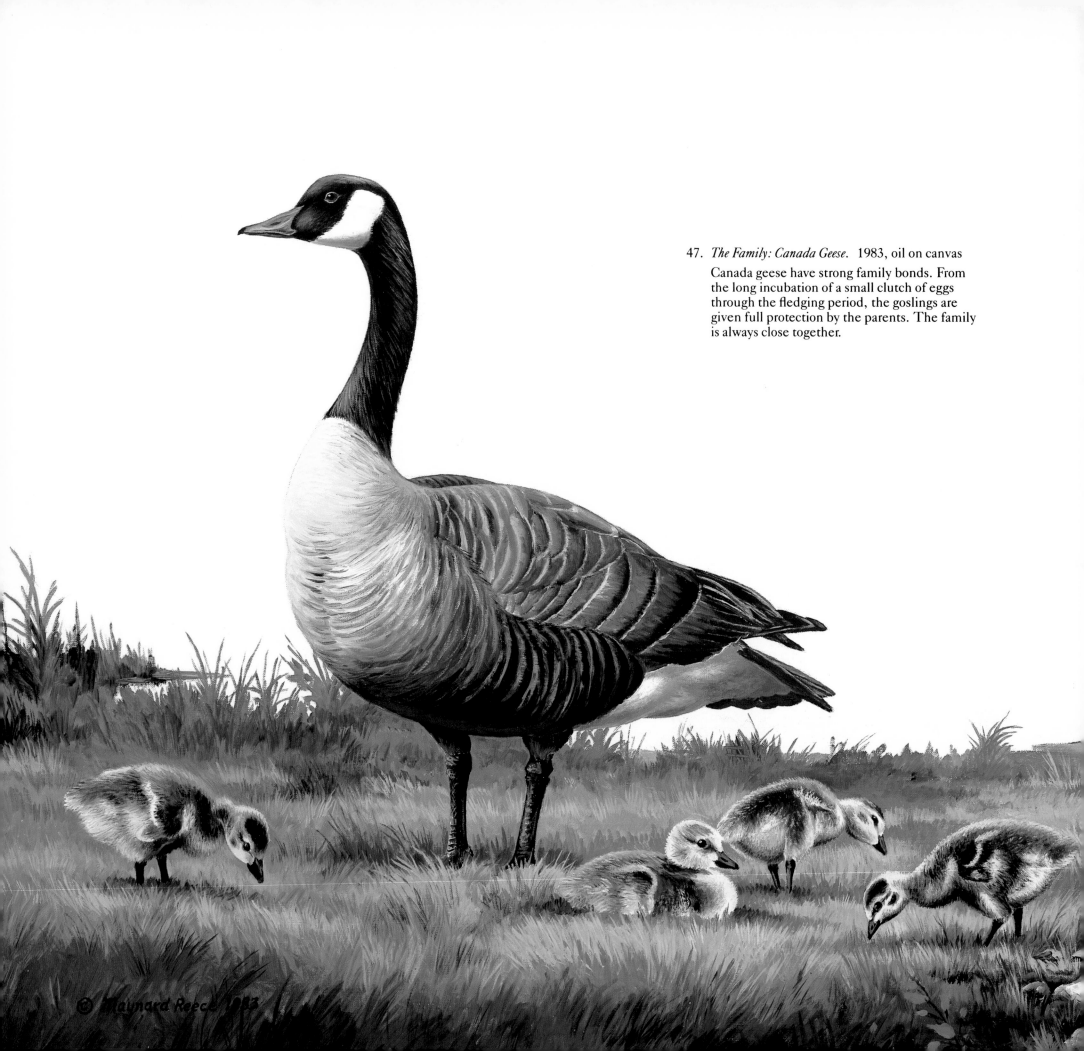

47. *The Family: Canada Geese.* 1983, oil on canvas
Canada geese have strong family bonds. From the long incubation of a small clutch of eggs through the fledging period, the goslings are given full protection by the parents. The family is always close together.

© Maynard Reece 1983

You can expect Canada geese to do the unexpected. Generally, they are rather vocal when landing with other geese or approaching decoys, but a small flock sometimes slips in from behind you without a sound. Canadas ordinarily land only in places that are flat with no nearby trees or obstructions, though you can remember once seeing five hundred Canada geese land in a small oxbow surrounded by dense timber.

Other times you have been crouching down in a cornfield refuge with Canada geese flying less than ten feet overhead. When they suddenly see you so close they shift into a startled climb, their powerful wings beating against the air with a loud "clop-clop" sound. They twist their heads down at you in disbelief as they make a frantic exit. (You have to have once felt the wings beat against your body as you held this bird to realize their strength.)

Normally Canadas cruise along with slow wingbeats, much slower than ducks, yet their speeds are about the same, thanks to the Canadas' larger wings. You have been amused watching a mallard trying to keep in formation with a flock of Canadas, much like a child trying to keep up with its parents.

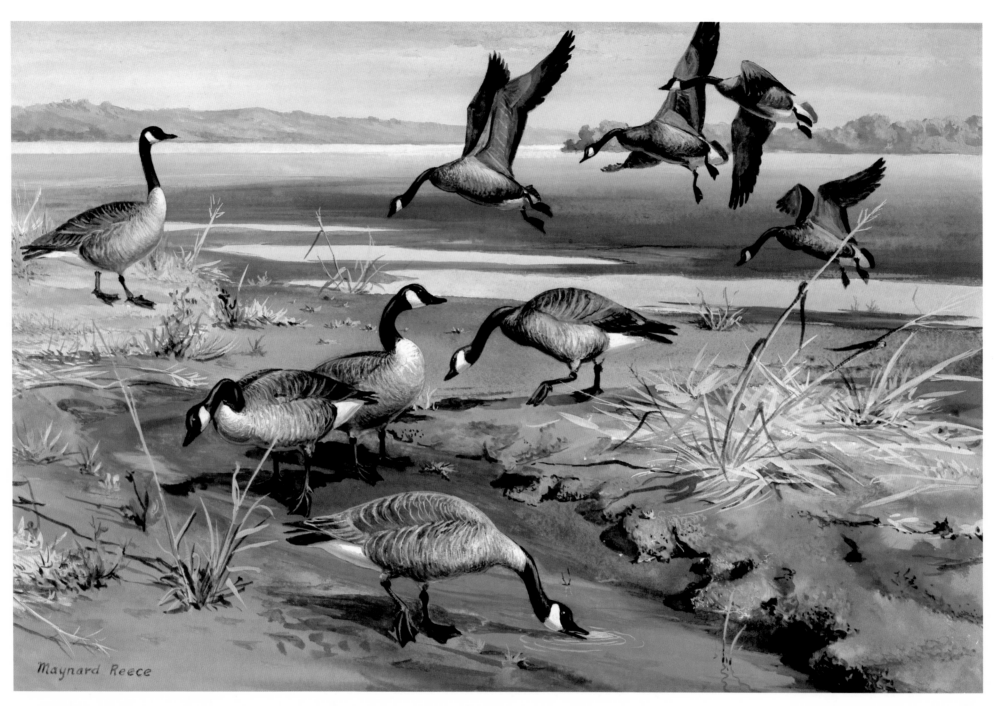

Maynard Reece

48. *The Sandbar: Canada Geese.* 1974, watercolor

Before the Missouri River was channeled and restricted, it used to spread in floods that left large sandbars when the water receded in the fall. These gave the geese resting spots with available water nearby, and unrestricted visibility.

88

49. *Dark Sky: Canada Geese.* 1978, oil on canvas

A dark sky has the fascination of danger mixed with beauty. As the storm front builds up, the sun behind you still bathes the birds, nearby weeds, and the trees on the far shore in brilliant color that intensifies the dark color of the ominous clouds. The water becomes nearly black as it reflects the sky.

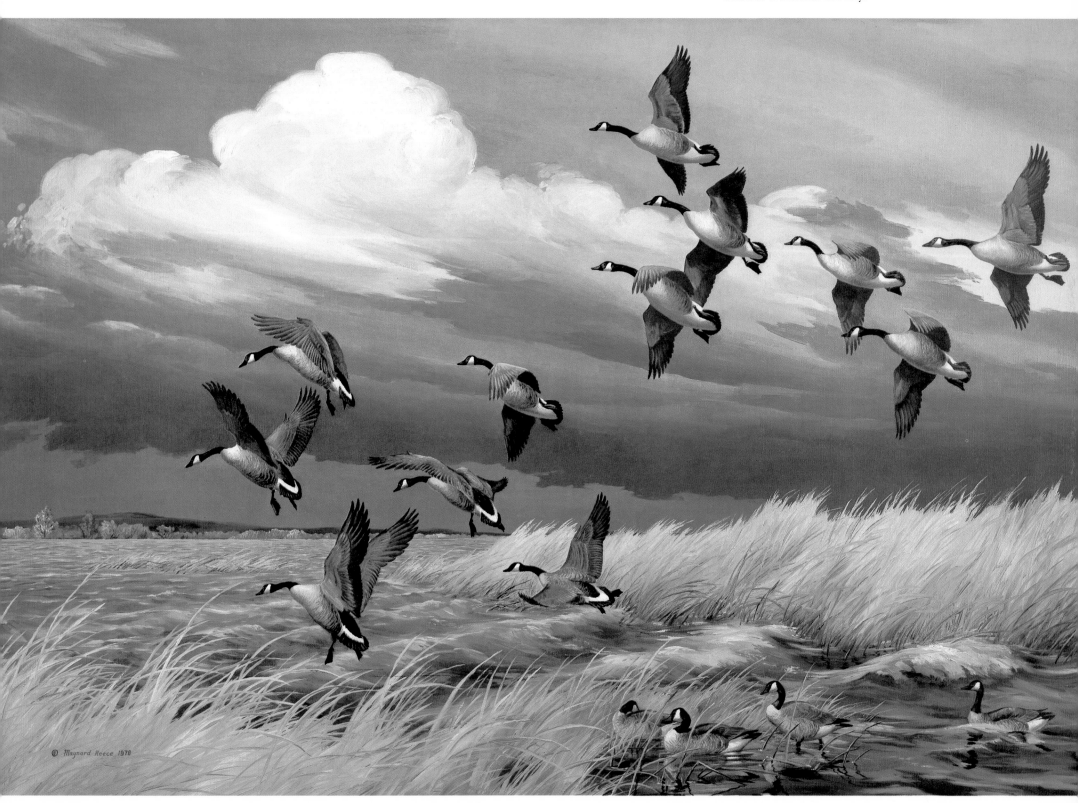

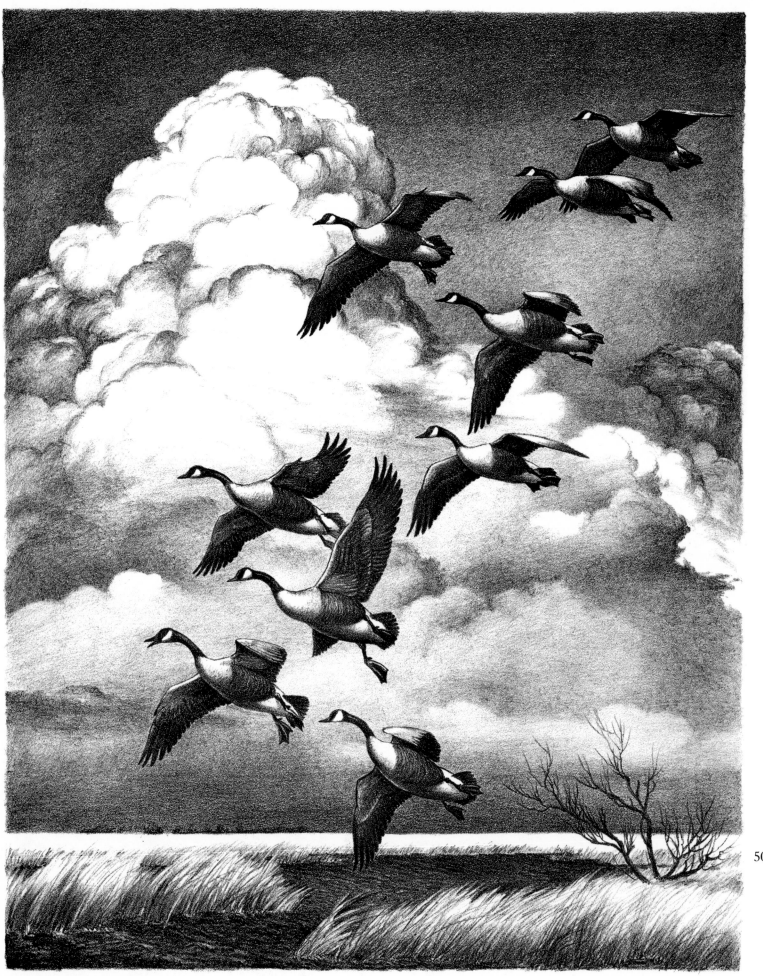

50. *Thunderhead: Canada Geese.* 1976, stone lithograph

Stone lithography is a medium of marvelous tonal qualities: the power of its black-and-white values is demonstrated in this study, from the black birds and dark lower clouds to the white, churning top of the cumulonimbus cloud.

51. *Nine Travelers: Canada Geese.* 1977, oil on canvas

Lifting off from a wintry marsh, these Canada geese have not yet formed the "V" they will assume in their long migration flight.

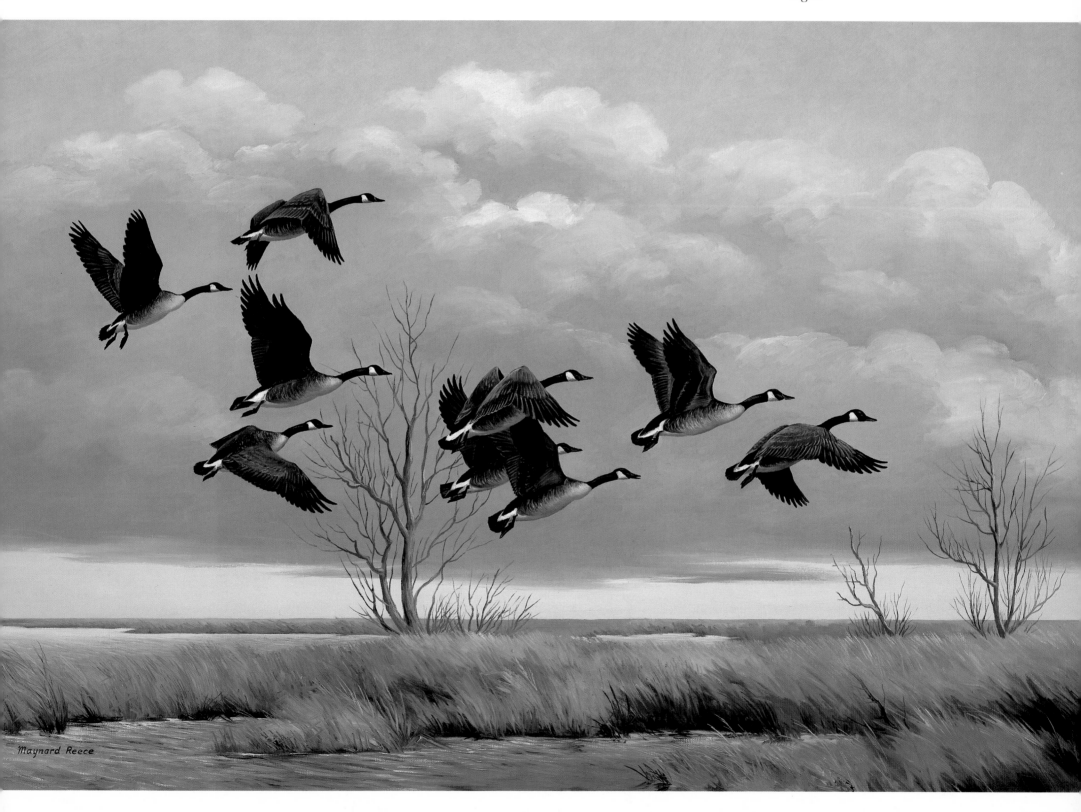

52. *Snow Geese.* 1974, oil on canvas

Geese love flat, open areas where they can safely rest and feed. They prefer shallow water or mud flats with unobstructed views, and they land easily in strong wind with scarcely a wing motion. To know geese is to dream of the unknown, and of faraway places.

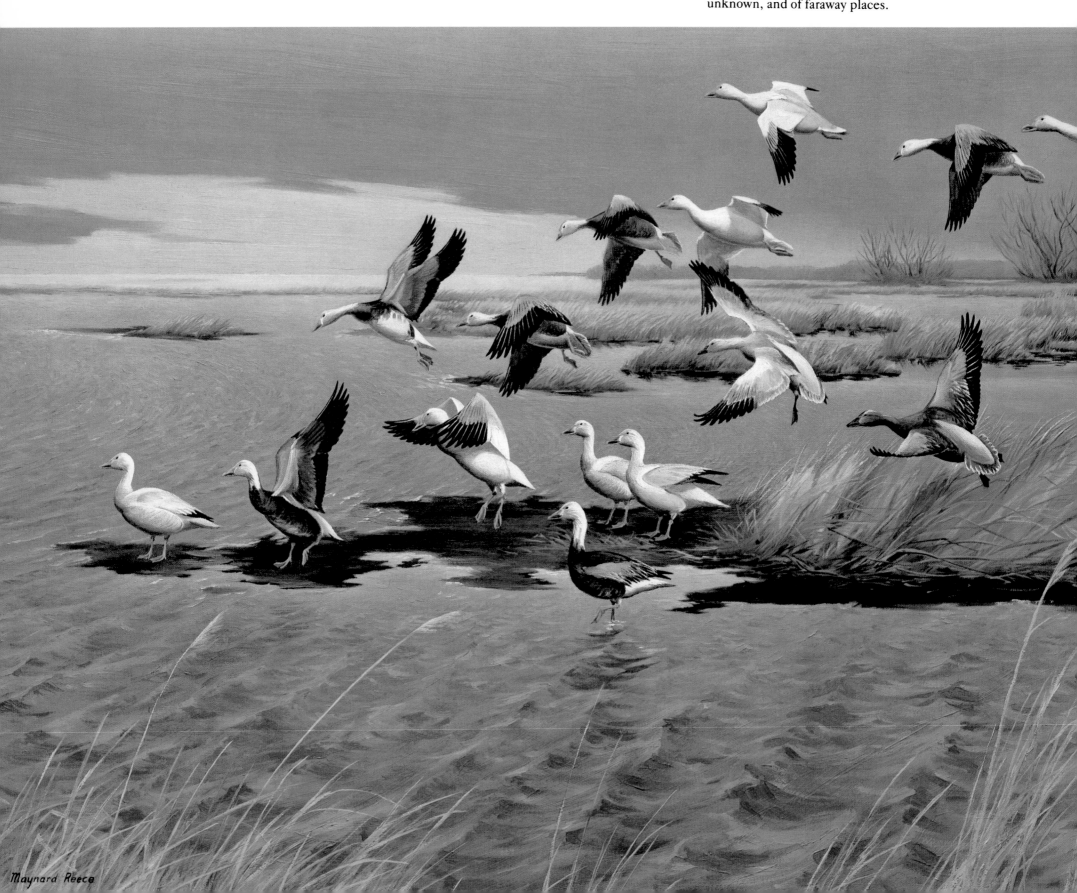

Maynard Reece

SNOW GEESE

Snow geese used to have two names for two separate species: snow geese and blue geese. Both are now called snow geese, and scientists speak of the "blue phase" and the "white phase," and of intermediate colorations between the two. The young of both phases are gray or grayish, their bills and feet gray instead of pink like the adults. Forty years ago most birds along the Mississippi flyway were of the blue phase with just a few white ones dotting a flock, but now the white phase is dominant there; on the Atlantic and Pacific coasts the geese have always been white. Whatever we call them, snow geese are great birds who fly together, migrate together, and nest together.

One of the major staging areas of snow geese is along the shores of Hudson Bay where they gather from their nesting sites to begin their long trip south to the bayous and salt flats of Louisiana and Texas.

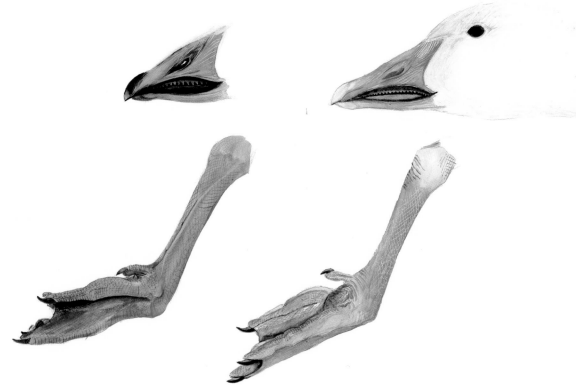

53. *Bills and Feet of Young and Adult Snow Geese.*
1948, watercolor

The adult bill and feet on the right are pink, while the immatures are gray.

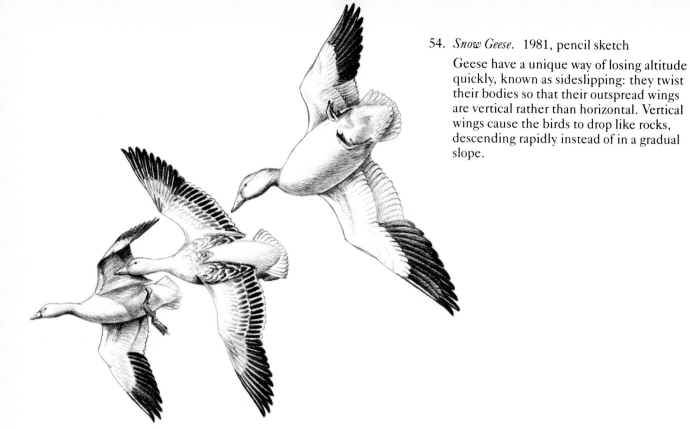

54. *Snow Geese*. 1981, pencil sketch

Geese have a unique way of losing altitude quickly, known as sideslipping: they twist their bodies so that their outspread wings are vertical rather than horizontal. Vertical wings cause the birds to drop like rocks, descending rapidly instead of in a gradual slope.

You got up before daybreak: it is snowing lightly, and a cold wind is blowing off Hudson Bay. It is still dark as you trudge along age-old animal trails across the tundra, skirting the shallow ponds strewn throughout the land. Flights of ducks jump from the ponds and streak off through the first rays of light; you can hear geese honking above you, ahead of you, and now even behind you. Sensing that you have arrived in a feeding area, you look more closely at the ground that begins to take shape as the light strengthens. Small patches of scrub willow and shrubs are waist high among larger areas of grass or water, and the wind and high tides from the bay have brought in a few gnarled pieces of driftwood. You put out your six nesting decoys on a grassy strip and build a blind by sticking small branches of shrubs into the ground, making sure you are upwind from the decoys. With the shrubs as camouflage you lie down on your raincoat, for the moss and grass are wet. From the distance comes a small group of snows winging their way over the tundra, barely twenty yards above the ground. Closer, closer they come. Seeing the decoys they become vocal and set their wings, coasting in with wings cupped. Feet drop, webs spread, and wings are in full braking position. Fifteen yards high, now ten, they start to flap their wings, dropping vertically as they lose speed. You raise yourself; with startled honking they execute an amazing climb up and away from you, curling in a fast turn and picking up speed. The next instant they are gone, and it is quiet again. But how close they were!

55. *Dark Sky: Snow Geese*. 1981, oil on canvas

Along Hudson Bay the geese fly low over the flat terrain of tundra. The white geese with black wing tips show up at a great distance against the dark sky.

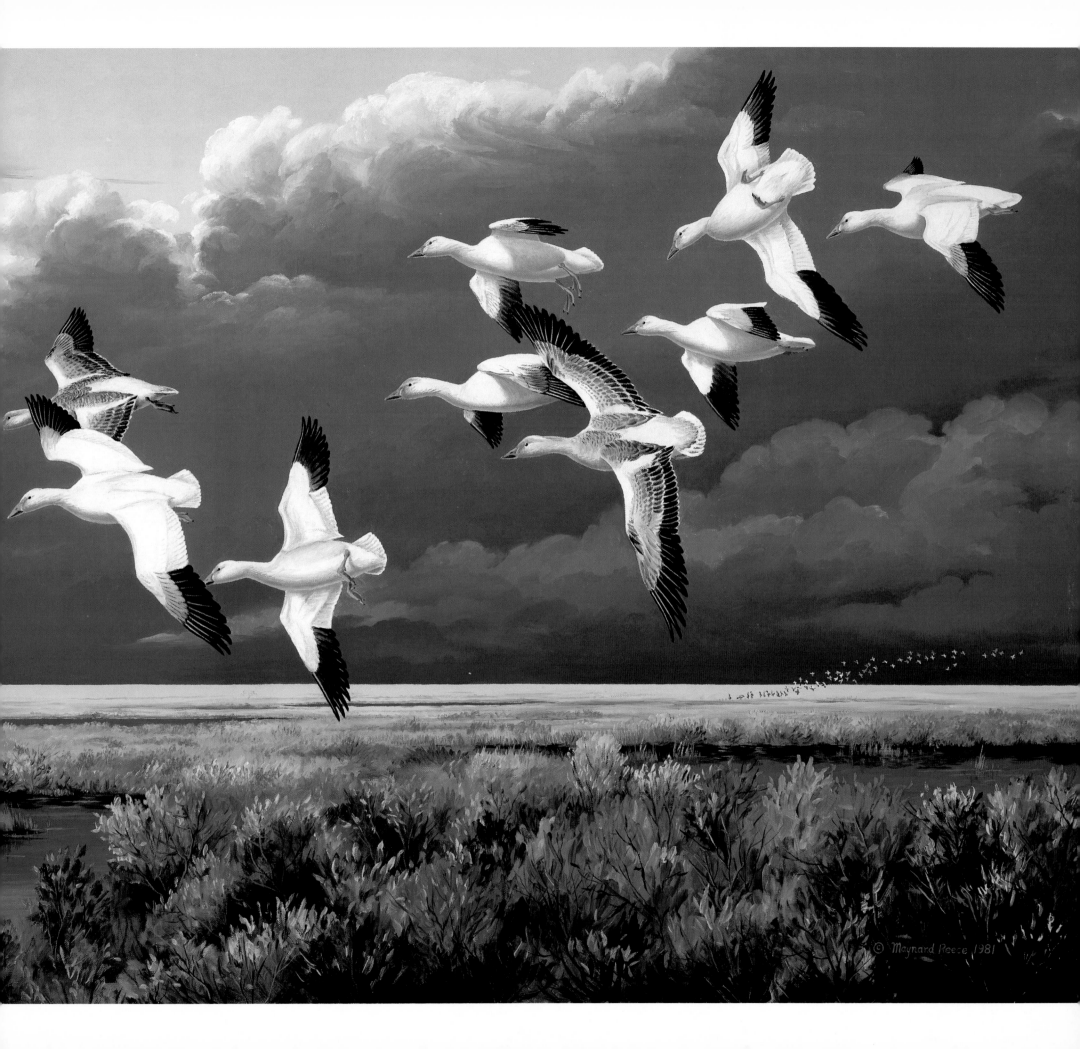

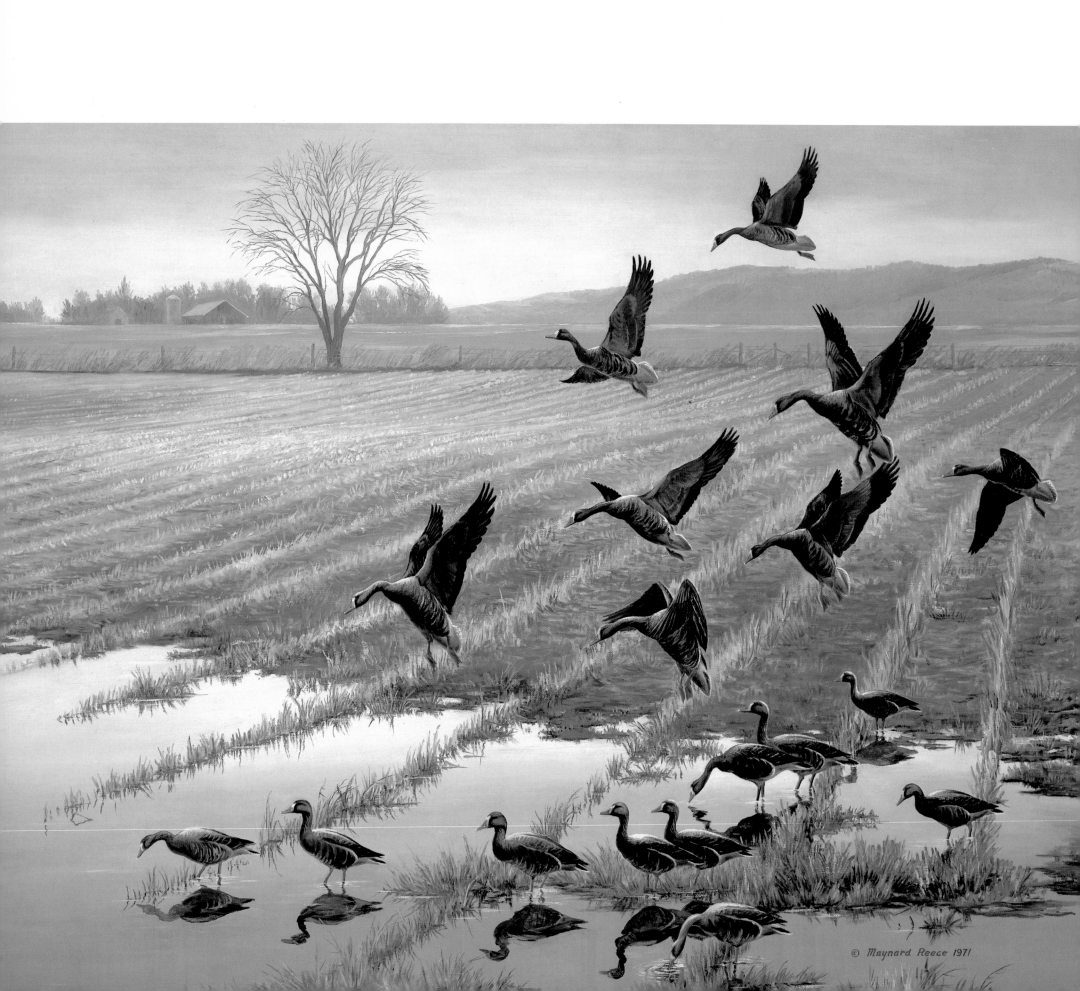

WHITE-FRONTED GEESE

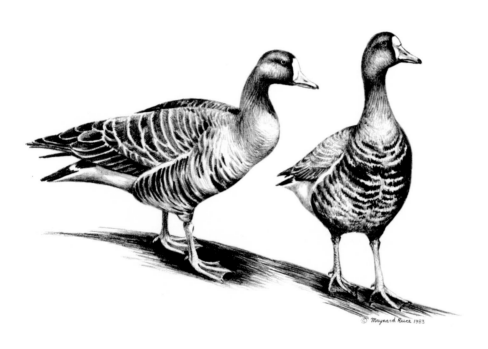

© Maynard Reece 1983

57. *White-fronted Geese.* 1983, pencil drawing

 The white-fronted goose gets his name from
 the white feathers at the front of the head,
 bordering the bill.

56. *Stubble Field: White-fronted Geese.* 1971, oil on
canvas

On their spring migration north, white-fronts
stop at suitable areas to rest and feed. They are
feeding on waste grain in this stubble field,
partly flooded from melting snow.

It is three o'clock in the morning.
The blackness of the night permits
no shadows or light. The air is cold,
its chill going through your parka
as you pick your way with a
small flashlight between plowed
ground and wheat stubble.
Yesterday afternoon you had seen
large flocks of white-fronts feeding
in this stubble and you know that
if the birds were at this spot last
night they will return again this
morning, though the flat, wheat
country of Saskatchewan stretches
for miles.

With your spade you start digging
a round hole in the wheat stubble
about two and one-half feet in
diameter and a little more than
four feet deep. You dig in a circle,
backing up around the hole and
standing on the high step as you
dig lower and lower like a giant
auger. Leaving one side for a seat,
you dig a deeper hole for your legs
and feet. Deep enough! Now you
carefully smooth down the waste
dirt and gather wheat straw and
chaff, sprinkling it over the black
dirt to hide your digging.

Setting out your decoys downwind,
you collect your equipment
and sit down in the hole,
placing over the top a screen lid laced
sparsely with wheat straw to make
camouflage you can see through.

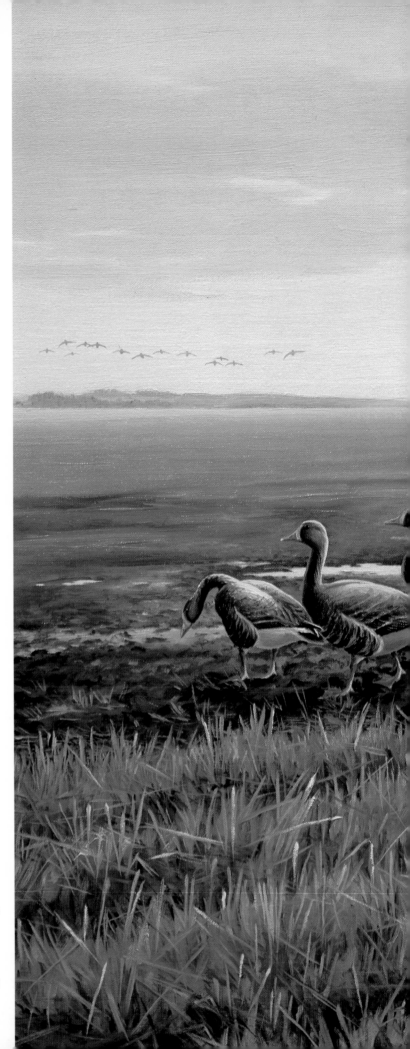

It is still dark, but the first light glows in the east. The cold dampness of the earth begins to penetrate your body, overheated from your digging; you mumble something to yourself about "feeling like a gopher." But listen! Now you hear geese. Yes, they are "speckle bellies" all right. (This name for white-fronted geese comes from the black stripes and specks across their bellies and chests.) White-fronts have their own honking sound—higher pitched, more melodious, and rapid, like laughing.

Across the brightening sky come strings of geese that have left a lake and are heading back to the feeding ground. Now the sky is full of waves of geese. They are coming your way. Huddled in your damp hole, you wait. Louder honking. It is light enough to see them against the salmon-colored sky; they are getting closer. They see the decoys and turn into the wind. The wingbeats slow down; the birds are coasting toward the decoys, their feet dropping down, spread out, and now close enough to show the orange color of the feet and even the bills. The birds seem to hang motionless in front of you. You raise the lid, stand up, and watch the frantic confusion of birds flailing the air in mass exodus. In seconds the scene is over and you slowly fill up your freshly dug hole, but it was worth it to be among the wild birds.

58. *Rendezvous: White-fronted Geese.* 1978, oil on canvas

White-fronted geese send out scouts in the late afternoon to select a feeding site for the next morning, generally a stubble field with waste grain and good visibility in all directions. The next morning, flock after flock will leave their resting area and rendezvous at the field selected the afternoon before.

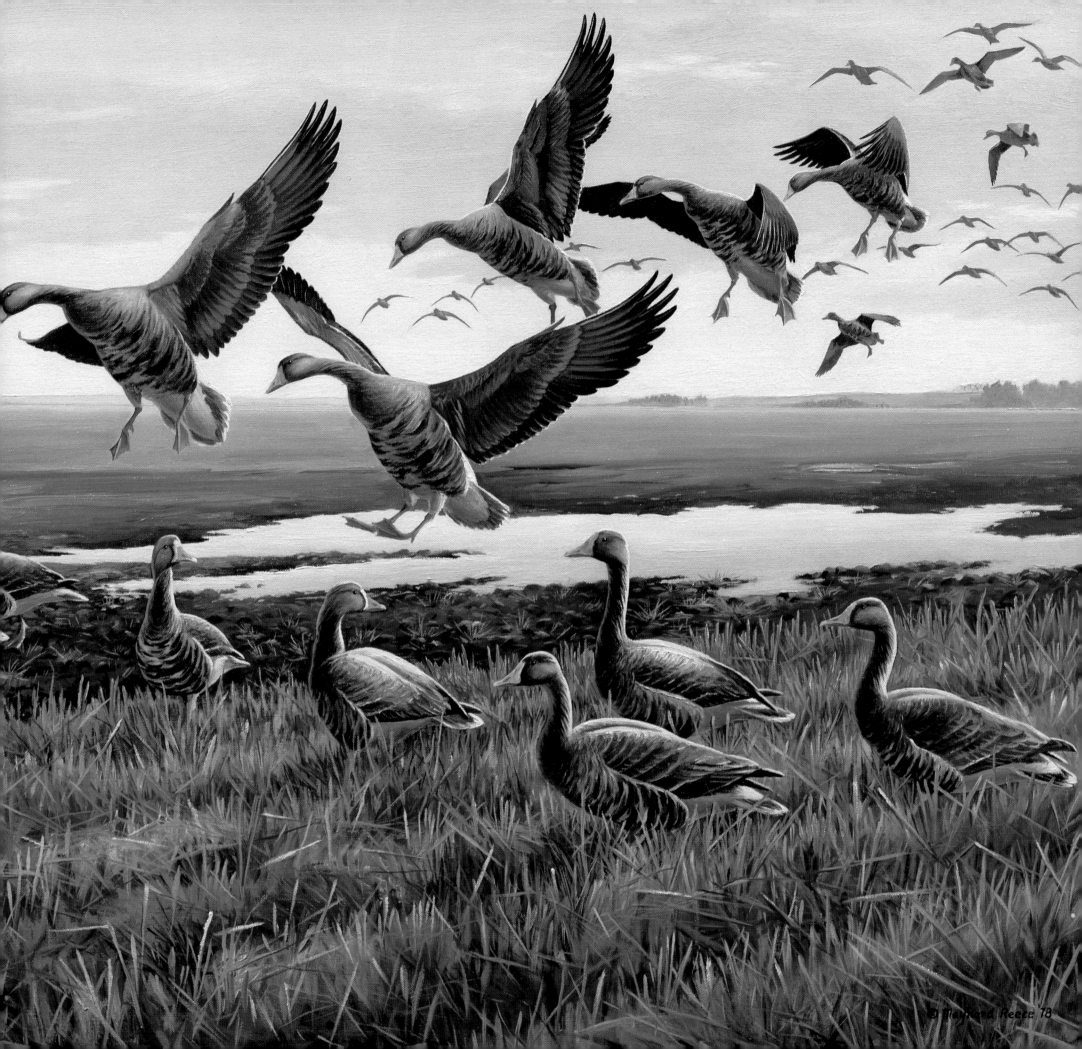

© Maynard Reece '78

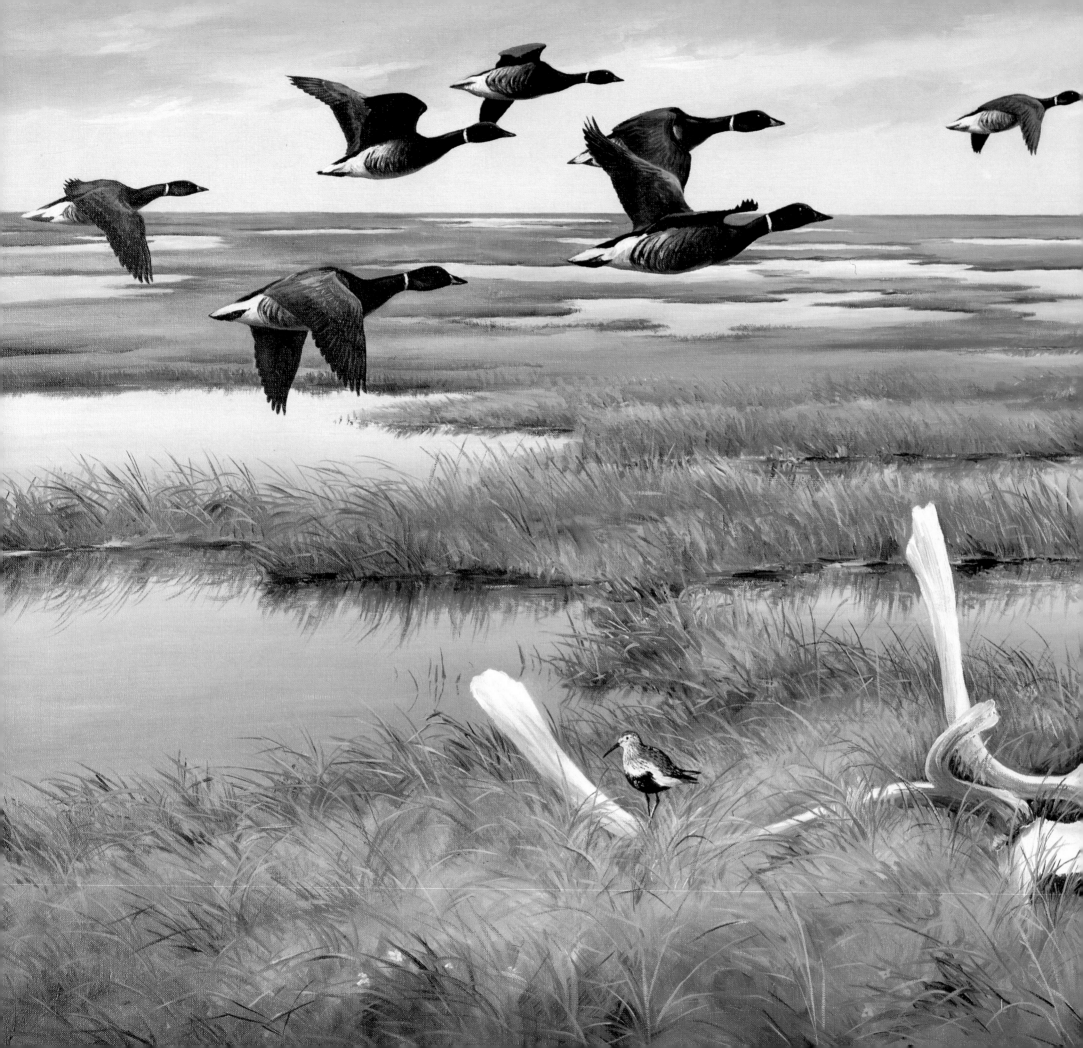

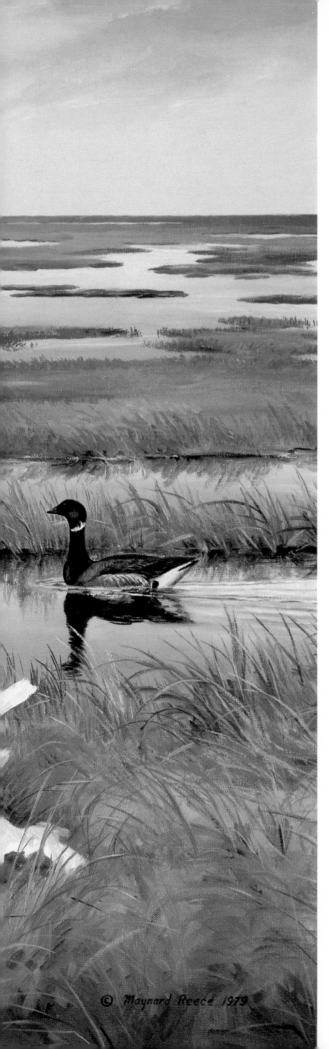

BRANT

All across the Arctic the black brant nests along the tundra ponds, spread out so there is no heavy concentration of birds in one area. Moving in for a closer look at a nest, you find a female brant sitting on the eggs, her head and neck flat against the ground; evidently she thinks that by flattening herself she is hidden. The male is close by, swimming on the shallow pond. This scene repeats itself about every hundred yards. Now and then small flocks swing low over the tundra only to land again as they survey nesting sites and paired-up birds.

The brant split up in the fall, the black form going down the Pacific Coast as far as California and the eastern light-bellied flocks heading down the East Coast to the Carolinas. Their favorite winter food is eelgrass, and indeed the species depends on the abundance of this food. Their flight is in bunches, not in lines like Canadas or snow geese, and they are smaller, making them easy to identify.

59. *Tundra: Black Brant.* 1979, oil on canvas

Stretching across northern Canada and Alaska are thousands of miles of the vast, flat terrain called tundra. Moss, lichen, grasses, flowers, and tiny shrubs grow above the solidly frozen ground, or permafrost. Brant are flying across this treeless land and another is swimming near its nest. A dunlin (formerly called a red-backed sandpiper) is standing on the caribou antlers that have been half chewed away by lemmings.

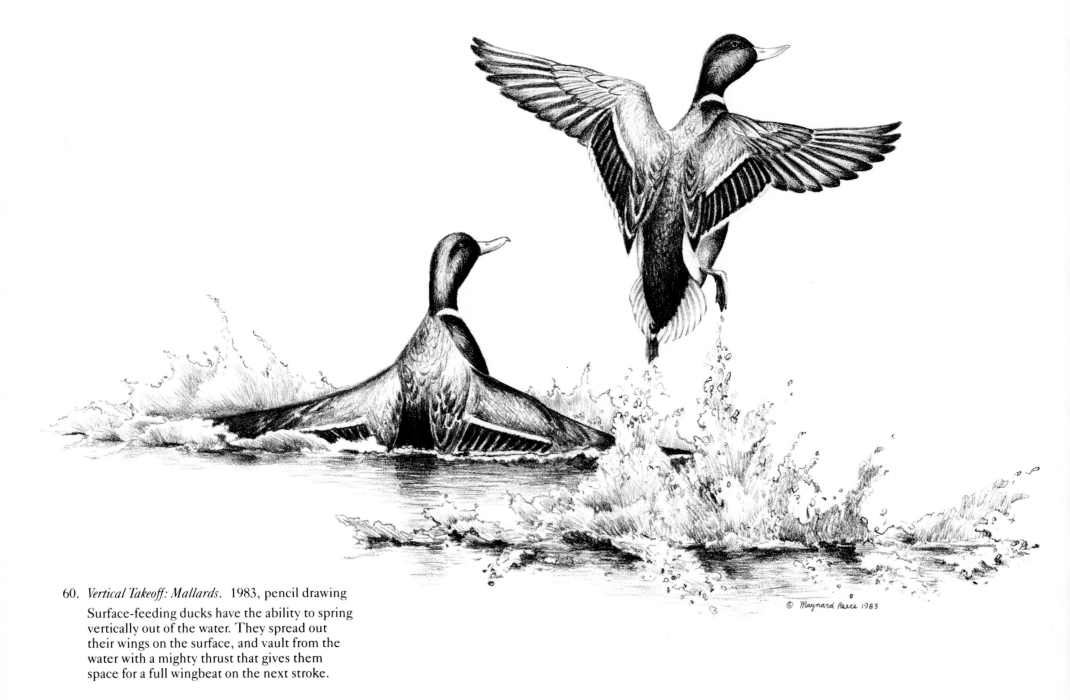

60. *Vertical Takeoff: Mallards.* 1983, pencil drawing

Surface-feeding ducks have the ability to spring
vertically out of the water. They spread out
their wings on the surface, and vault from the
water with a mighty thrust that gives them
space for a full wingbeat on the next stroke.

© Maynard Reece 1983

THE DUCKS: SURFACE-FEEDERS

CHAPTER VI

THE DUCKS

SURFACE-FEEDERS
(Dabblers)

Ducks—ever since you were a small child living near lakes and marshes, you have seen ducks fly overhead, and watched them swimming, feeding, and waddling about with their amusing pigeon-toed walk, leaving wide, webbed footprints in the mud.

For years you tried to make drawings of them, but the birds were wary, and not easy to see or find. You sketched them in zoos and on game farms, but somehow these didn't look like the wild birds. During the war you were stationed for some time near San Francisco and saw lots of ducks in the bay area, and at Lake Merritt in Oakland you found what you had been looking for—wild ducks tamed, because they were fed by people in this park. In sketching the ducks, you recognized differences among individuals even within the same species: there were fat ducks and skinny ones, small and large ones, ducks with athletic builds and sloppy-looking ducks. And you began to see what made the wild birds look different from tame or zoo birds. New ducks that arrived from the north after migrating long distances were in prime physical condition, sleek and hardened like athletes from long hours of flying. At first, these newcomers were suspicious of people and stayed out on the lake, then gradually they worked closer to the shore until they could feed by tipping up, stretching their necks and heads toward the bottom while kicking with their feet, tails and wing tips remaining above water. This is the manner of all surface-feeding ducks, hence their name "dabblers."

If you got too close, they would panic and vault out of the water with a big splash, flying upward almost vertically until they picked up speed and leveled out as a launching missile does. (Years later you could see in high-speed photographs how they spread their wings on the surface and launch themselves upward, with one mighty push, out of the water.)

As the new birds got used to people, they would waddle up on shore to feed on grain, bread, and tidbits offered by the park visitors. In a few weeks they would begin to lose their sleek, muscular bodies and show the lower belly bulge so common in tame or domesticated ducks. It was interesting to see how a duck drinks, scooping up the water with its level bill and tilting up its head to let the water run down its throat—without the convenient suction or siphon equipment that mammals have.

Ducks like to doze in the warm sun, laying their heads back over their shoulders and tucking their bills under the top feathers of the wings. They close their eyes, but pop one open occasionally to check around. This sleeping is generally done on land while standing on one leg with the other leg tucked up out of sight, or while merely floating around on water.

The most important function of ducks is flight, for without this gift, ducks as we know them would not exist. Flying is their means of keeping mobile, free to travel thousands of miles in enjoying their unique style of life.

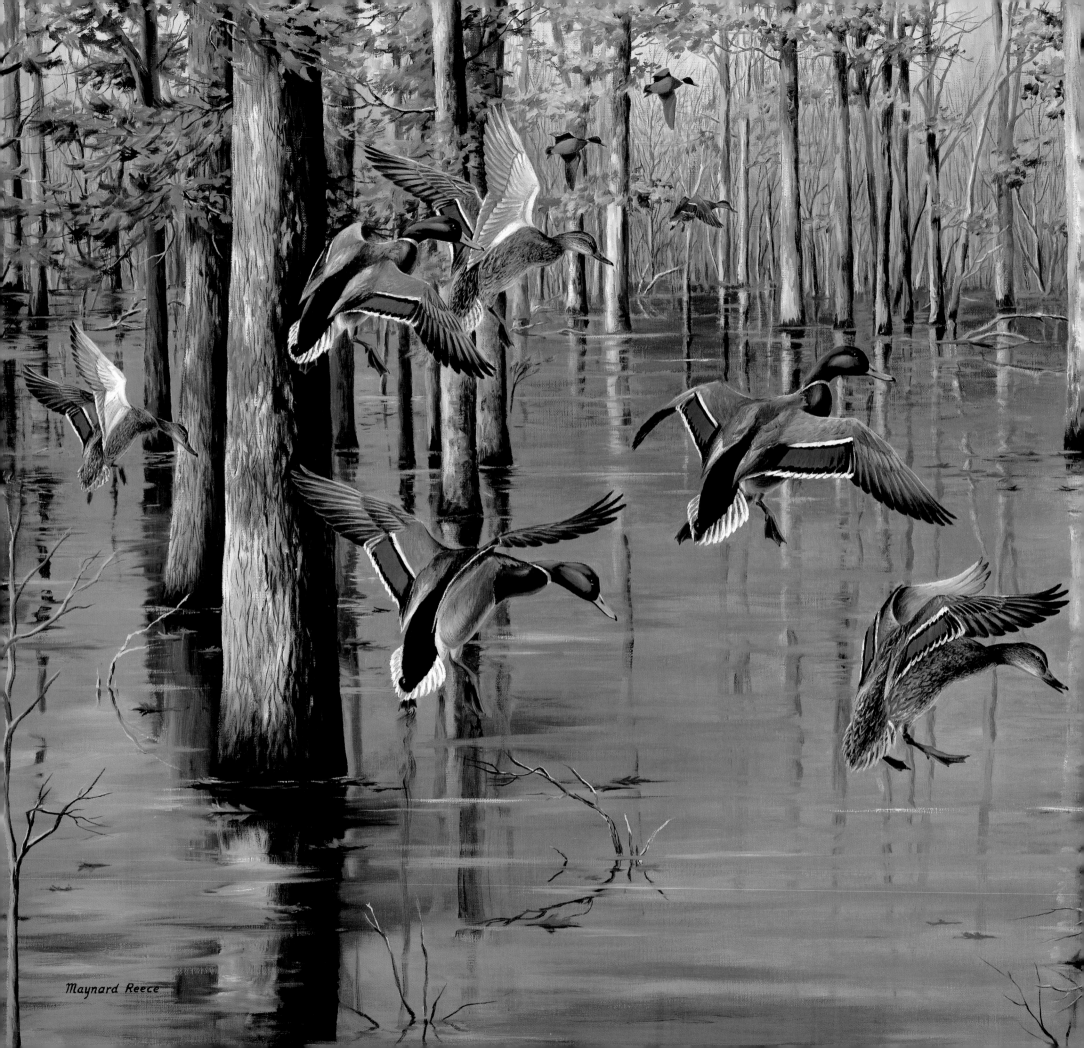

Maynard Reece

MALLARDS

Your first experience of observing masses of mallards was at a winter haven in Arkansas, watching birds funnel out of a large tract of flooded timber. From a distance they looked like a column of smoke rising upward and curling out horizontally, blown by the wind, and for nearly an hour this small cloud rose, straightened, and disappeared in the haze. From closer by you realized it was made of thousands of mallards funneling out of the timber on their way to feed in the rice fields. You waded out in the flooded timber and waited for their return.

At mid-morning you suddenly heard what sounded like a freight train swishing past, and looking upward you could see countless mallards with cupped wings dropping straight toward you like rocks. The roar was produced by the wind whistling through their wings, multiplied a thousand times. From an altitude too high to see they were dropping in a matter of seconds toward the treetops, where they slowed down and then dropped onto the water like a heavy rain. By evening an estimated half million of ducks were resting on the water.

Mallards are found worldwide and are certainly the best known and most plentiful of all waterfowl. The birds are wary, with good eyesight, and hardy enough to stay in sub-zero temperatures in comfort. Think of ducks, and you think of mallards.

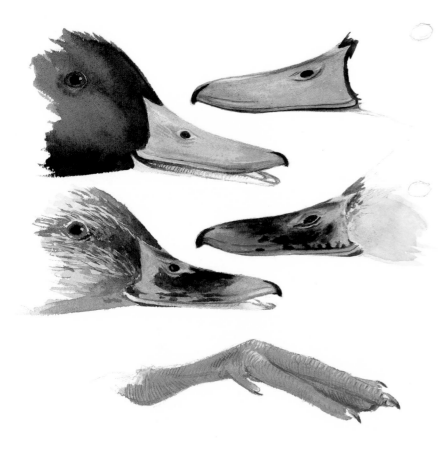

62. *Mallard Bills and Foot*. 1980, watercolor
Every mallard bill shows some variation.

61. *Flooded Oaks: Mallards*. 1974, oil on canvas
Mallards are attracted to flooded timber, but to land there without wind means using wings, spread tail, and outstretched feet to their fullest capacity. Balance must be maintained or the duck will fall into the water like a clumsy diver.

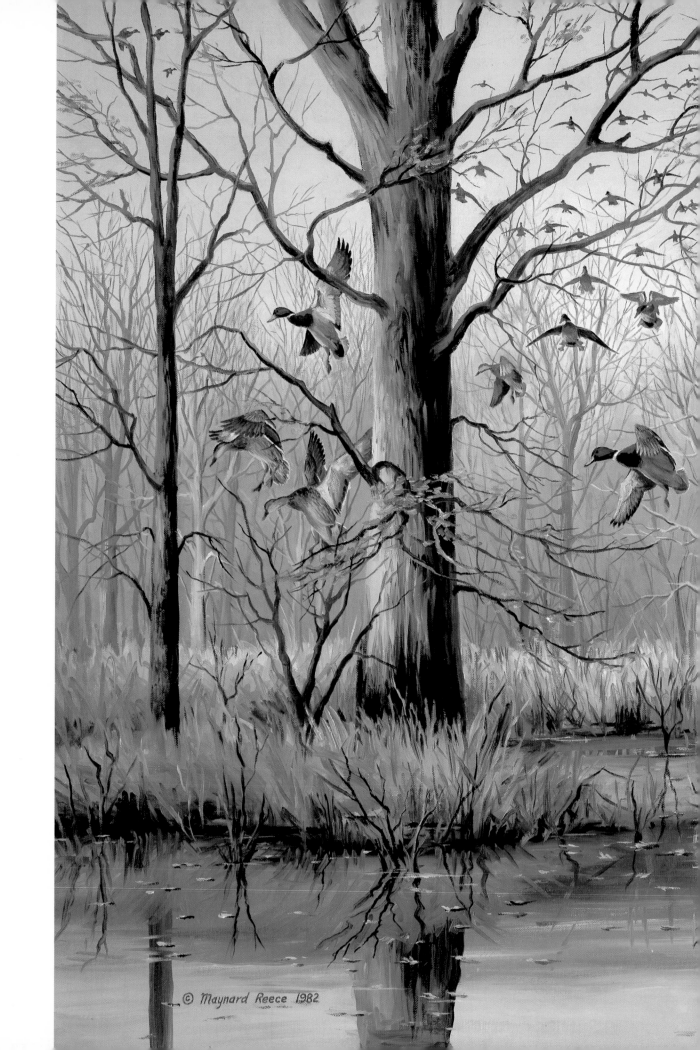

63. *Flooded Timber: Mallards*. 1982, oil on canvas

Mallards can be so intent on avoiding trees and obstacles that they forget their fear of man: they may even run into you in their effort to reach the water. They strike the surface with a large splash, slide to a stop, and then fold their wings, wiggle their tails, and dip their heads. Suddenly they see you standing hip-deep in the water beside them.

© Maynard Reece 1982

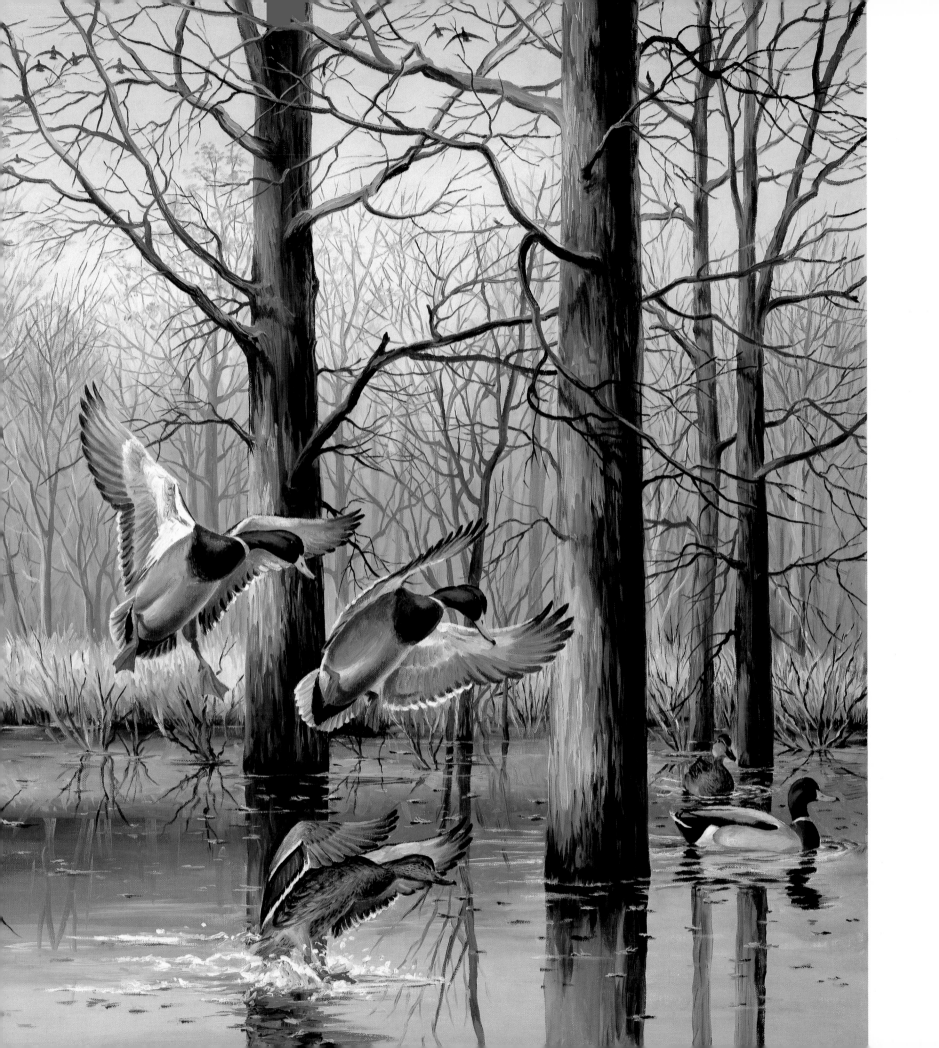

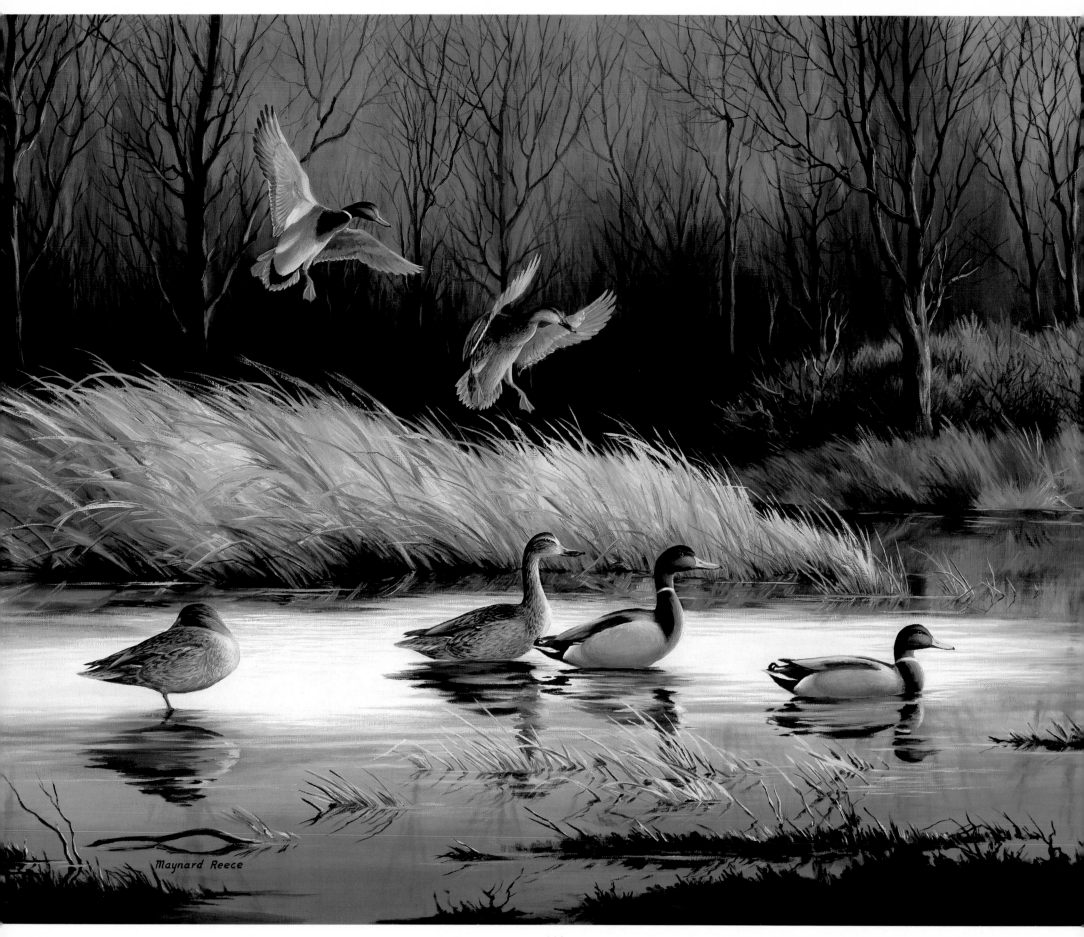

64. *Shallow Pond: Mallards*. 1976, oil on canvas

In a sheltered pond, dark because of the heavy timber, a few streaks of the late afternoon sun are striking the ducks, water, and reeds. This sunlight creates a brilliant contrast against the somber forest.

The mallards are standing on an underwater mudbar which makes the water too shallow for swimming, but just right for resting or napping.

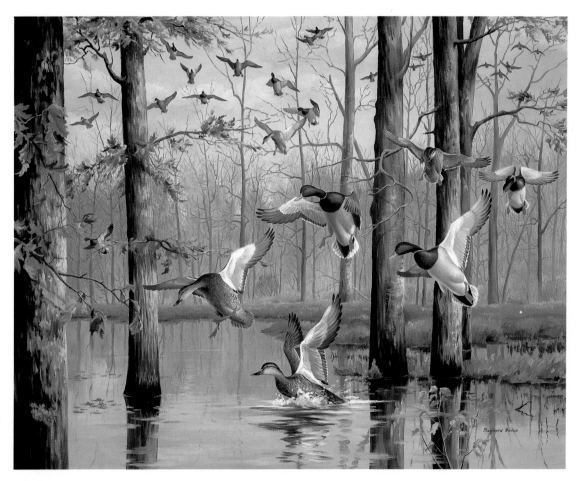

65. *Pitching In: Mallards*. 1969, oil on canvas

A small opening in the flooded timber gives mallards a little space to twist and turn as they near the water. Through such a "hole," as it is sometimes called, the birds can drop down through the trees and still maintain a little forward speed.

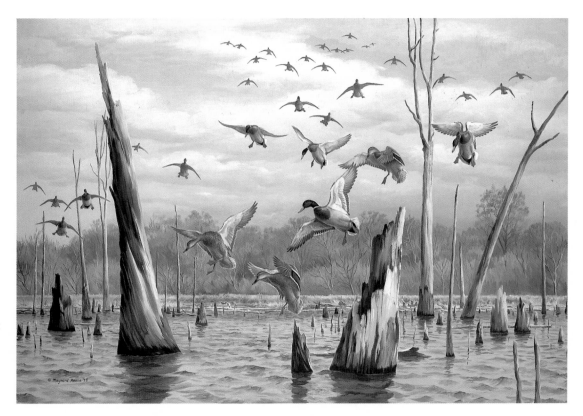

66. *Stick Pond: Mallards*. 1977, oil on canvas

Reservoirs have been constructed throughout the country to hold water for agricultural purposes. In these areas flooded trees have often died in the water, leaving a tangle of stumps, trunks, and limbs exposed above water level. Ducks enjoy these reservoirs.

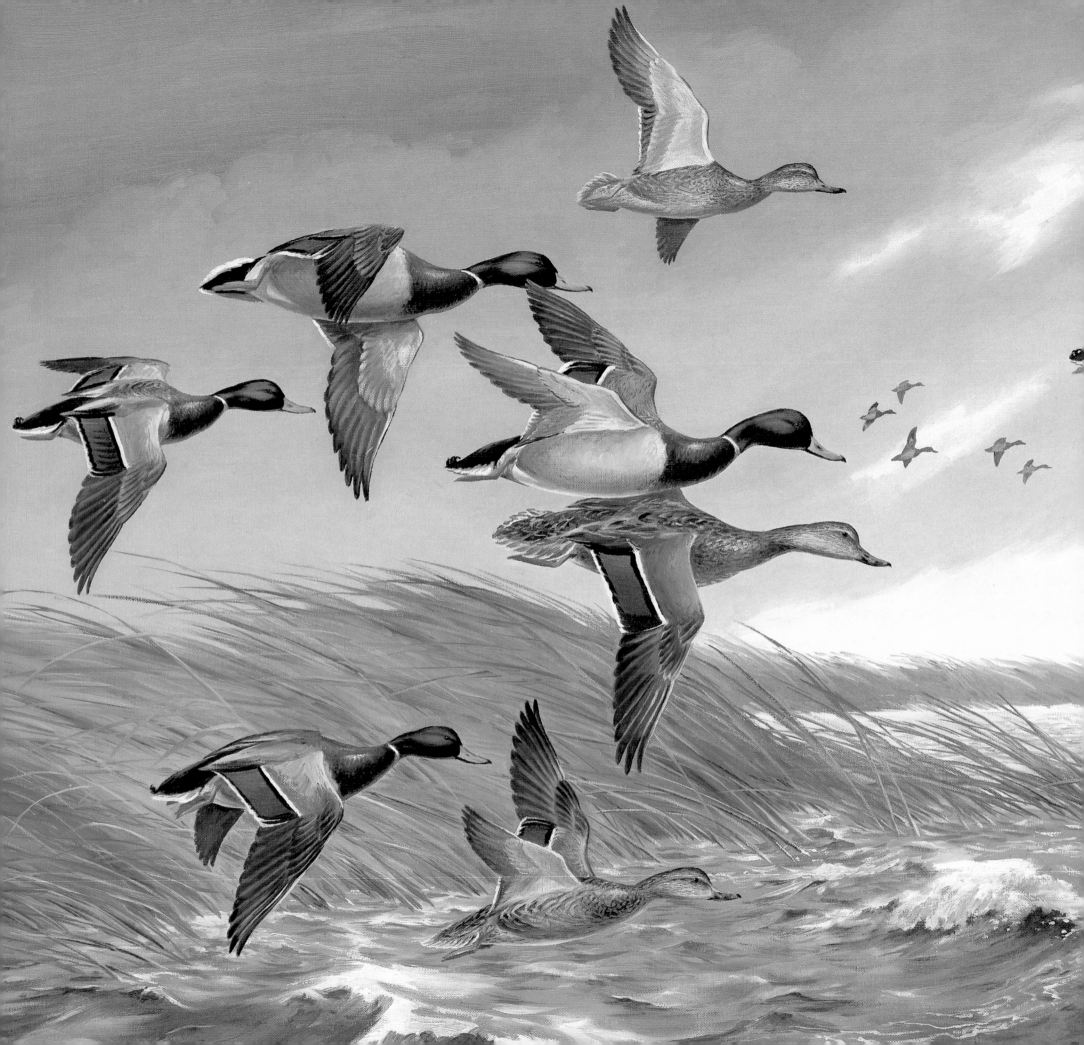

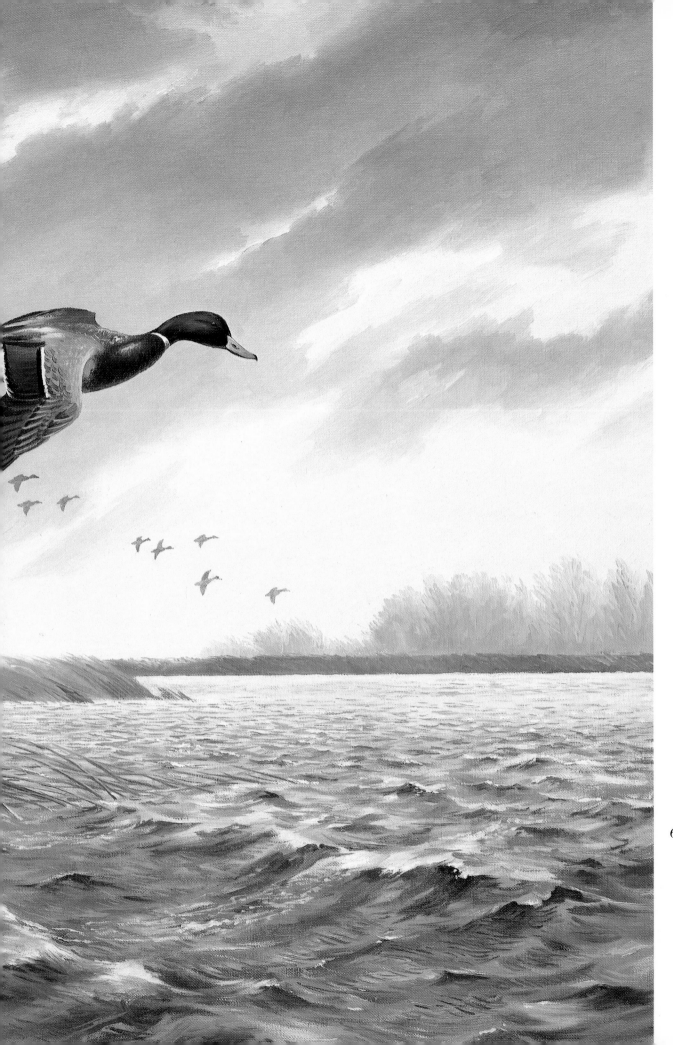

67. *Windy Day: Mallards*. 1979, oil on canvas

When the wind whips across a marshy lake, the surface quickly roughens into choppy waves, and gusty wind currents pick off the spray from the churning water. Mallards knife through the strong wind by tilting back their wings, retaining thrust with lessened wind resistance. Powerfully they drive their way across the flattened weeds into the lake for a chilly landing.

BLACK DUCKS

American black ducks, sometimes called black mallards, look like mallard hens, only darker. They have the mallard's iridescent purple or blue wing patch but without the white edge above and below, and their feet are pink, red, or brown rather than orange. Other similar ducks are the Mexican duck, lightest in color and nearly as light as a hen mallard; the Florida duck, in color about halfway between the mallard and the black duck; and the mottled duck, almost as dark as the black duck. But these three species stay in the far south and are non-migratory, so there is little chance of confusing them with the wide-ranging mallards and black ducks.

Black ducks are more wary than mallards, but both species will fly in the same flock and use the same water areas.

The black duck inhabits only the eastern half of North America, and is most prevalent along the East Coast. It was once plentiful but in recent years the population of this bird has dropped drastically in spite of stricter controls on harvesting it. The black duck may be in danger, and in need of complete protection. Managing waterfowl is a complex problem, for many factors determine the success of maintaining a healthy population.

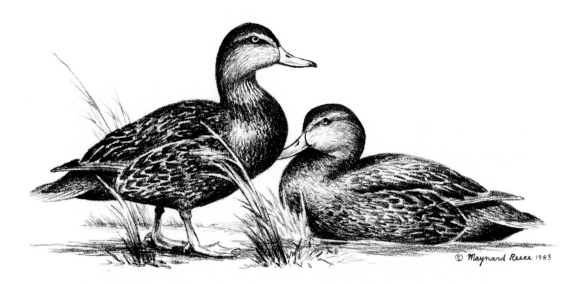

68. *Black Ducks*. 1983, pencil drawing
Black ducks can often be confused with mallard hens.

69. *The Alarm: Black Ducks*. 1983, oil on canvas
The back of a black duck, shown here, illustrates the characteristics of his wing patch. The mallard's wing patch has white both above and below the blue; the black duck has no white, and is purplish in color.

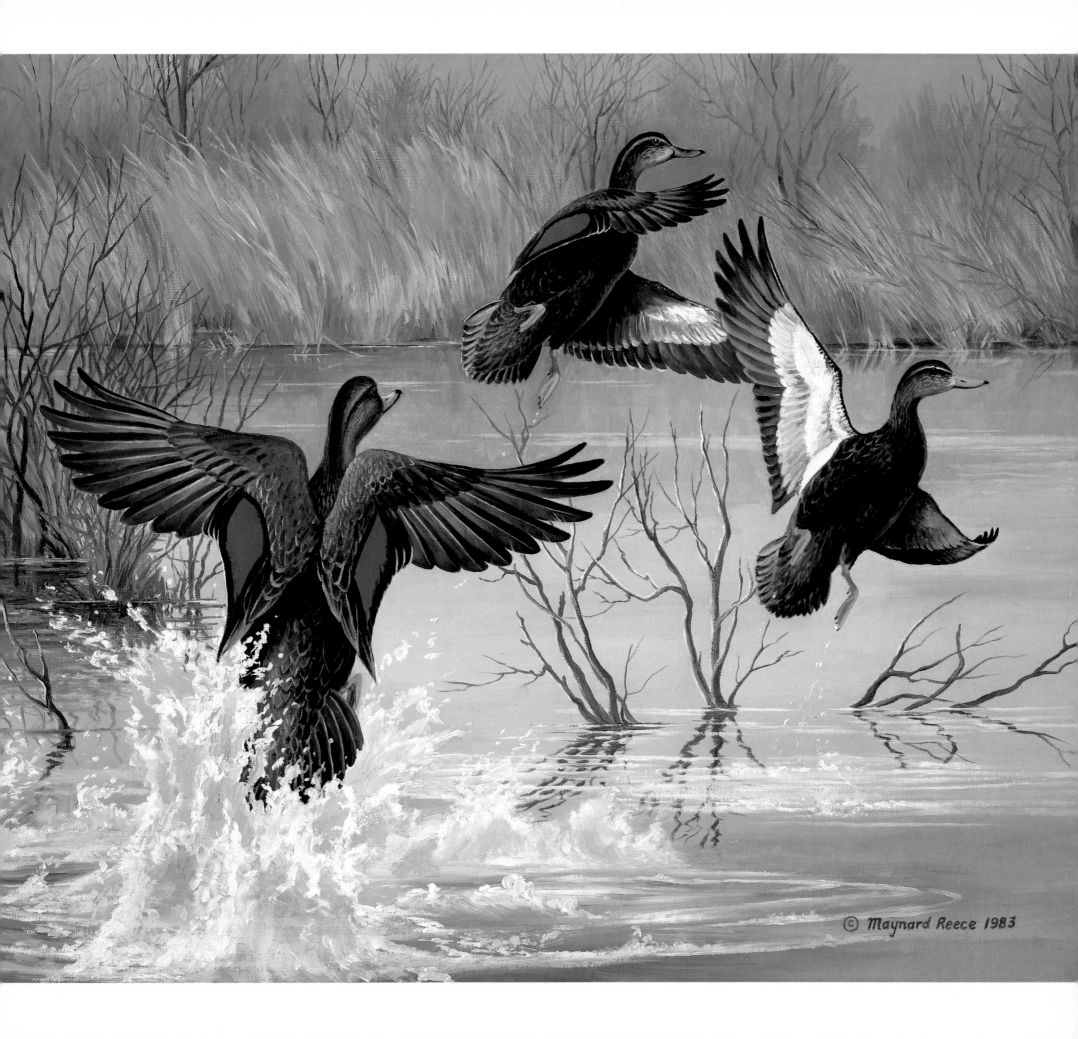
© Maynard Reece 1983

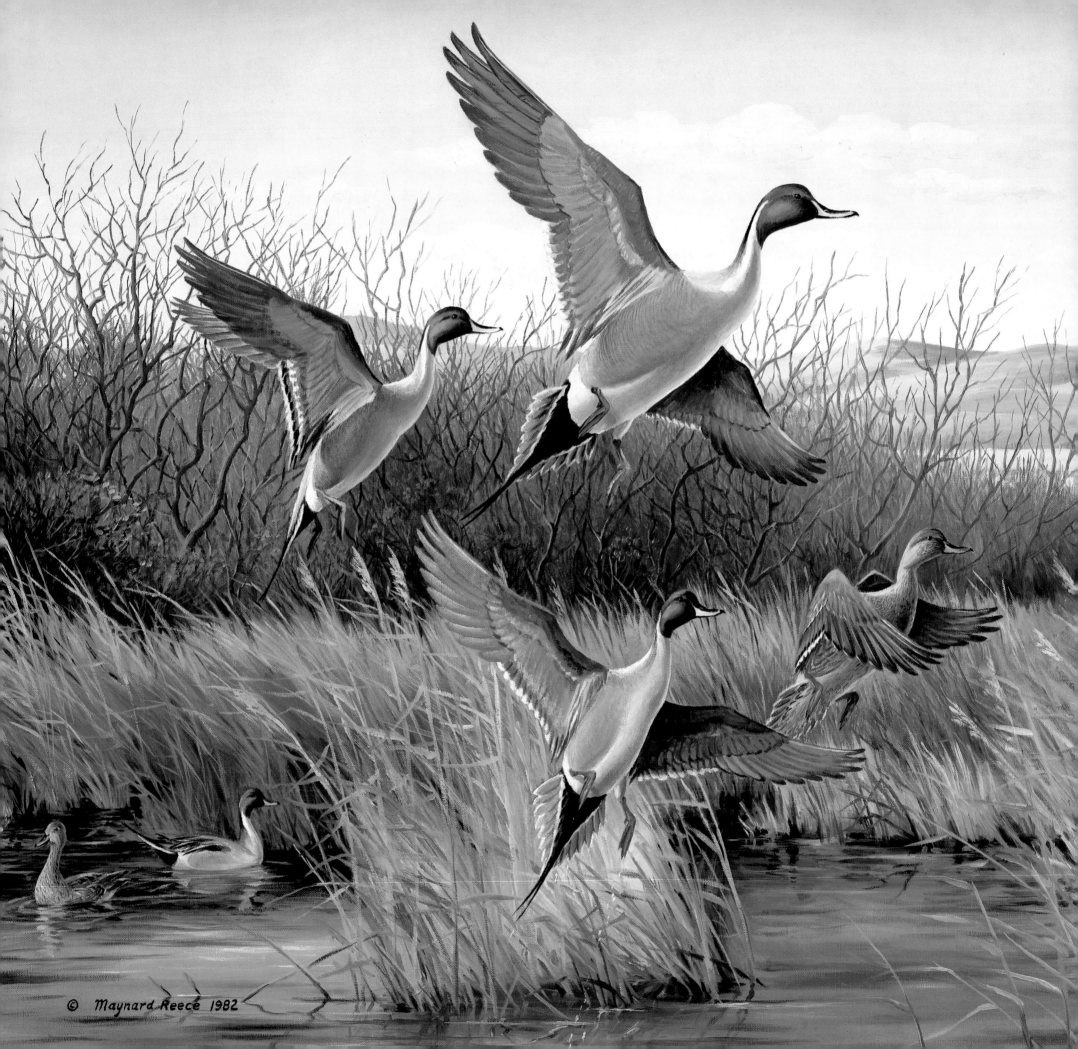
© Maynard Reece 1982

PINTAILS

A drake pintail is the ultimate in grace and beauty, with his long neck, narrow long wings, slim body, and tail with the two elongated feathers that give him his name—pintail. All his features seem to accentuate his streamlined look, from the strip of black along the bill, the line of white from the head and neck into the brilliant white breast, and the long striped feathers (scapulars) along the back, to the tapered tail ending in long, black tail feathers. His colors of brown, black, gray, and white form a masterpiece of design. Pintails are plentiful throughout North America, from the Arctic down into Mexico. Wintering in California, the Gulf Coast of Texas and Louisiana, and east to Florida and the Carolinas, the pintail is a favorite of all lovers of waterfowl.

Pintails prefer the shallow water of marshes, flooded fields, and the low tidal flats of the Gulf Coast. All ducks are said to circle a marsh a couple of swings before landing, but pintails like to make about thirty swings before landing. They are among the first migrants to head south in the autumn, preferring the warm weather of the southern states, but toward spring they are the first ducks to fly north, braving ice and blizzards to arrive among the earliest in Canada and the arctic regions.

71. *Pintails*. 1983, stone lithograph

Pintails like to loaf about on land, their heads sometimes pulled down against their breasts or tucked along their backs.

70. *Breaking Away: Pintails*. 1982, oil on canvas

Four drakes and one hen jump off the water in vertical flight, leaping clear of the weeds. The two birds still on the water hold their heads up with necks outstretched, alert to danger and ready for instant flight.

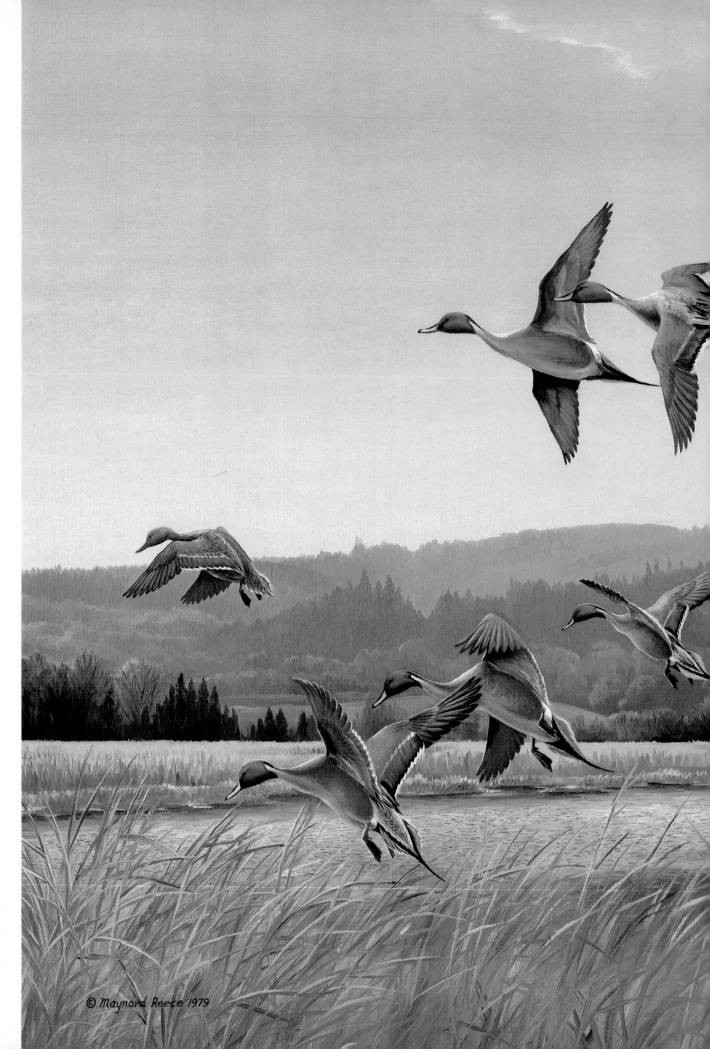

72. *The Valley: Pintails*. 1979, oil on canvas

Pintails are popular birds in the West and along the Gulf Coast. The low hills of this valley are the coastal hills of Oregon. Backlighting can be used effectively in depicting birds.

© Maynard Reece 1979

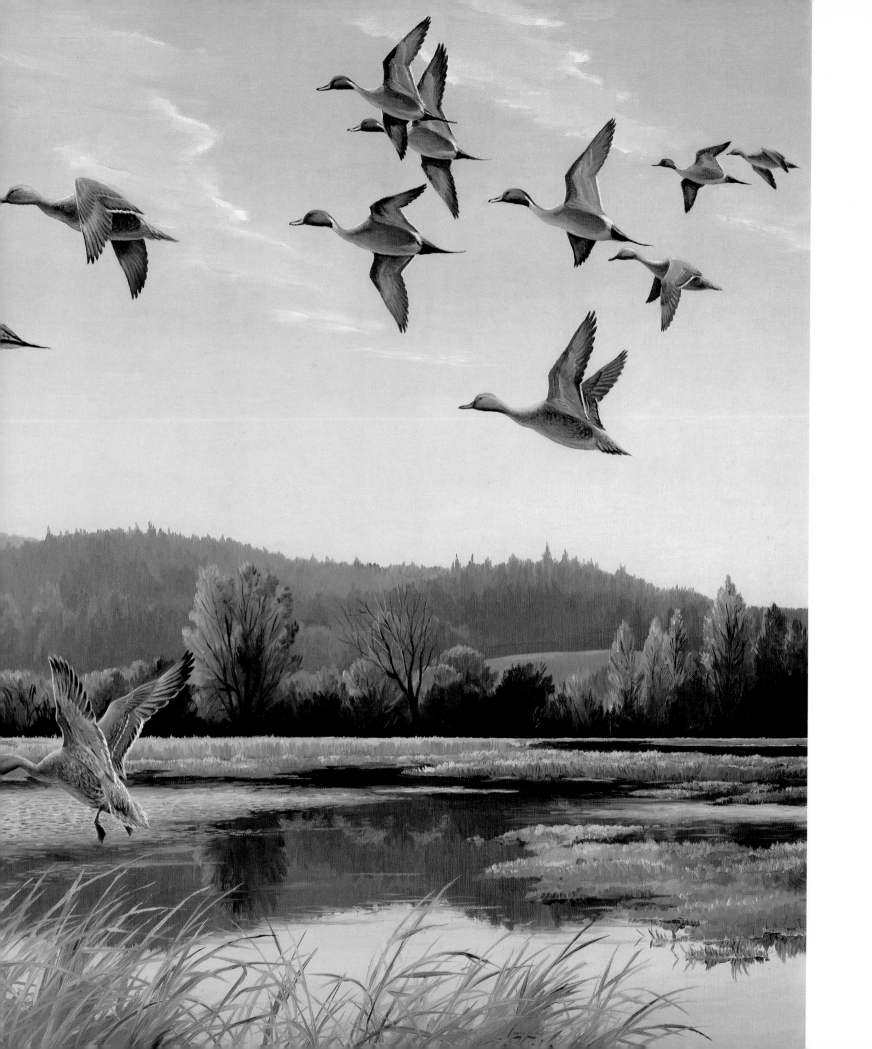

73. *Wood Ducks*. 1983, stone lithograph
Wood ducks can stretch their necks or pull their heads in against the body. When standing, they assume many different poses.

WOOD DUCKS

Wood duck drakes have colorful plumage: crested heads, white striping, hues of green, blue, and purple, a burgundy chest, white belly, and iridescence on the dark back and tail. Even the females are more colorful than most hen ducks. Wood ducks make a squealing call instead of a quack.

Wood ducks nest in the hollow cavities of trees, sometimes high above the ground and not necessarily near water. The hen can fly at full speed through the opening hole and stop instantly inside. As soon as the ducklings hatch, the mother calls to them from the ground below the nest cavity, and the young drop down to earth, bouncing like rubber balls. When all the ducklings are out, the hen starts walking toward water with all her young strung out behind in single file. She takes them there by the most direct route—sometimes right across a busy highway, stopping traffic to let motorists enjoy this unique family sight.

These ducks will land in trees as well as on water, flying from limb to limb like songbirds. When natural nests are unavailable, wood duck nesting boxes can be installed in the timber and the woodies will nest in them successfully. This has helped to increase the population of this favorite species.

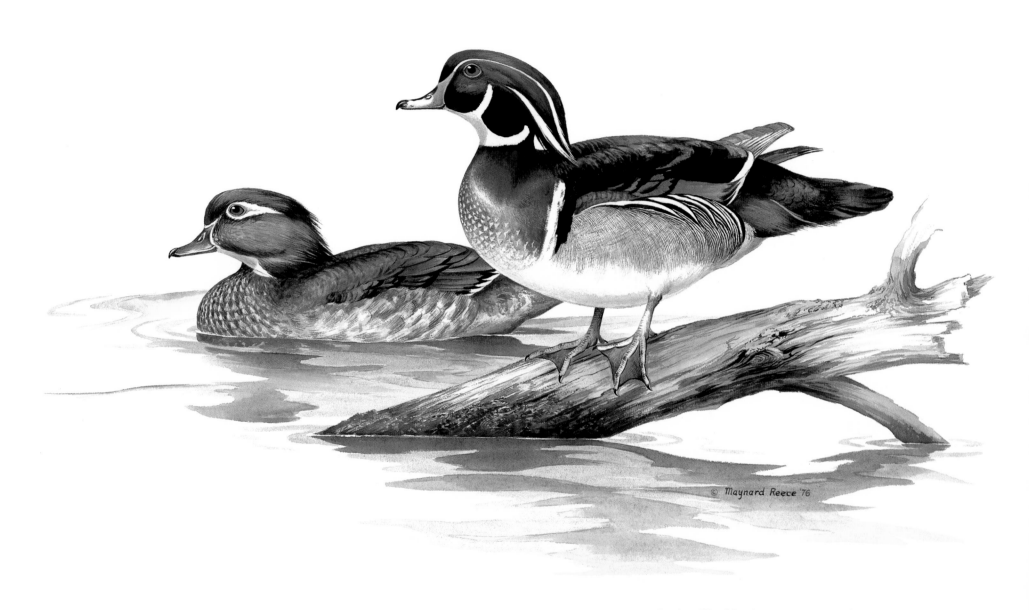

74. *Resting: Wood Ducks*. 1976, watercolor

The body build of wood ducks is noticeably different from that of other ducks. They are deeper-bodied, short-legged, long-tailed, and short-necked. Their plumage is the most colorful of all North American waterfowl.

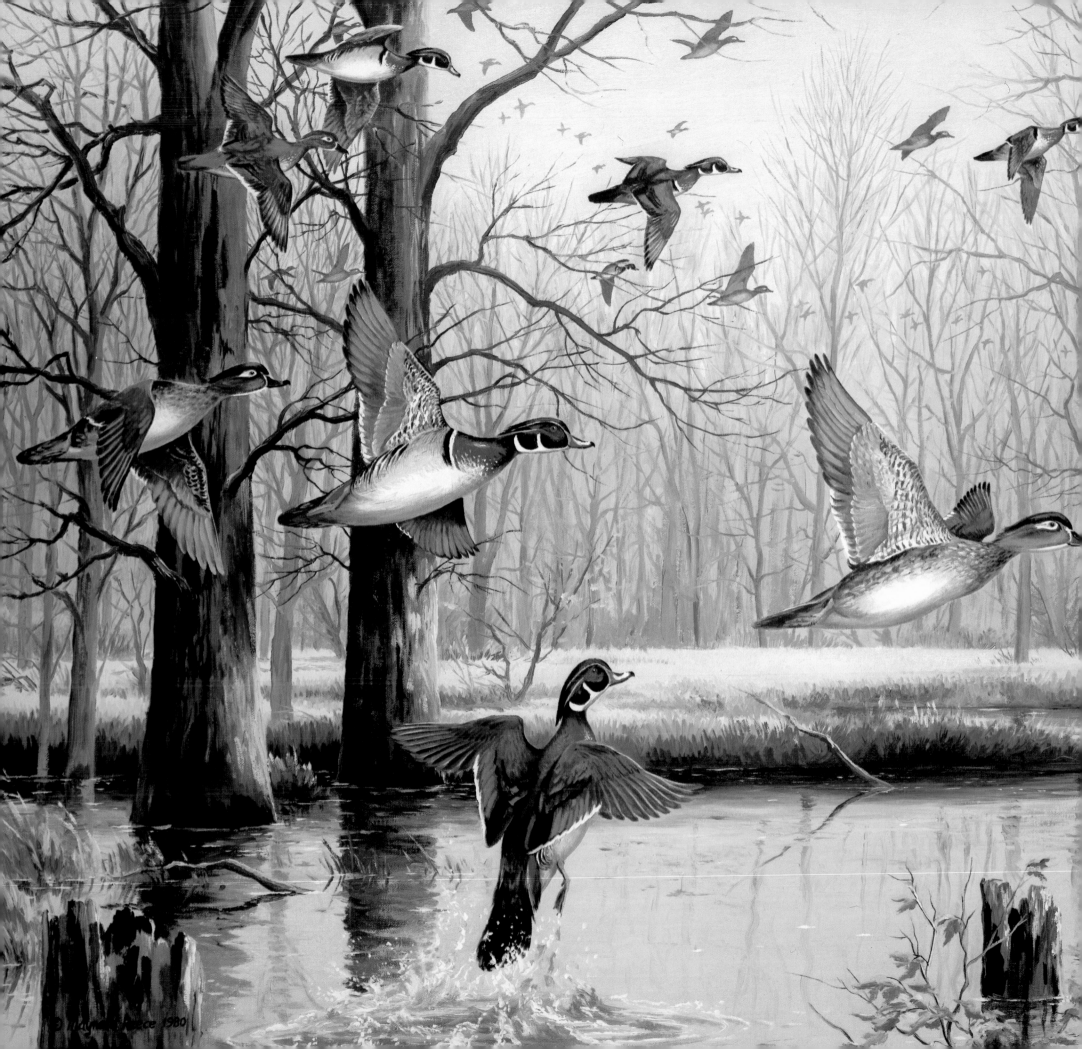

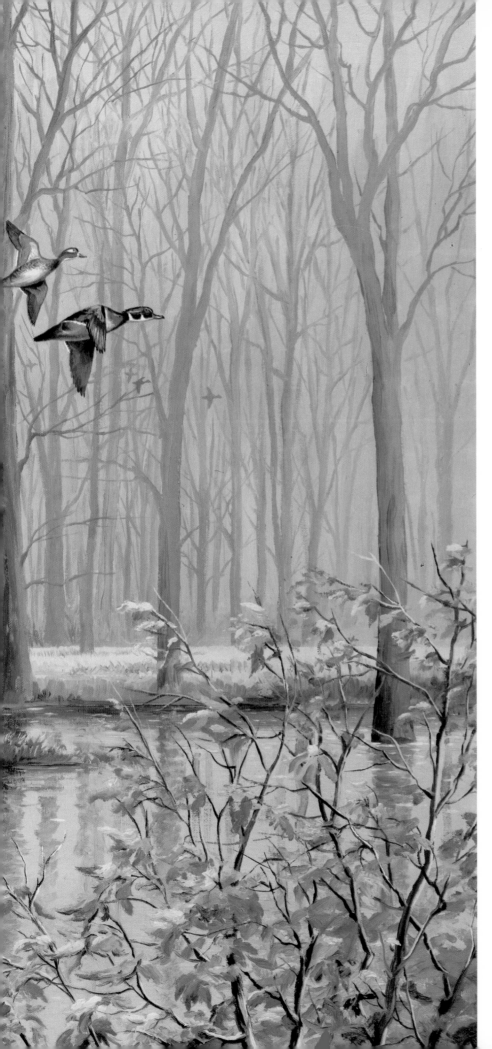

75. *Timber: Wood Ducks*. 1980, oil on canvas

Rarely you may surprise a large flock of wood ducks sitting in a secluded spot. They spring up with amazing ease and speed off through the trees with skill, darting and twisting without touching a twig. In seconds they have vanished, leaving only their ripples on the water.

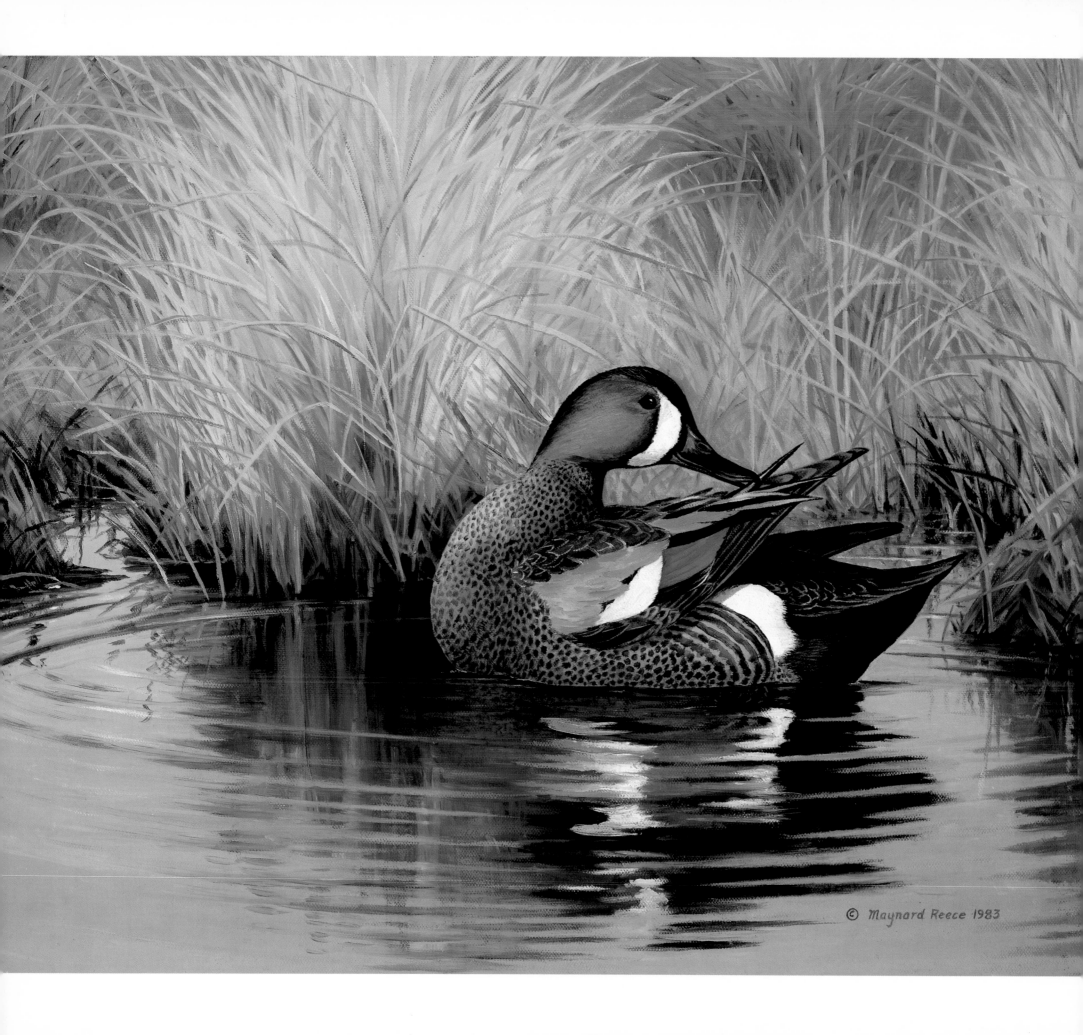

© Maynard Reece 1983

BLUE-WINGED TEAL

You imagine blue-wings to be friendly ducks, because you find them nesting in any small water hole, ditch, pond, or marsh in the Midwest, from Missouri north to Canada. These small ducks have a large blue patch on their wings that shows prominently in flight. The male's crescent-shaped, vertical white patch at the base of the bill is absent in his moulting plumage, and on immature drakes. The female shows the blue wing patch, but she is otherwise drab with streaks of brown and white.

Indeed, most female surface-feeding ducks have brown and white camouflage markings that blend perfectly with the grasses and reeds at the nesting sites, protecting the ducks and their nests against predators.

Except for the blue-wing's small size, it is similar in shape to the larger surface-feeding ducks. Its flight is more erratic with much swinging and dipping around the marsh before landing. Blue-wings are among the first to migrate south in the fall, leaving in August and September; though they do not migrate in flocks as large as the mallards', they build up sizable numbers in one area before moving on. Blue-winged teal nest farther south than most other ducks.

76. *Preening: Blue-winged Teal*. 1983, oil on canvas
Blue-winged teal are a familiar sight on small ponds and marshes in the spring. This drake is preening his feathers as he rests on the shallow edge of a marsh. When he migrates south in the fall he will have lost the crescent-shaped white patch on the side of his head.

GREEN-WINGED TEAL

Green-winged teal are our smallest waterfowl, and the drake is one of the handsomest. They have shorter necks and smaller bodies than the blue-winged teal. Green-wings are among our fastest fliers, though their small size accentuates their speed. Their flight is erratic, circling and wheeling about the marshes in small flocks.

These are hardy birds, quite able to withstand cold weather, and they migrate north early in the spring, during February. In the fall they linger along the flyways until winter snowstorms and frozen marshes drive them south. Their diet consists mostly of vegetable matter, and they are less fussy about their food than blue-winged or cinnamon teal. Green-wings are widely distributed throughout North America; they nest much farther north than other teal, reaching the arctic regions and northern Alaska, and they winter as far south as Central and South America. They migrate in larger flocks than do most other ducks and their longer flights are usually made at night.

A green-winged teal makes a nest out of long grass, weeds, and down from its own breast. The nest is on the ground, frequently quite a distance from water. Even when you see a hen leaving her nest, you will not easily find it hidden in the grass.

Green-winged teal are the miniature acrobats of the waterfowl kingdom.

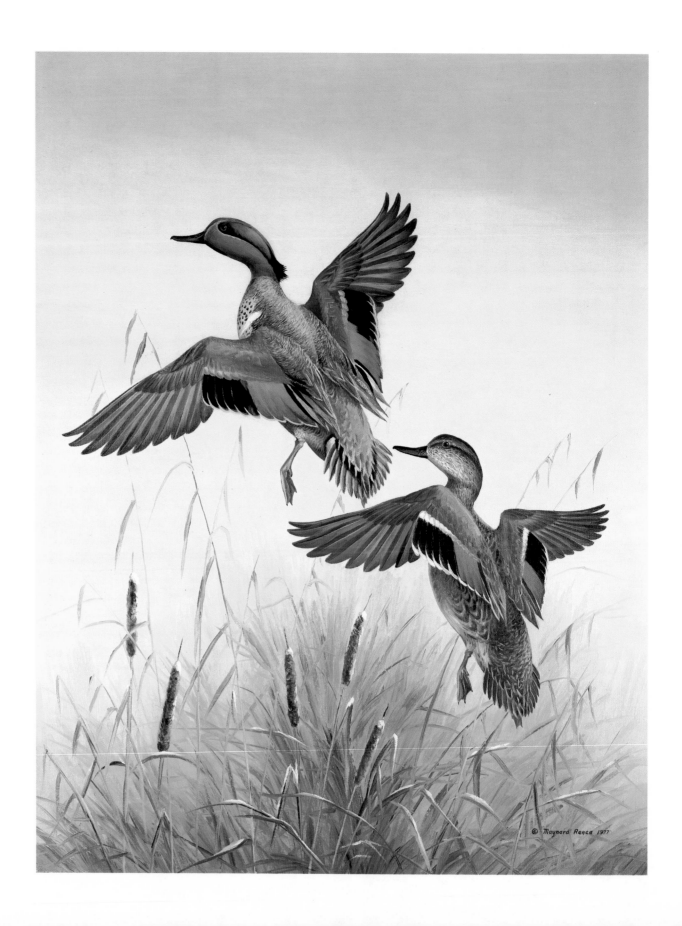

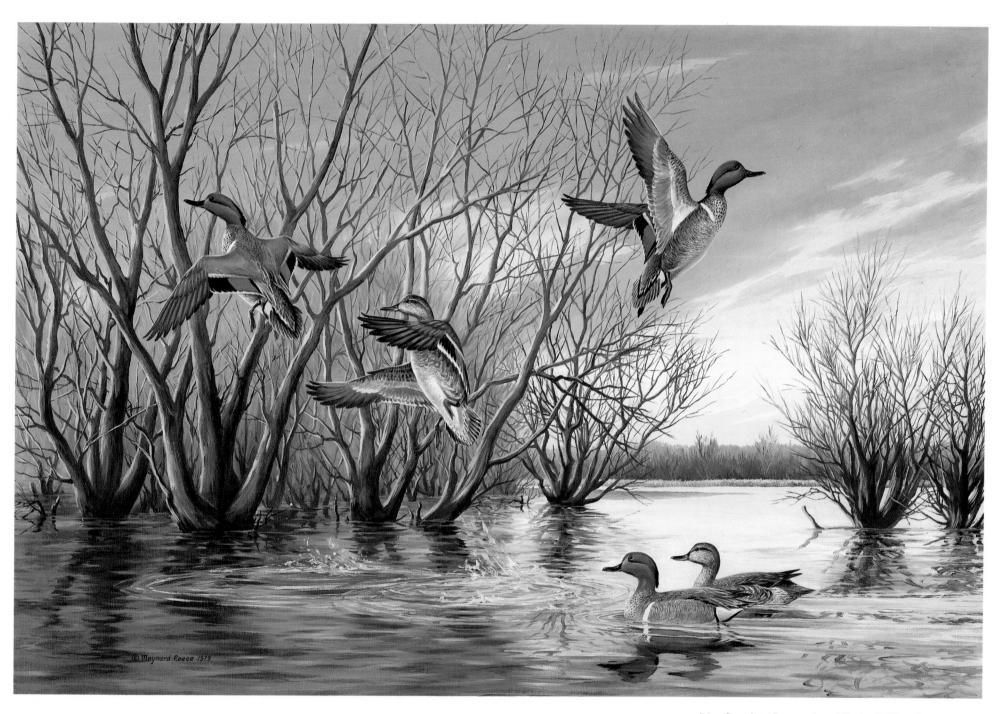

78. *Sunrise: Green-winged Teal.* 1979, oil on canvas

The first rays of sunlight sweep across the flooded flats, lighting the bare willows with a warm orange glow. As the sky reflects the early sun, the birds and the landscape pick up brighter colors.

77. *Jumping Green-wings: Green-winged Teal.* 1977, oil on canvas

A pair of green-winged teal erupt from a clump of cattails, climbing vertically through the early morning mist. With brilliant green flashing on the edge of their wings, the birds are aptly named.

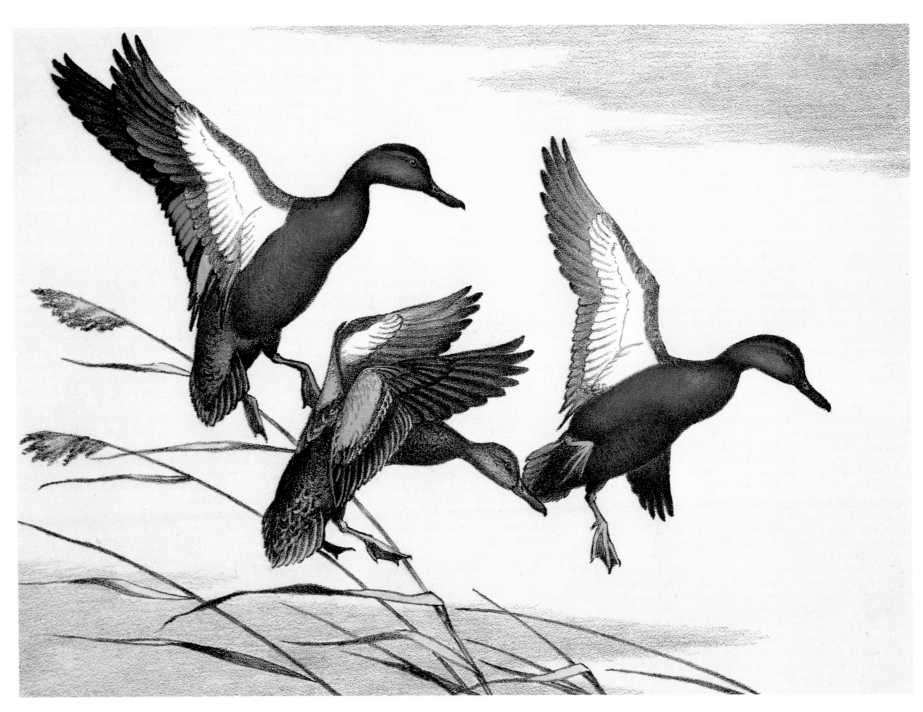

79. *Cinnamon Teal.* 1971 Federal Duck Stamp
Design, stone lithograph

1970 was the first year that the federal govern-
ment allowed contestants to submit designs in
color, so I selected the richly colored cinnamon
teal the following year. The lithograph was
colored by hand.

80. *Bear River Marshes.* 1983, pencil drawing

The Bear River Marshes in Utah offer some of
our best breeding areas. Over half the popula-
tion of cinnamon teal nest here.

CINNAMON TEAL

Cinnamon teal are found from the Missouri River west to the Pacific Coast. The drake is a colorful bird with a cinnamon-red body, red eyes, blue wing patches, and yellow feet and legs; the female is so like the female blue-winged teal that they cannot be told apart in the field. Both species are the same size and have the same flight patterns, but cinnamons generally fly in smaller flocks.

Nesting almost exclusively in the western United States, these teal spread only slightly north into western Canada. A large number of the breeding sites are in Utah, north of Great Salt Lake. Most of them winter in Mexico, a small number staying in California.

Cinnamon teal are tamer than the blue-wings and when frightened they only fly a short distance away. Like all ducks they have many natural enemies, their most dangerous one being the coyote.

© Maynard Reece 1985

AMERICAN WIGEON

The American wigeon is a medium-sized duck, about halfway between the mallard and the teal. The drake is one of our more colorful ducks with a broad white patch on the forewing and black and green on the trailing edge. The large white area on top of the head gave him the name "baldpate," a name still commonly used. The plumage of the wigeon has a pinkish tone; the bill and feet are blue-gray in color, and shorter than those of other surface-feeders of similar size. Wigeons ride high in the water and do a lot of bobbing of their heads like coots.

The wigeon grazes on land more than other ducks do. It enjoys alfalfa, wheat, and barley, and particularly lettuce and truck-garden crops, which gets this species into trouble with farmers. In the marshes it eats aquatic plants and seeds. It also likes the underwater roots and plants that it steals from diving ducks and swans after they have surfaced with food, a habit that has earned for the wigeon the name of "poacher."

Wigeons are among the early fall migrants, along with blue-wings and pintails, and they winter further south than most ducks—in the islands off Florida and down to Central America.

81. *American Wigeon.* 1944, pencil drawing
Wigeons ride higher in the water than most ducks and they do a lot of nodding of their heads.

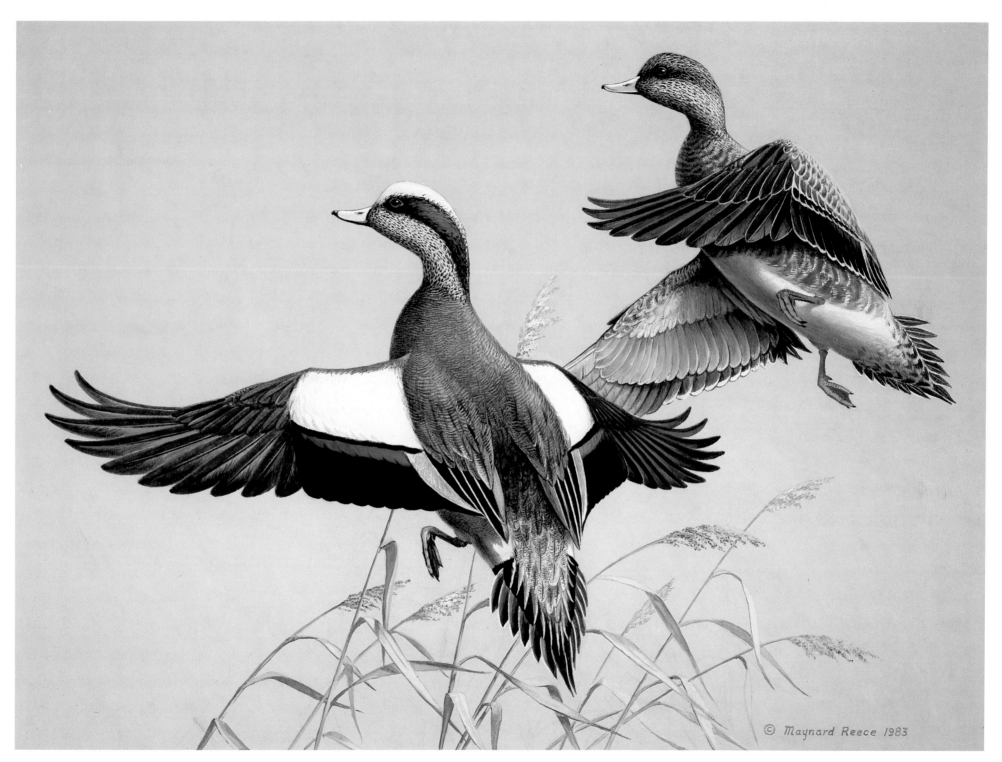

© Maynard Reece 1983

82. *American Wigeon.* 1983 Texas Duck Stamp
Design, watercolor

Wigeons are popular birds in the South and
they winter in abundance throughout this region.

83. *Shallow River: American Wigeon.* 1981, oil on canvas

The Platte River is shallow and meandering, with a fluctuating water level. Two birds are sitting on an old log washed down by the last rain. Below the log a muddy sandbar is building up, sculptured but impermanent, which will last until the next rush of water comes down the river.

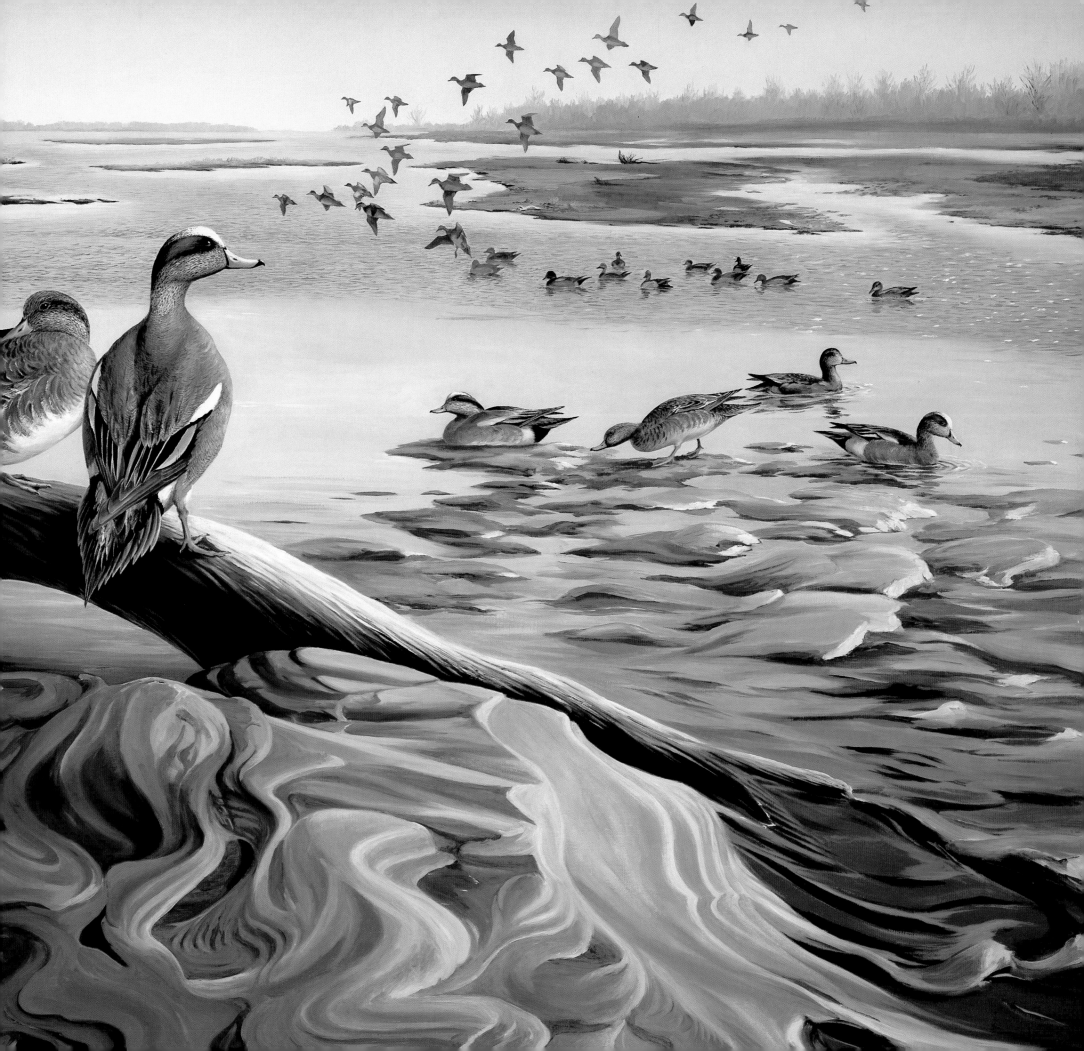

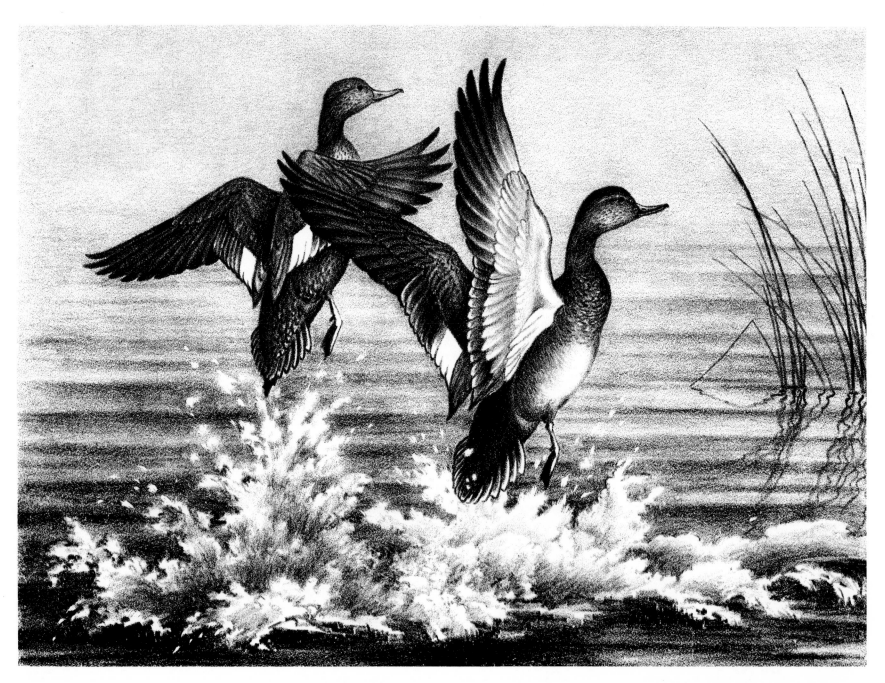

84. *Gadwalls*. 1951 Federal Duck Stamp
Design, stone lithograph

Gadwalls are surface-feeding ducks that
take off vertically with a great splash of
water. Both the male and female are
shown here.

GADWALLS

Gadwalls, sometimes called "gray ducks," are difficult to identify among similar species in the field. Your first experience with gadwalls was in the marsh country of southern North Dakota: settled down in a marsh and hidden by bulrushes, you were watching flocks of flying hen mallards when suddenly you saw a black rump and a white patch on the rear edge of the wing and you realized that these were gadwalls, not mallards. On comparison with mallards they were slimmer—and when a flock of pintails flew by, the pintails were slimmer still with longer necks. Then you compared them with the wigeons that were flying about, and the wigeons were slightly smaller still and their wingbeats were faster.

So finally you had them all sorted out: largest and slowest were the mallards, with the widest wings; next came the gadwalls, a bit slimmer; then the pintails, slimmer still and more streamlined; and last the wigeons, slightly smaller and with the fastest wingbeats.

Of course, at close range there are many differences among the drakes of these species and different wing-mark colors that help with identification, but you had to admit that it was confusing when they were all circling the marsh that day in early fall.

© Maynard Reece 1983

85. *Gadwalls*. 1983, watercolor
 Often called "gray ducks," gadwalls show quite a bit of color when seen up close. They are nearly as large as mallards.

NORTHERN SHOVELERS

Shovelers are often called "spoonbills"
because of their wide, spoonlike bills.
The bill is longer than the head
and the comblike teeth on
the sides of each mandible are more
developed than on any other duck.
The shoveler feeds by skimming
water and food into the spoon,
sorting and tasting it, and squirting
the rejected food and water out
through the teeth and back
part of the bill. Sometimes shovelers
spin around in circles to stir up
food particles by agitating the water,
or swim along in single file,
the ducks in back picking up morsels
stirred up by the feet of those ahead.
They do feed to some extent
in the mud on a shallow bottom,
but less than people suppose.

About one third of their diet
is animal matter such as fish, clams,
insects, and smaller zooplankton.

Apart from his oversized bill,
the drake shoveler is a handsome and
colorful duck, with its green head,
white breast, and chestnut sides,
and striped black and white feathers
along the back. The wings have
a gray-blue patch at the front and
a green patch at the back, like a
blue-winged teal. The mottled
brown females resemble the males
in summer, for the males get their
gaudy colors only in fall or later.

It is generally agreed that each hen
shoveler has two mates instead of the
usual one, but there is no squabbling
within these domestic triangles.

86. *Northern Shovelers*. 1983, oil on canvas

The drake's striking plumage is reflected
in the water. The color of the water was
chosen to compliment this handsome pair,
quietly swimming past a few of last year's
cattails.

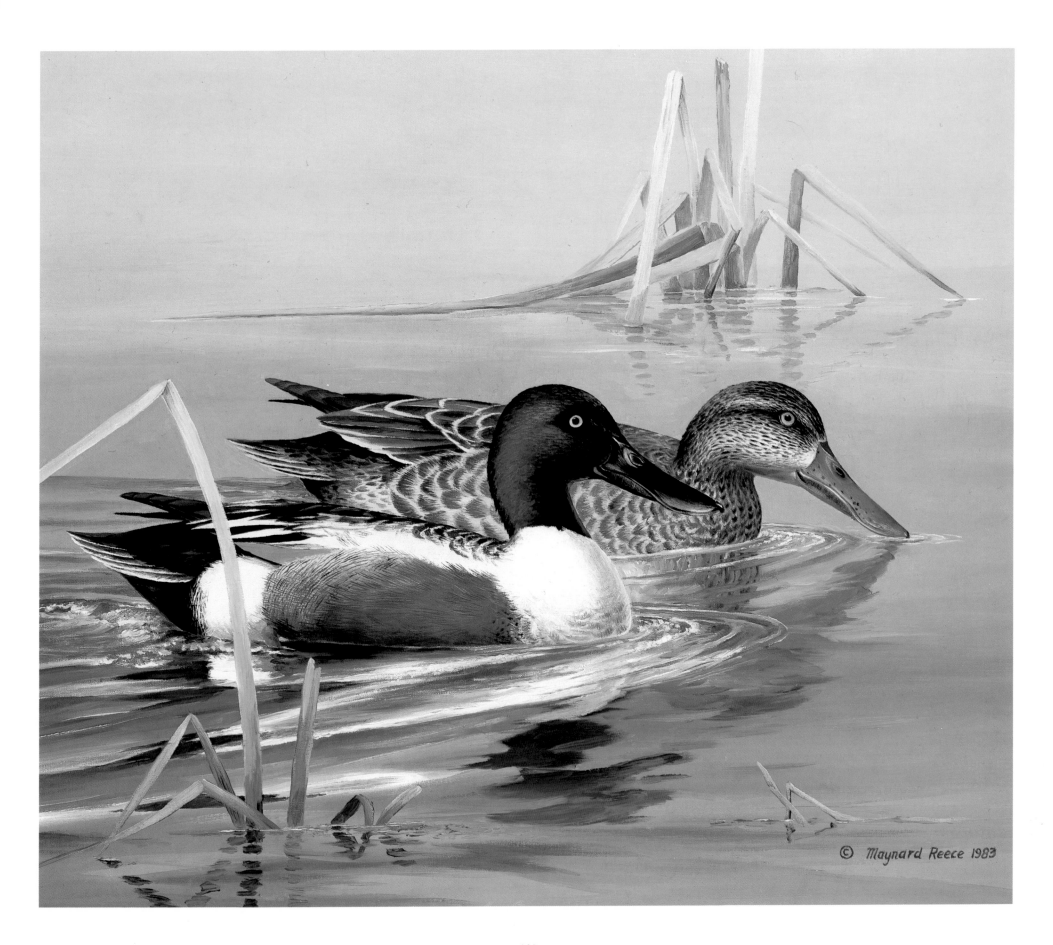

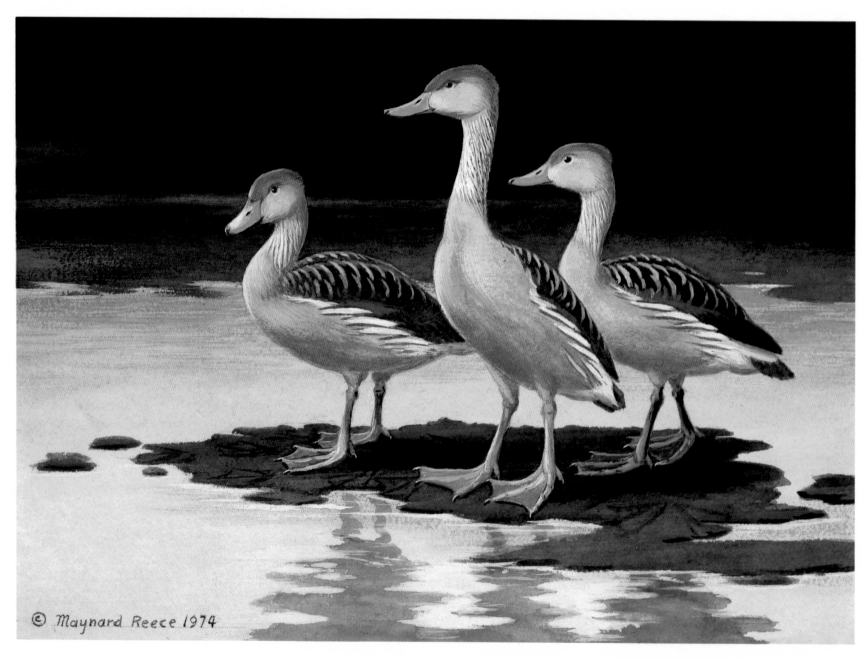

© Maynard Reece 1974

87. *Fulvous Whistling Ducks*. 1974, watercolor
When standing on land, these ducks look
almost like tawny geese. Their legs are
long, and they stand upright.

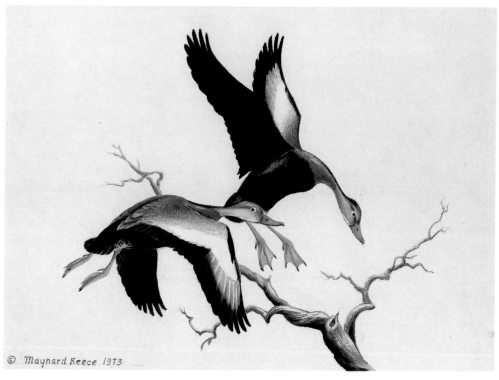

88. *Black-bellied Whistling Ducks.* 1973,
watercolor

With their rounded wings, long necks and
legs, and feet sticking out behind in flight,
it is easy to see why these birds are so
distinctive.

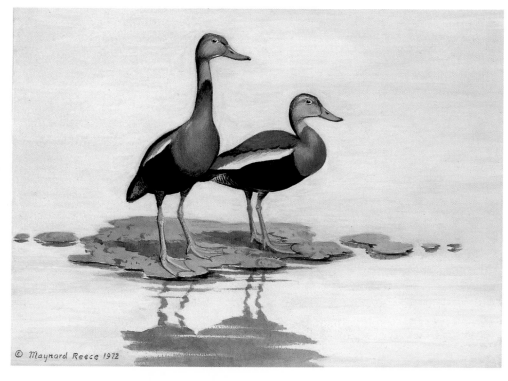

89. *Black-bellied Whistling Ducks.* 1972,
watercolor

All whistling ducks have an un-ducklike
stance—these are so upright they might
be herons.

WHISTLING DUCKS

North America has two species of
whistling ducks, the fulvous and
the black-bellied, both found far
in the South. The black-bellied
whistling duck largely inhabits
south Texas and Mexico; the
fulvous whistling duck is more
widespread throughout Texas,
Louisiana, and into Florida. The
fulvous whistling duck might well
be called the "wandering duck,"
as it shows up in spots all over the
United States, Canada, India,
Africa, South America, indeed
almost anywhere in the world.
These birds used to be called
"tree ducks," but ornithologists
have changed their name
to "whistling ducks."

Whistling ducks resemble
geese or herons, standing more
upright than other ducks. Their wings
are more rounded at the ends and
they have short, stumpy tails, with
long legs and feet that hang out
behind in flight. Fulvous ducks nest
in rice fields or heavy vegetation in
water; the black-bellied duck
prefers to nest in tree cavities or
in nesting boxes provided by man.

Though these birds have a
restricted range, don't be surprised
if you see one in your favorite
marsh some day.

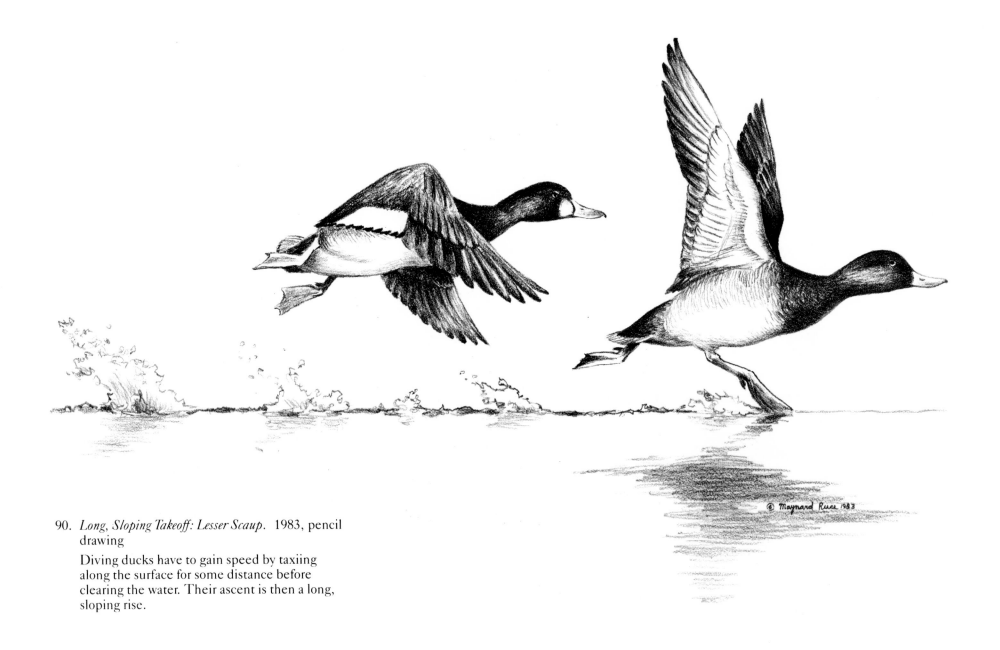

90. *Long, Sloping Takeoff: Lesser Scaup.* 1983, pencil drawing

Diving ducks have to gain speed by taxiing along the surface for some distance before clearing the water. Their ascent is then a long, sloping rise.

THE DUCKS: DIVERS

CHAPTER VII

THE DUCKS:

DIVERS

The diving ducks are quite different from the surface-feeders: they dive for food, sometimes far below the surface of the water, instead of tipping up on the surface. Divers are faster fliers, with wingbeats about twice as fast as dabblers'. Their flight is also more direct; they do not have the dabblers' ability to swerve, climb, and change direction. Divers land at a fast speed, skidding along the water for some distance, and in taking off they must taxi along the surface to pick up speed because their wings are shorter and less maneuverable. Divers can be compared to airplanes, surface-feeders to helicopters.

Diving ducks are found on large lakes, rivers, and oceans. They like to raft up in large flocks far out from shore. Their food includes more mollusks and fish; they do not feed on grain or food found on land, and do not even walk much on land because their legs are placed farther back on the body for more efficient diving and swimming; the large flaps or lobes on their hind toes aid the same purpose. Diving ducks are so adapted to their watery environment that the best divers have the most trouble in taking off and flying. Some of them, such as the mergansers, have specially shaped bills—narrow, toothed, and hooked at the end, the better for catching fish; eiders and scoters have heavy bills for crushing mollusks, but some species do not need powerful bills.

Besides feeding, diving ducks are constantly active in preening, a regular activity for ducks. All waterfowl use the bill to coat the outer feathers with oil from the oil gland located at the upper base of the tail; this is a duck's way of waterproofing the outer feathers so that he can float and also keep the down feathers underneath from getting wet. Preening not only enables the diving duck to swim, but produces a coating over the down that insulates him. The rest of his time is mostly spent in stretching his wings and legs and routing out parasites with his bill and feet.

It is estimated that about one half of the duck population dies each year, and half of this mortality comes from disease, predators, and accidents. The most common disease is botulism; other hazards are lead poisoning, oil pollution, malnutrition, and pesticides. With the oceans as part of their habitat, diving ducks are more vulnerable to floating oil spills: when oil sticks to their feathers it ruins the insulating and waterproofing function of the plumage, and the birds drown or die of cold. To counteract this heavy mortality, diving ducks lay a large clutch of eggs and, in the case of an early disaster, produce a second clutch as well, thus maintaining a strong population.

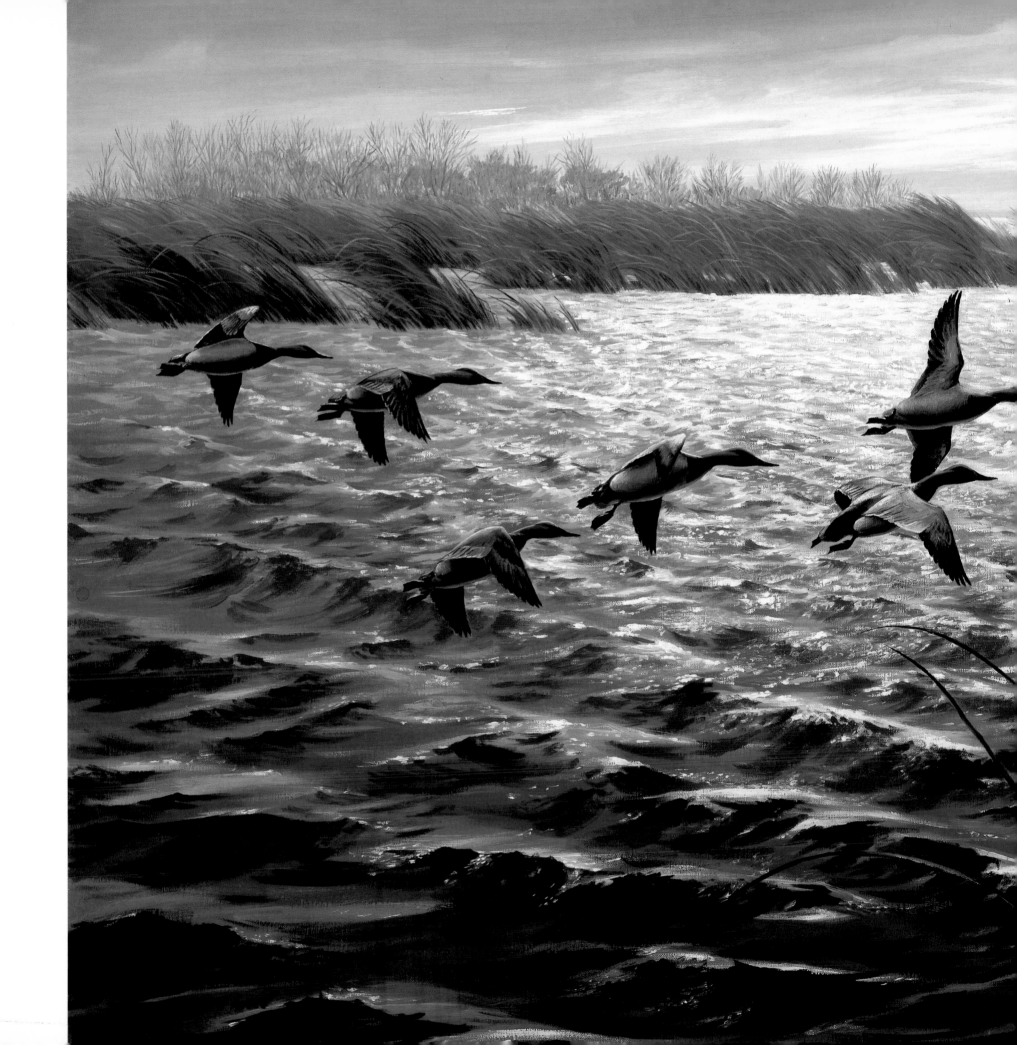

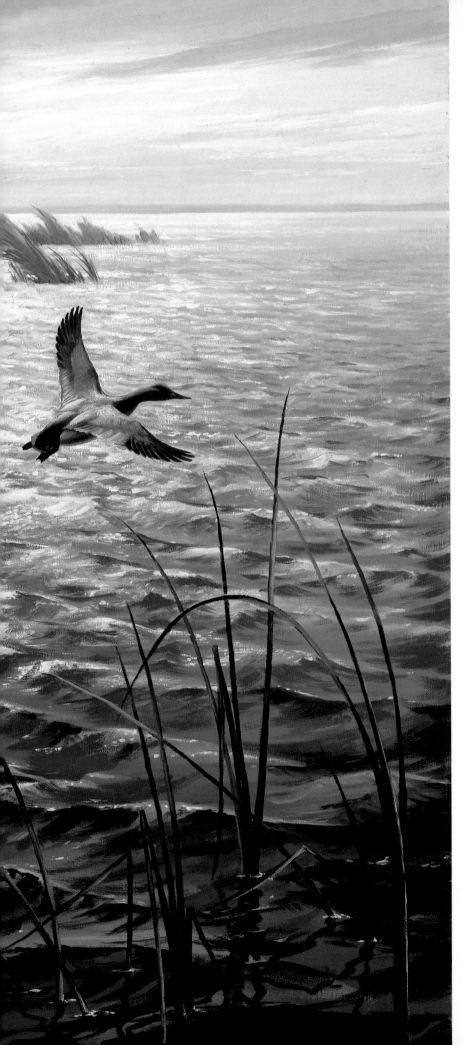

CANVASBACKS

The canvasback is probably our most beloved duck. In pioneer times it was a very common bird along the Atlantic Coast, but it is becoming more rare and the population is now in serious trouble. The problem comes to some extent from its inability to change its nesting habits if its chosen habitat becomes no longer suitable. The canvasback builds its nest with reeds in the water, but stable marshes having a constant water level are everywhere being drained, and it refuses to nest in any substitute area.

The canvasback is a chunky bird with powerful wings, as large as a mallard. It is a strong flier, as fast as any duck, and among the diving ducks its flight is the most direct: it drills through to its destination with no wheeling or turning. The head and neck are held parallel to the ground, the body pitched slightly up.

There is no mistaking the drake with his wedge-shaped bill and head, his neck nearly as thick as his head, and his contrasting color pattern of rust head and neck, black breast and tail, nearly white back, and white belly.

The name "canvasback" does not come from the canvas-colored look of the back, but from the nineteenth-century practice of shipping the ducks to the meat markets in sacks labeled "canvas back," a notation to return the canvas sack for a future shipment.

91. *Against the Wind: Canvasbacks.* 1972, oil on canvas

These canvasbacks are flying into the wind with powerful, swift wingbeats. Among the strongest fliers of all waterfowl, they bore through the air with no maneuvering or displays of tricky acrobatics.

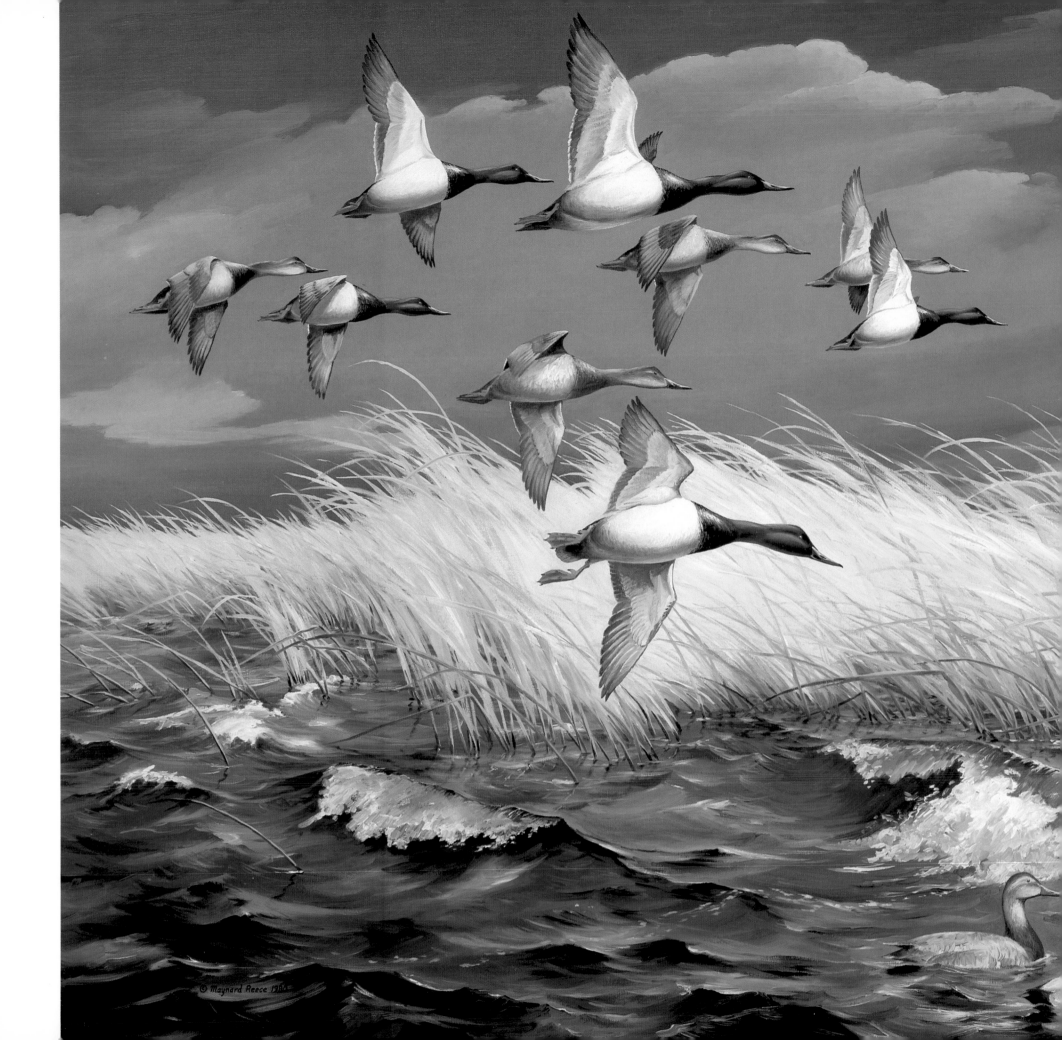
© Maynard Reece 1984

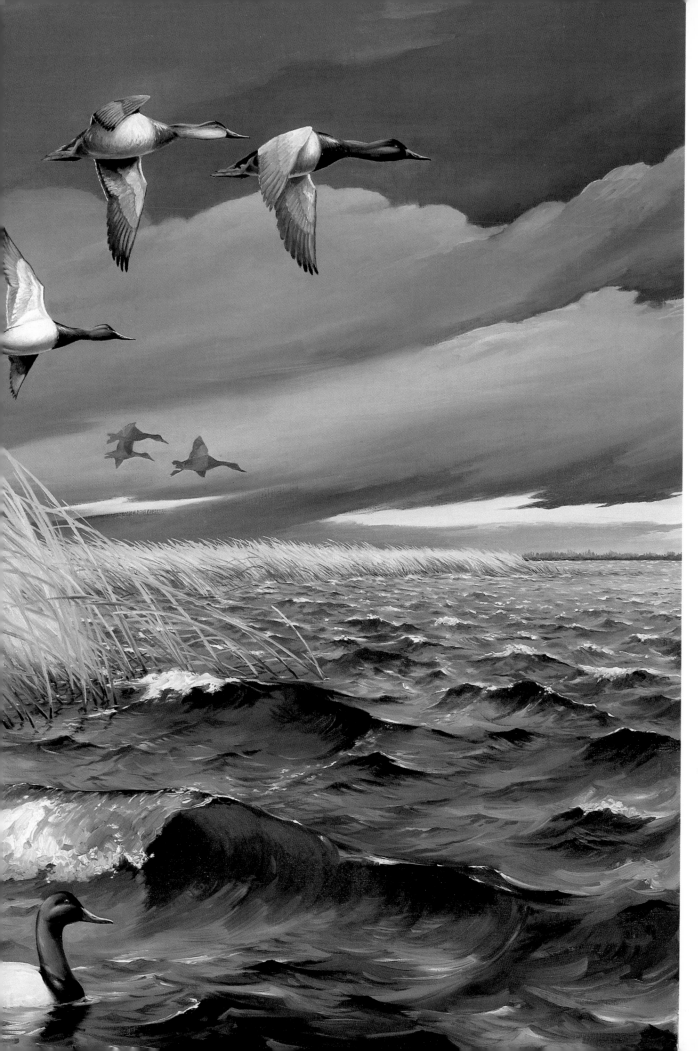

92. *Dark Sky: Canvasbacks*. 1980, oil on canvas

The colors of the canvasbacks' plumage stand out in strong contrast against the dark sky of an approaching storm. The warm glow still lighting the birds and weeds intensifies the dark gray of the clouds in the background. Two birds have landed in this rough water and are riding easily on the surface, bobbing over the waves like corks.

REDHEADS

The redhead might at first glance be mistaken for a canvasback, but the higher forehead and much darker gray back quickly identify the redhead drake. In flight redheads look more like scaups or ring-necks, but of larger size. Redheads are more plentiful than canvasbacks though their population level is still low.

Canvasbacks nest farther north than redheads do; redheads migrate only to the northern United States and up to central Canada. Redheads spend more time inland than the other divers, though a great number winter along the coasts of Texas and California and into much of Mexico; their food contains a higher percentage of vegetable matter.

Redheads migrate in large "V"-shaped flocks and approach a new area very cautiously, circling a lake many times before selecting a landing site. During the day they have a habit of often getting up from the water, as if they wanted a little more exercise.

On inland flights during their migration north in the spring, they often land on the small borrow pits or ponds bordering the interstate highways, pits which may still be partially covered with ice. They stay a few days and then move on north.

93. *Bill and Foot of Redhead*. 1982, watercolor
The colors of bill and feet are helpful in identifying waterfowl.

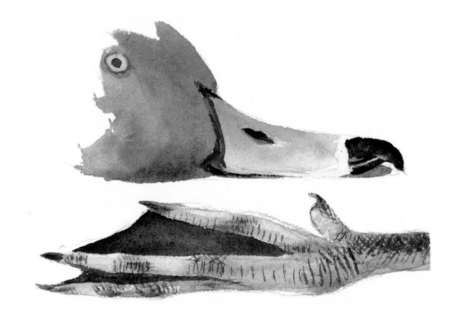

94. *Along the Shore: Redheads*. 1980, oil on canvas
These redheads are enjoying the challenge of their environment as they wing along the shore against a wind that whips the lake into foam. The foam slides over the waves in streaks and collects along the shore against the weeds, out of the wind.

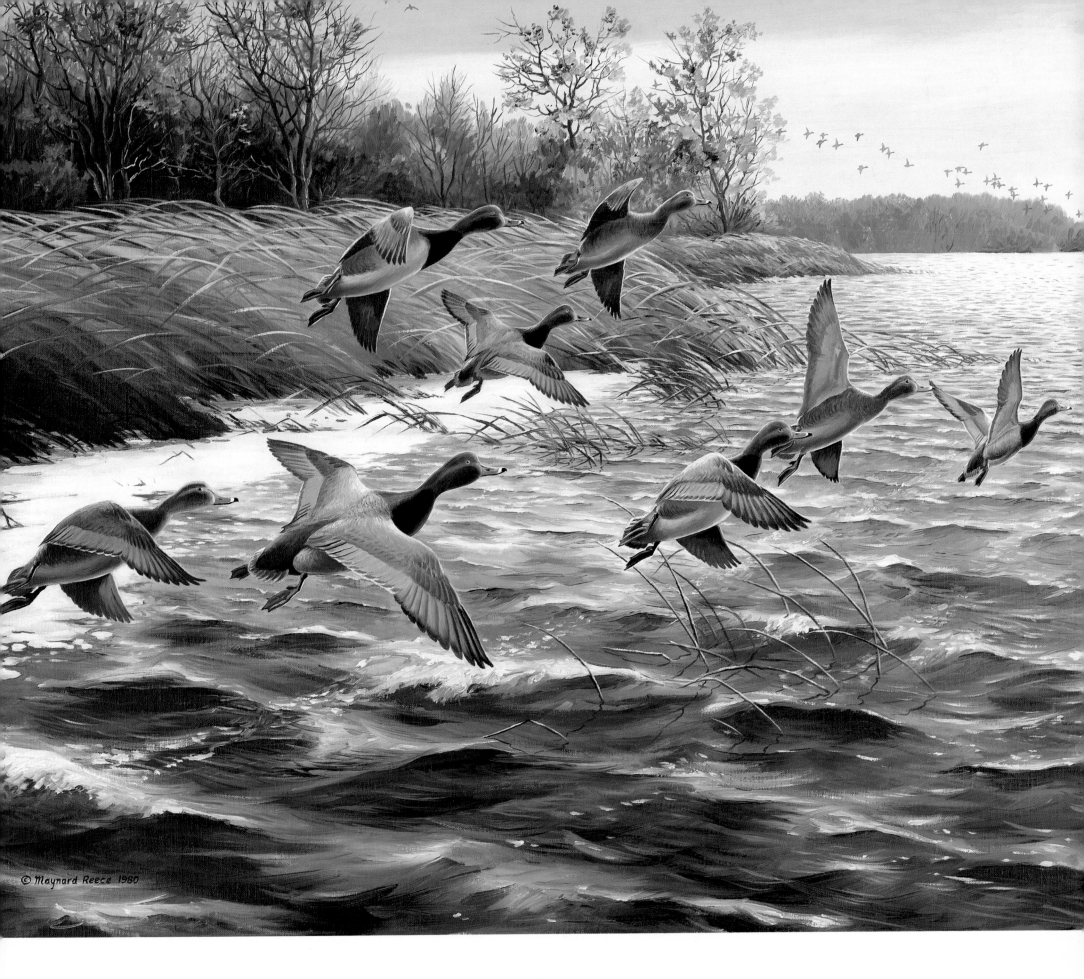

© Maynard Reece 1980

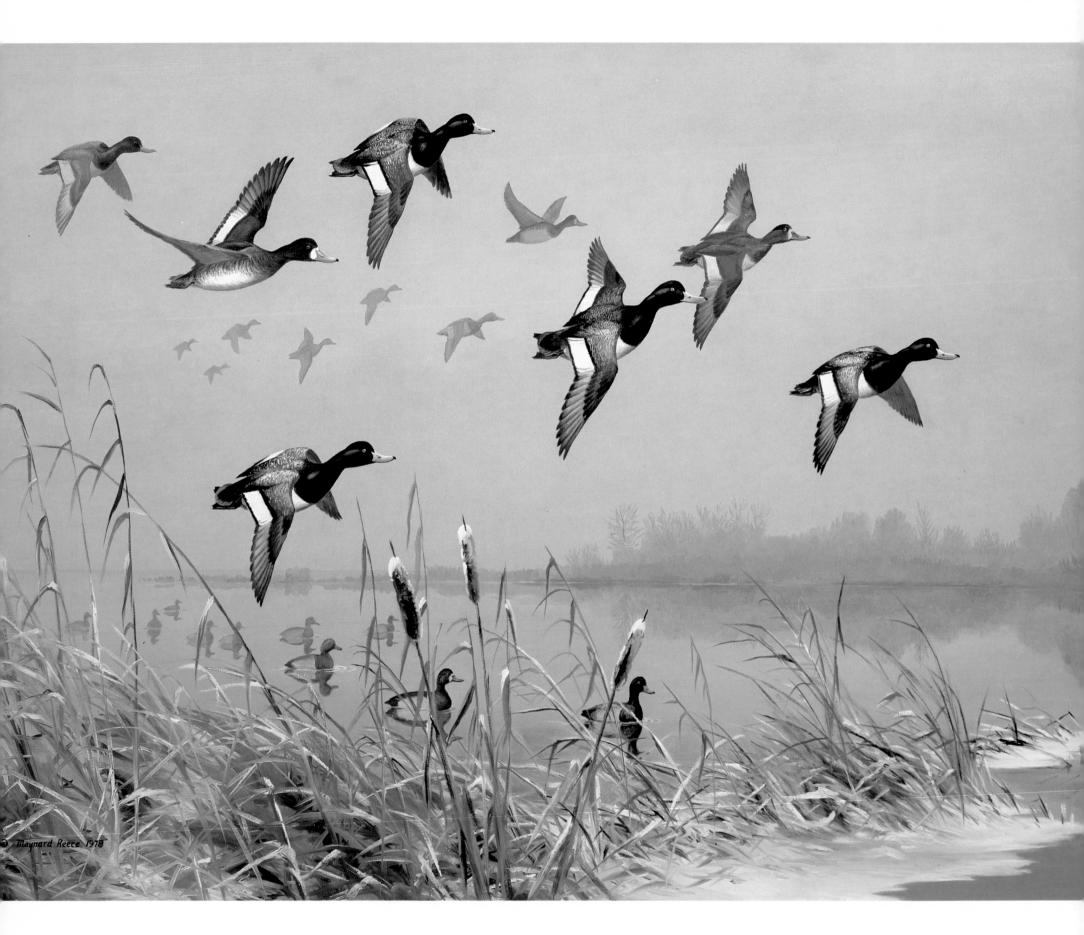

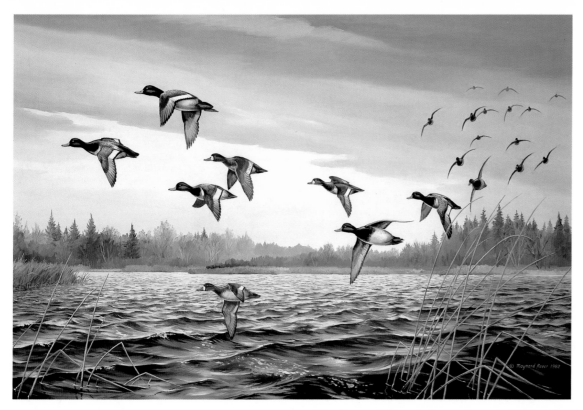

SCAUPS

There are two species of scaups, the greater and the lesser, both similar except for size and such variations as the greenish sheen on the head of the adult male greater scaup, and the purplish sheen on the lesser. But the main difference, occurring in both sexes, is in the white area on the rear edge of the wing; this runs out toward the tip on the greater scaup but stops abruptly on the lesser scaup.

The greater scaup remains mostly along our seacoasts, nesting in Alaska. The lesser scaup is found farther inland, wintering all across the southern United States.

Your fondest memories of "bluebills" (their common name because of their gray-blue bills) are from the Two Point Club in northern Minnesota, where a large lake filled with wild rice is the transit home of countless scaup migrating south. In the dark you waded out to a blind on one of the points, really only a strip of weeds running out into the lake in the middle of a flyway between large areas of water. As day breaks you crouch down, waiting for the flight; then from far down the lake dozens of round balls suspended on knife-edged wings come boring straight at you at tremendous speed. They are low over the water and suddenly they are right in front of you, but instead of flaring, they swish over you just above your head and speed away in the distance. That's bluebills.

96. *Passing Through: Lesser Scaups.* 1982, oil on canvas

The "bluebills" are coming toward you on the right like little jet planes. As they approach the shore, they make a slow curve and head out again across the water, speeding past you with a sound like the wind—or better, they "sizzle" past.

95. *Over the Point: Lesser Scaups.* 1978, oil on canvas

An early snowfall has settled on the weeds and shore of the lake during the night, and a heavy fog has formed with the morning. The black and white birds contrast with the grays and tans of the landscape.

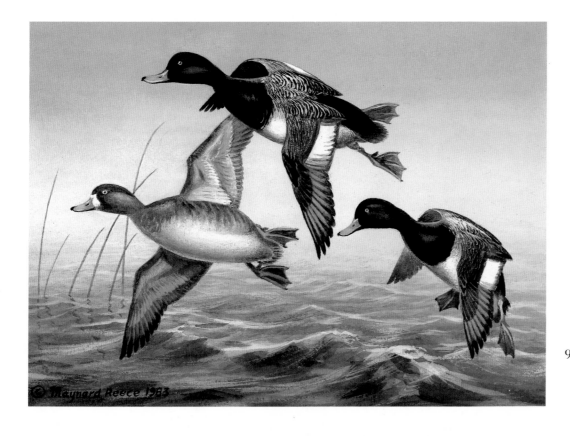

97. *Lesser Scaups.* 1983, watercolor

These birds are coming in for a landing, though at a higher speed than surface-feeding ducks.

RING-NECKED DUCKS

A ring-necked duck might better be called a "ring-billed" duck since the ring on the bill is much more prominent than that on the neck. In his full spring plumage the drake does have a dark brownish ring that blends into the black of his neck. The principal difference between the ring-neck drakes and scaup drakes are the ring-necks's black back and gray bar on the rear edge of the wing, and the scaup's gray or whitish back and white bar on the wing. The ring-necked hen looks like a redhead hen, but smaller. During the fall months, ring-necked ducks will be found with bluebills and redheads and frequently they fly and rest together.

Ring-necked ducks love wild rice, and in the fall they are found in large numbers on the Minnesota lakes where wild rice grows. From these lakes the birds filter down to Louisiana for the winter months; Florida and California also hold large concentrations of wintering ring-necked ducks. By February the birds start their long journey back to their nesting grounds in suitable marshes in the northern United States and Canada.

Ring-necked ducks are among the few diving ducks that regularly frequent flooded timber and shallow flooded areas. They like to feed in shallower water than do the other divers.

98. *Takeoff: Ring-necked Ducks*. 1968, oil on canvas

Drake and hen are pattering along the water as they pick up speed. Their wings do not have the lifting capacity to make a quick climb, but once airborne they are fast fliers.

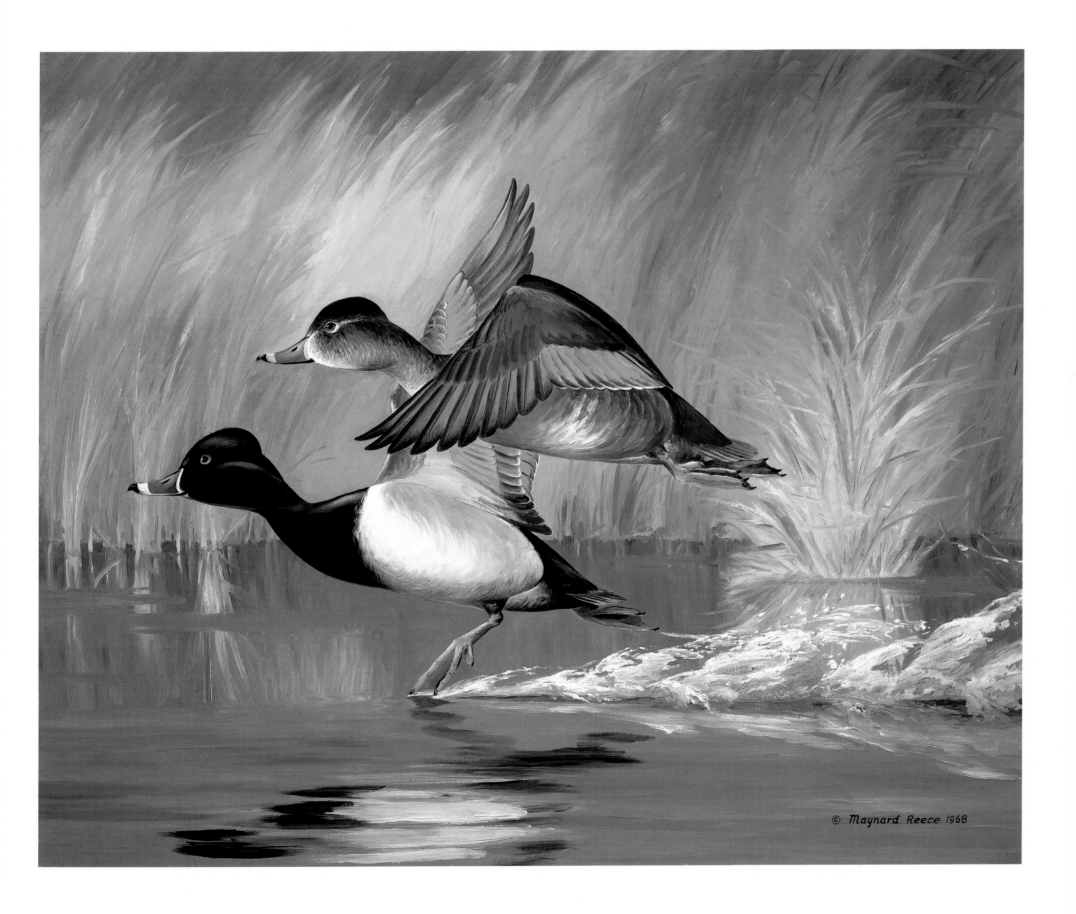

© Maynard Reece 1968

153

GOLDENEYES

Two species of goldeneyes are found in this country: the common goldeneye and the Barrow's goldeneye.

You don't have to see goldeneyes to identify them. Even hidden in a heavy fog the familiar whistling of their wings—"whee-whee-whee"— in direct cadence with the wingbeat tells you that goldeneyes are passing overhead.

Goldeneyes are large ducks and prefer the larger lakes and rivers, and the seacoasts. In flight it is almost impossible to tell the two species apart, but at close range the white spot behind the bill of the common goldeneye has an oval shape, while that of the Barrow's goldeneye is crescent-shaped; the common's head has a green sheen, the Barrow's is purplish. The males of both species are basically black and white, the females brown and white. Goldeneyes nest in the cavities of trees, but they will also nest in wooden boxes put up for their use.

The range of the Barrow's goldeneye is quite similar to the harlequin duck's, up the rivers and mountain streams of the western United States and Canada. Along the East Coast there is a group which is thought to nest in Labrador.

Goldeneyes tolerate cold weather and are at home around ice and snow. They migrate early in the spring and remain as far north in the winter as open water can still be found.

99. *Barrow's Goldeneyes in Flight.* 1978, watercolor

The western mountains hold a sizable population of Barrow's goldeneyes during spring and summer. When winter comes, they head for the seacoast.

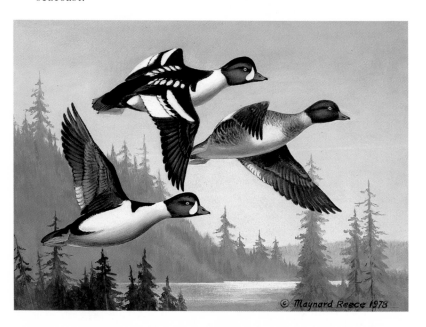

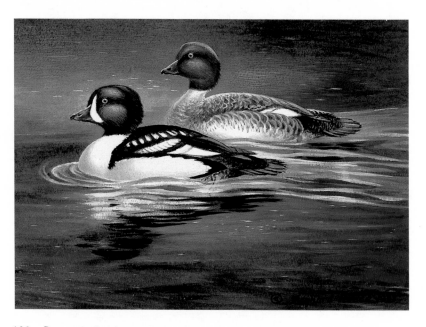

100. *Barrow's Goldeneyes Swimming.* 1977, watercolor

Goldeneyes enjoy mountain streams and rivers. Notice the large white spot behind the bill of the drake, its crescent shape a key to separating this species from the common goldeneye with its round spot.

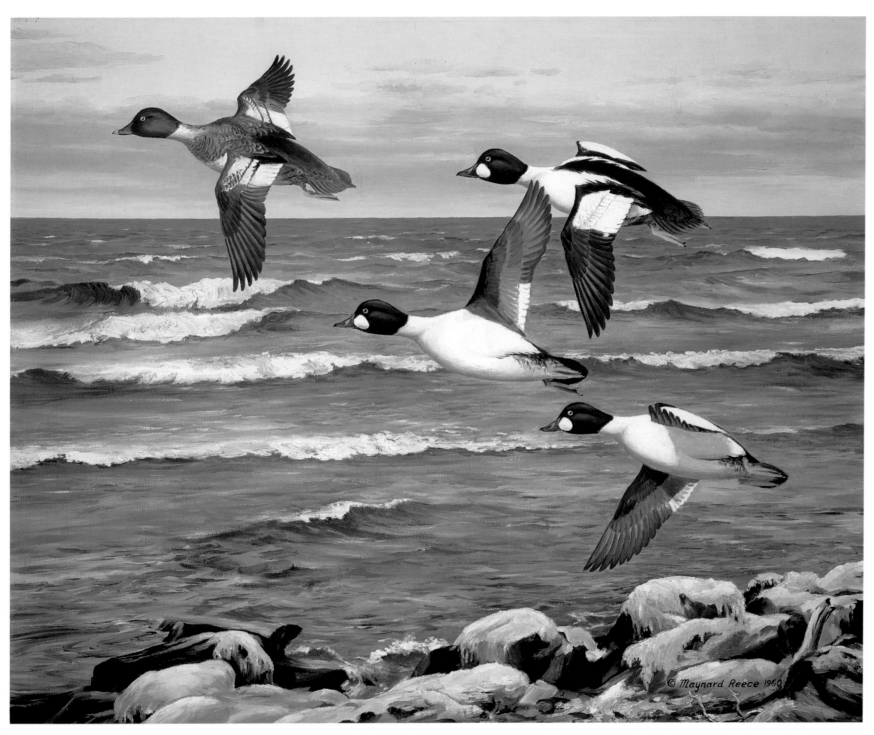

101. *Common Goldeneyes*. 1960, oil on canvas

Goldeneyes like to stay near large bodies of water. This scene on Lake Superior shows common goldeneyes flying along a shore where the waves are freezing on the rocks. As the water splashes, the spray forms a hard coating of ice over the boulders.

102. *Buffleheads*. 1948 Federal Duck Stamp Design,
 watercolor

 The original design was done in black-and-
 white; later this watercolor was made of it.

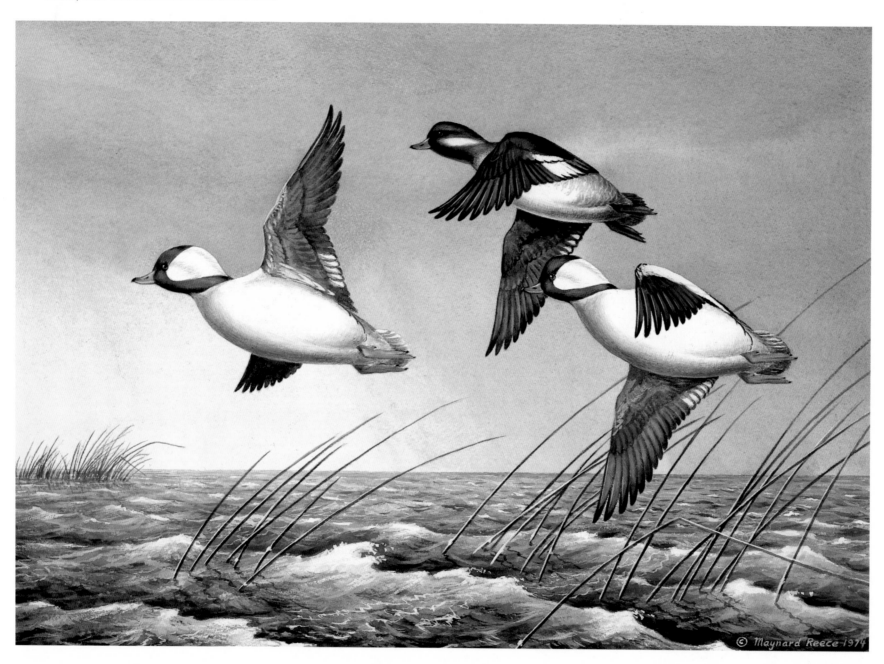

BUFFLEHEADS

103. *Buffleheads*. 1983, watercolor

Buffleheads are black and white birds, the drake having a beautiful iridescence of purple, blue, and green in the black of his head. The large, white head patch gives him a perky look.

If a diving duck could be called a jewel, the tiny drake bufflehead would be the choice. It is nearly as small as the striking green-winged teal. When buffleheads are bouncing around on blue waves on a clear, sunny day they look like diamonds set in platinum. You can see them for a great distance in spite of their size because they ride high in the water and are pure white except for their backs and half of their heads.

Buffleheads are speedy fliers with a fast wingbeat, and give the illusion of little jets zooming across a lake. In shape and coloring they most resemble goldeneyes, but they are much smaller.

Buffleheads nest in trees in small cavities, generally in holes made by flickers. If the holes are large, the goldeneye will give them severe competition for these nesting cavities. The buffleheads' favorite tree is the aspen, but they will accept other varieties that offer suitable holes; if possible they choose nests within two hundred yards of water.

These birds nest primarily in central and western Canada, but they winter on both coasts and all across the southern United States and into Mexico.

OLDSQUAWS

Oldsquaws have long, pointed tails like pintails, but not the pintail's long neck. They are trim little birds, among the handsomest of our waterfowl. Noisy and chatty, they make a low musical call that is more like a gutteral song than the usual quack, and their scientific name, *Clangula hyemalis*, means "noisy winter duck."

These birds indeed spend most of their time under winter conditions, nesting in the upper arctic regions and wintering down both coasts and in heavy concentrations on the Great Lakes.

The total population of the species remains rather stable, though the Eskimos eat oldsquaw eggs when they can find them and several predators take their toll —foxes and the jaegers are adept at locating nests. The nests are beautifully constructed and lined with plenty of down; the eggs are olive brown, generally six or seven in number.

Oldsquaws have marvelous diving abilities, the best of all the ducks. They have been caught in nets 150 feet deep, and many are found at the 80-foot level. Their bodies and feathers are tight and compact, able to withstand the severe water pressure at such depths.

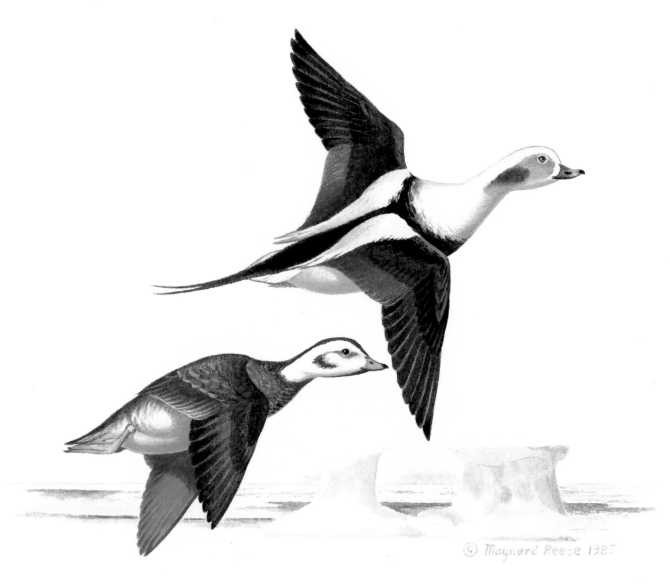

104. *Oldsquaws.* 1983, watercolor

This pair in flight shows the drake's pintail and striking colors. The drab tones of the hen give her protection while nesting. In the background, icebergs from an Arctic icepack.

HARLEQUIN DUCKS

The harlequin duck has two ranges: the eastern population stretches from Iceland and Greenland down to New Jersey; the western population nests in Alaska and the arctic regions and winters from along the Aleutian Islands down to California. During the winter harlequins stay along the rocky shores of seacoasts, either climbing around on the rocks or riding the waves and surf in the ocean. During the spring they move up the rivers and streams to nest in mountainous areas.

Harlequins can dive and swim underwater in the swiftest rapids and currents, and they even walk underwater on a river bottom against a heavy current like water ouzels. When they dive below the surface they propel themselves through the water by using their feet and wings. Harlequins will dive into water from full flight, and they can spring up into flight from beneath the water without pausing on the surface. These slate-blue ducks with their chestnut sides and patches of white are among our most colorful waterfowl, and it is fascinating to watch them as they feed in a mountain stream.

Harlequins are abundant, but few people see them because they frequent such remote areas. It is estimated that nearly one million harlequins spend the winter in the Aleutian Islands.

105. *Harlequin Ducks*. 1983, watercolor

Two drakes and a hen swimming, to show the bizarre markings of the drake birds. White spots and slashes appear in precise places on the plumage, and the combination of vivid colors is unusual.

© Maynard Reece 1983

SCOTERS

Scoters have three species: the black scoter, the surf scoter, and the white-winged scoter. The black scoter is just that—the males all black, the females black-brown in color. In fact all scoters are basically black; the white-winged scoter in flight shows some white on the wings, and the surf scoter has white head patches. The scoters' predominantly dark color has led to their being commonly called "coots" or "sea coots." Most scoters stay along our seacoasts, but white-winged scoters have been seen in central parts of the United States.

Within the world of waterfowl, scoters have been the least studied and their habits can still pose questions to us. The black scoter, for instance, nests in Alaska, but during the winter there is a sizable population along the Atlantic Coast: did these birds make the 5,000-mile trip from Alaska? or did they nest somewhere nearer in Canada? No one knows for sure.

You will always remember the day you saw large flocks of surf scoters on Knight Inlet, opposite the northern tip of Vancouver Island. The water was emerald green from the runoff of nearby glaciers and the sun was shining, giving a sparkle to the water. Swooping low across the water came wave after wave of surf scoters, jet black and in precise formation not three feet above the surface, like silhouettes against the bright green. It was a startling sight: you could see their orange-red bills and feet and the white patches on their heads with perfect clarity.

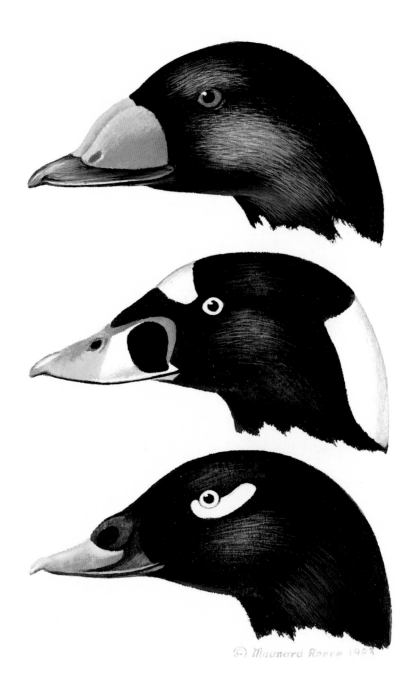

106. *Scoter Heads.* 1983, watercolor sketch

Head studies of the three species of scoter drakes, showing the differences that occur only in the spring. From top to bottom: black scoter, surf scoter, white-winged scoter.

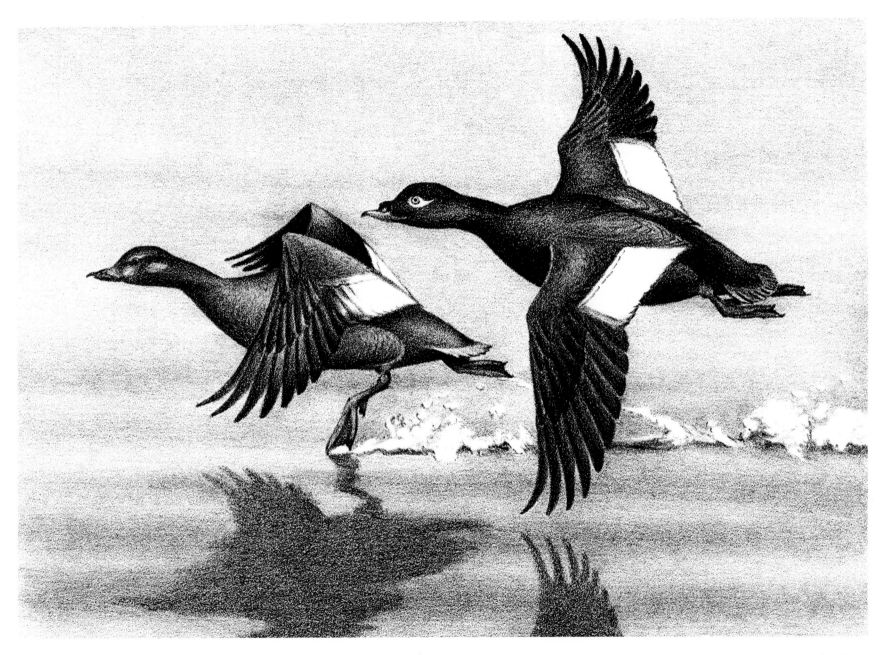

107. *White-winged Scoters.* 1969 Federal Duck Stamp Design, stone lithograph

Except for the heads of the drakes, the only white area on a scoter is the wing patch on white-winged scoters, both male and female.

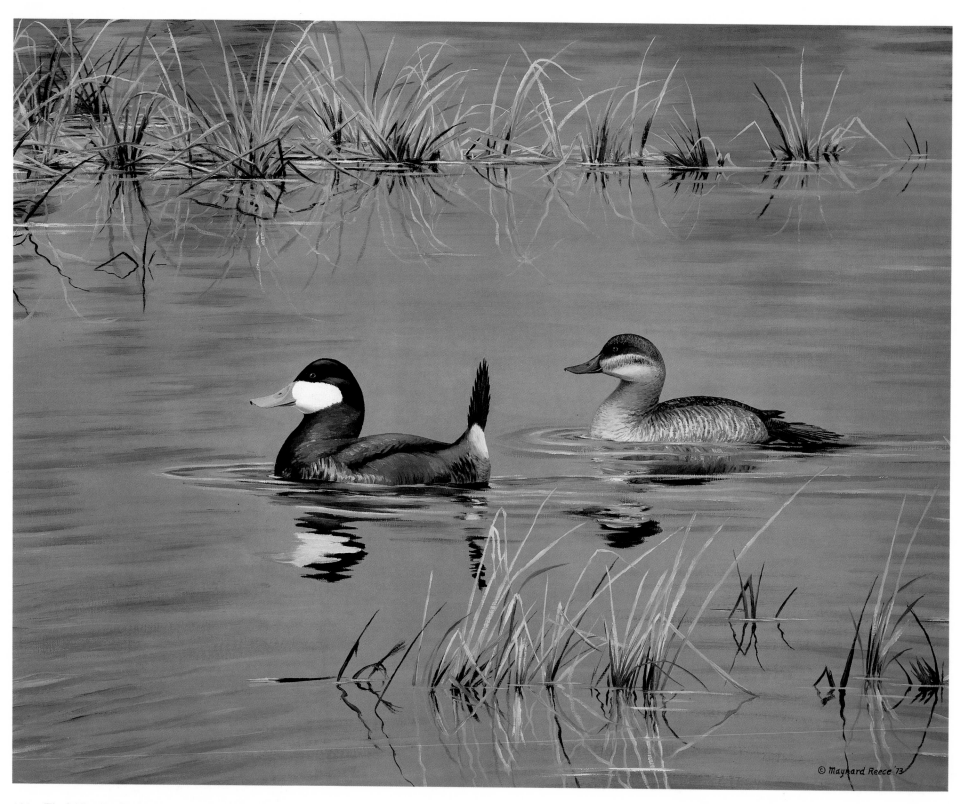

108. *The Stiff-tails: Ruddy Ducks*. 1973, oil on canvas

Two ruddy ducks have finally paired up after
much courtship display by the male, whose
stout neck sometimes gives him the name
"bullneck."

RUDDY DUCKS

Ruddy ducks belong to the group of stiff-tailed ducks, the other species being the masked duck that is rarely seen in the United States but generally found from Mexico south to Argentina.

In the spring the male ruddy duck looks as if he had stuck his bill into a can of light blue paint. He is a comical little fellow who prefers to dive away from danger like a grebe instead of flying. In the fall the males take on the female coloration, brown and drab.

In their nesting grounds in southern Canada you were sitting on the bank of a water strip about ten feet wide, and along came a drake ruddy duck that had decided to break the world's record for a duck while swimming past you. Throwing out such a wake and pushing the water so high in front of him that only his head, neck, and tail could be seen, he steamed straight ahead like a fast-moving little tugboat. When he thought he was out of danger he slowed down, his body popping up from the water, and he resumed his normal swimming pace at about half speed.

Whenever ruddy ducks fly, which they seldom do apart from migration, they stay low over the water, their short wings beating furiously to keep them airborne. They fly fairly fast and look as if they were all body because their necks are so short and heavy.

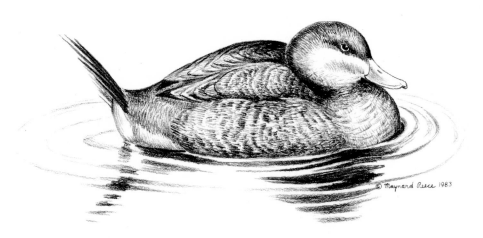

109. *Ruddy Duck*. 1983, pencil sketch

A study of a ruddy duck, showing how compact and small he seems when quietly swimming on the water.

MERGANSERS

There are three species of mergansers in our hemisphere: the hooded merganser, common merganser, and red-breasted merganser. All three have long, narrow, serrated or toothed bills, with hooks on the ends that quickly distinguish these species. So equipped, mergansers eat more fish than do other groups of ducks.

The hooded merganser, smallest of the three and about the size of a wood duck, prefers flooded timber, streams, rivers, and swampy ponds. It is a beautiful black and white duck with golden chestnut sides. Hooded mergansers nest in tree cavities and will also use the houses provided for wood ducks. Since they are more elusive by nature, they stay in the deepest swamps and wooded areas.

Common mergansers are among the largest ducks. Except for their red bill and feet, the males are black and white and the females brown and white. Common mergansers also prefer to nest in cavities of trees, but if they cannot find one they will nest on rocks, in deserted houses, on docks, or any place they like. Their food is largely fish, and they show a preference for freshwater over saltwater areas.

Red-breasted mergansers are basically seacoast ducks, wintering along our ocean shores rather than in the interior United States with the common mergansers. The red-breasted merganser nests on the ground.

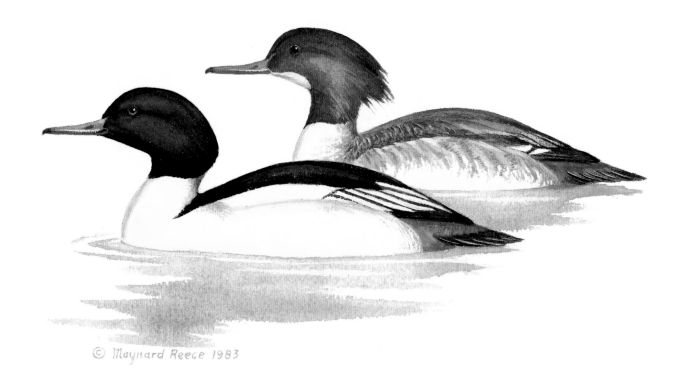

© Maynard Reece 1983

110. *Common Mergansers*. 1983, watercolor
This pair shows their black, white, and gray coloration, accented by a bright red bill.

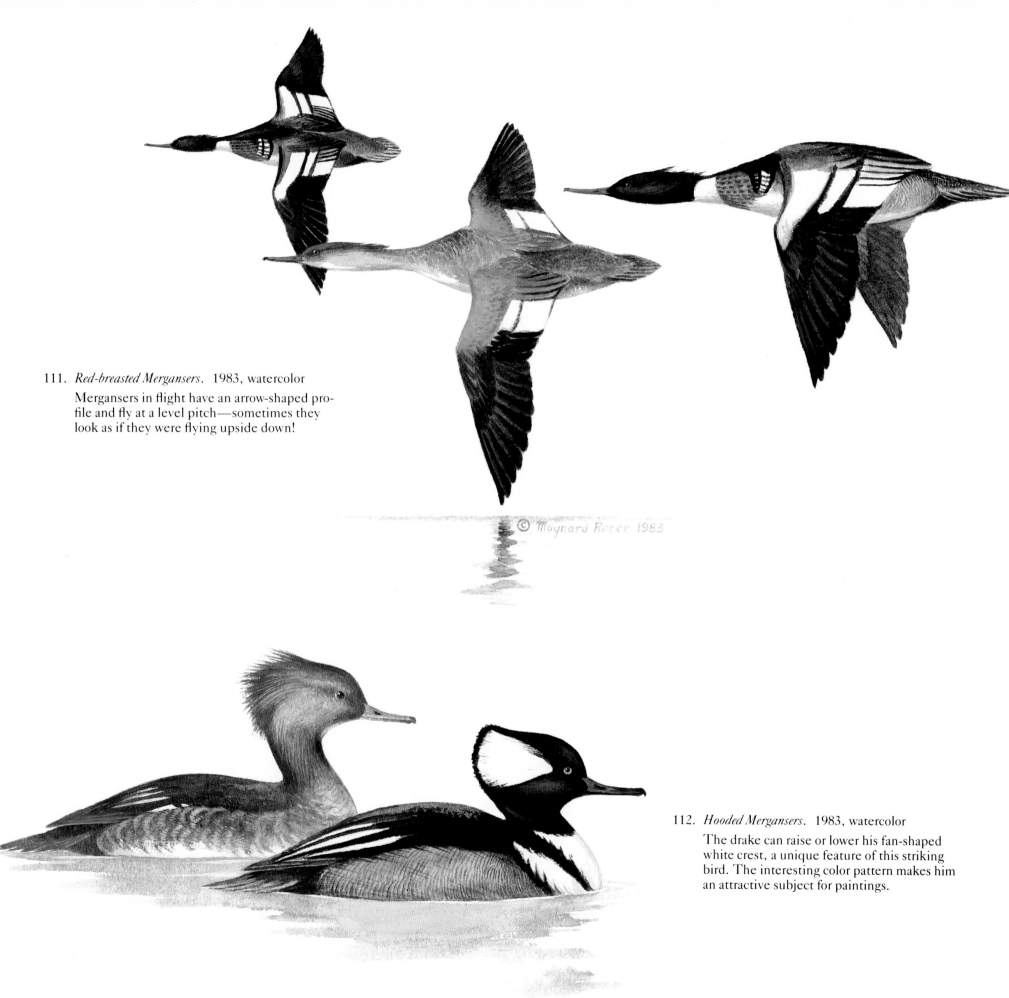

111. *Red-breasted Mergansers*. 1983, watercolor
Mergansers in flight have an arrow-shaped profile and fly at a level pitch—sometimes they look as if they were flying upside down!

© Maynard Reece 1983

112. *Hooded Mergansers*. 1983, watercolor
The drake can raise or lower his fan-shaped white crest, a unique feature of this striking bird. The interesting color pattern makes him an attractive subject for paintings.

© Maynard Reece 1983

EIDERS

Eiders are large birds, quite showy in their black and white coloration, and strong fliers. There are four species of eiders in North America: the common eider, king eider, spectacled eider, and Steller's eider.

Seeing eiders for the first time was quite an experience. You were standing on a small island in the Arctic Ocean north of Alaska, an island devoid of vegetation—just a strip of sand a few hundred yards long. Driftwood had washed up on the sand from some river mouth perhaps far to the south down the coast, for in the tundra region there are no trees. Pack ice of every shape surrounded the island in an expanse that stretched to the far horizons. The ice had melted next to one side of the island and common eiders were swimming in this narrow stretch of water—but only males: where were the females?

You found them in the driftwood under your feet. They were sitting on clutches of eggs, their nests so packed into the driftwood that one was almost on top of the next. You counted ten nests within an area six feet square. The eiders had no wish to nest so closely, but the driftwood offered only that small amount of space for hiding so many nests. In the tundra on shore you found other species of eiders nesting on more suitable sites, where they had plenty of room to spread out.

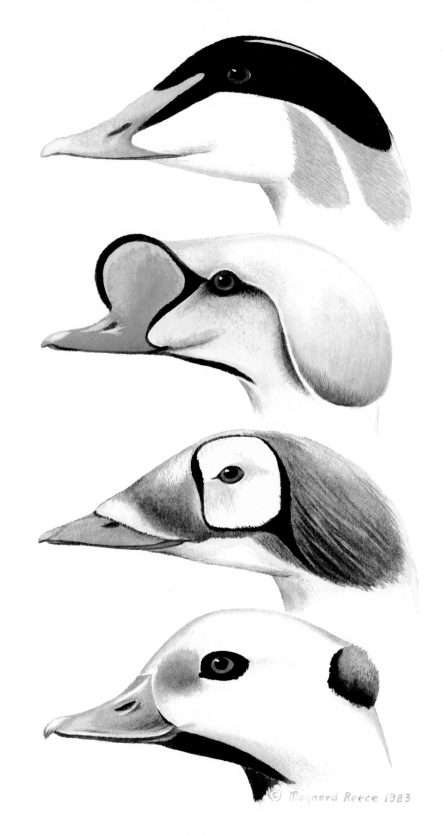

113. *Four Heads of Eiders*. 1983, watercolor
Drake heads of four species of eiders, to show the differences of each species in shape and color. The feathers are so short and fine that they are almost like fur. From top to bottom: common eider, king eider, spectacled eider, Steller's eider.

EPILOGUE

These fascinating birds called waterfowl
were here long before we were.
They can recall for us an early America
when our country was free and unspoiled.

Waterfowl traverse entire continents.
They fly and rest wherever
they please throughout the world.
The migrating birds return unerringly
to the same spot thousands of miles away,
making a mockery of our sophisticated,
computerized movements.
Waterfowl ask nothing of us;
they do not exist for us,
but with us.

At least we can make sure
that suitable habitat is saved for
them and for ourselves, so that our
children can enjoy the wonderful
experience of watching the flight
of waterfowl.

What would the world be, once bereft

Of wet and of wildness? Let them be left,

Oh, let them be left, wildness and wet,

Long live the weeds and the wilderness yet.

Gerard Manley Hopkins
(1844–1889)

INDEX OF WATERFOWL/
CATALOGUE OF PLATES

INDEX OF WATERFOWL/CATALOGUE OF PLATES

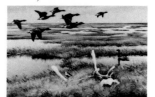
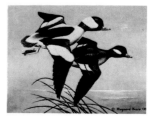
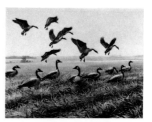
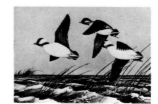
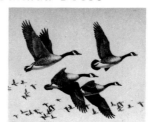
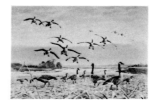
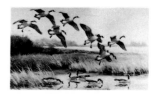
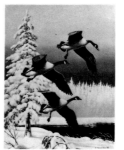
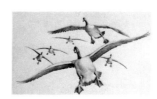

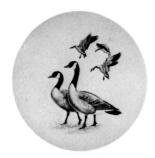

PL. 45. *Canada Geese,*
plate design

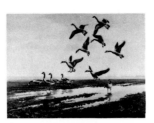

PL. 46. *Landing:*
Canada Geese

Canvasback (*see also* PL. *23*)

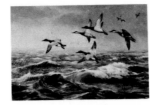

PL. 13. *Rough Water:*
Canvasbacks

PL. 25. *Canvasback Nest*

PL. 47. *The Family:*
Canada Geese

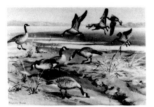

PL. 48. *The Sandbar:*
Canada Geese

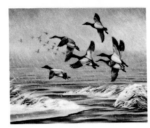

PL. 38. *The Muskrat*
House:
Canvasbacks

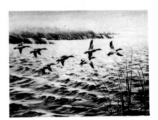

PL. 91. *Against the Wind:*
Canvasbacks

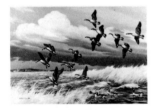

PL. 49. *Dark Sky:*
Canada Geese

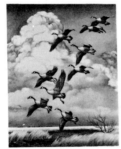

PL. 50. *Thunderhead:*
Canada Geese

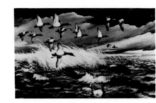

PL. 92. *Dark Sky: Canvasbacks*

Coot

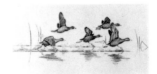

PL. 30. *Coots*

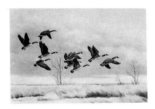

PL. 51. *Nine Travelers:*
Canada Geese

Ducks, Diving, *see Bufflehead; Canvasback;*
Eider; Harlequin Duck; Merganser, Common;
Merganser, Hooded; Merganser, Red-breasted;
Goldeneye, Barrow's; Goldeneye, Common;
Oldsquaw; Redhead; Ring-necked Duck;
Ruddy Duck; Scaup, Lesser; Scoter

Ducks, Surface-feeding, *see Black Duck;*
Gadwall; Mallard; Pintail; Shoveler,
Northern; Teal, Blue-winged; Teal,
Cinnamon; Teal, Green-winged; Whistling
Duck, Black-bellied; Whistling Duck,
Fulvous; Wigeon, American; Wood Duck

Dunlin, *see PL.* 59

Eider

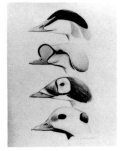

PL. 113. *Heads of Four Species of Eiders*

Federal Duck Stamps, *see PLS.* 79, 84, 102, 107

Gadwall

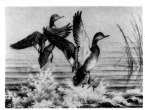

PL. 84. *Gadwalls,* 1951 Federal Duck Stamp

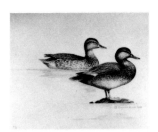

PL. 85. *Gadwalls*

Goldeneye, Barrow's

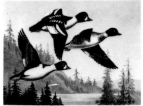

PL. 99. *Barrow's Goldeneyes in Flight*

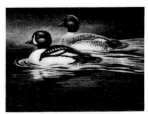

PL. 100. *Barrow's Goldeneyes Swimming*

Goldeneye, Common

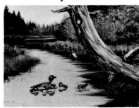

PL. 26. *Common Goldeneye with Ducklings*

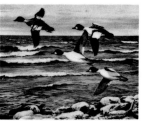

PL. 101. *Common Goldeneyes*

Goose, *see Brant, Black; Canada Goose; Snow (Blue) Goose; White-fronted Goose*

Harlequin Duck

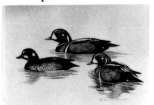

PL. 105. *Harlequin Ducks*

Mallard

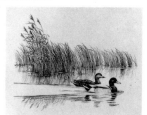

PL. 1. *The Pair: Mallards*

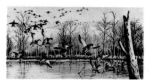

PL. 5. *Diamond Island: Mallards*

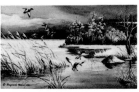

PL. 6. *Tranquil Marsh: Mallards*

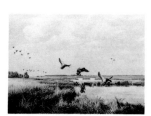

PL. 8. *Late Afternoon: Mallards*

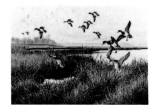

PL. 10. *Stony Lake:*
Mallards

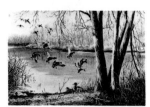

PL. 11. *Quiet Pond:*
Mallards

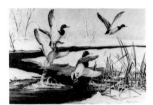

PL. 12. *Early Arrivals:*
Mallards

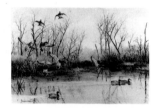

PL. 16. *Dropping In:*
Mallards

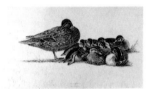

PL. 28. *Mallard Hen*
and Young

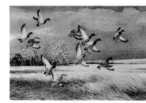

PL. 29. *Dark Sky:*
Mallards

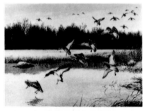

PL. 32. *Crescent Lake:*
Mallards

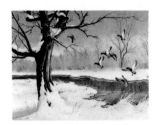

PL. 34. *Snowy Creek:*
Mallards

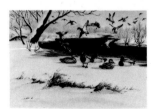

PL. 36. *Cold Morning:*
Mallards

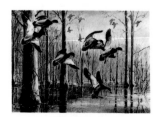

PL. 37. *The Snowstorm:*
Mallards

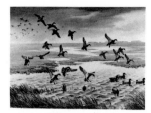

PL. 40. *Gloomy Day:*
Mallards

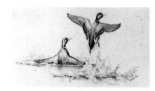

PL. 60. *Vertical Takeoff:*
Mallards

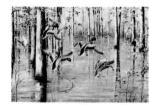

PL. 61. *Flooded Oaks:*
Mallards

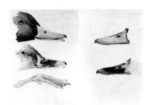

PL. 62. *Mallard Bills*
and Foot

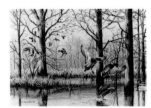

PL. 63. *Flooded Timber:*
Mallards

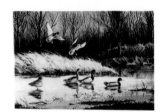

PL. 64. *Shallow Pond:*
Mallards

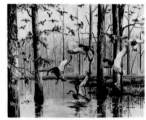

PL. 65. *Pitching In:*
Mallards

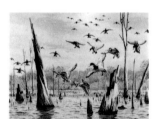

PL. 66. *Stick Pond:*
Mallards

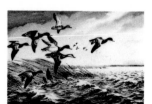

PL. 67. *Windy Day:*
Mallards

Marsh

PL. 18. *The Marsh*

PL. 23. *The Marsh*

PL. 80. *Bear River Marshes*

Merganser, Common

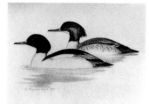

PL. 110. *Common Mergansers*

Merganser, Hooded

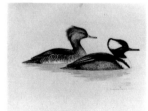

PL. 112. *Hooded Mergansers*

Merganser, Red-breasted

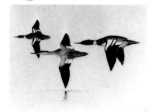

PL. 111. *Red-breasted Mergansers*

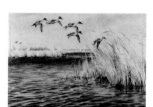

PL. 104. *Oldsquaws*

Pintail

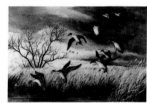

PL. 4. *Easy Landing: Pintails*

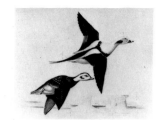

PL. 20. *Courtship Flight: Pintails*

PL. 39. *Pintails, plate design*

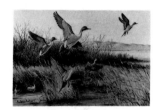

PL. 70. *Breaking Away: Pintails*

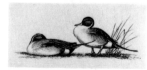

PL. 71. *Pintails*

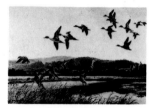

PL. 72. *The Valley: Pintails*

Plate Designs, *see PLS. 39, 45*

Redhead (*see also* PL. 23)

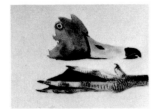

PL. 93. *Bill and Foot of Redhead*

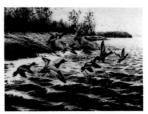

PL. 94. *Along the Shore: Redheads*

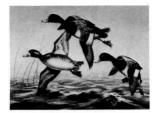

PL. 96. *Passing Through: Lesser Scaups*

PL. 97. *Lesser Scaups*

Ring-necked Duck

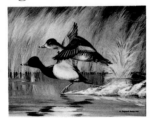

PL. 98. *Takeoff: Ring-necked Ducks*

Scoter

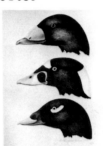

PL. 106. *Heads of Three Species of Scoter*

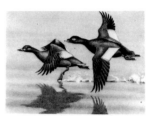

PL. 107. *White-winged Scoter,* 1969 Federal Duck Stamp

Ruddy Duck

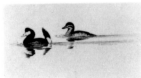

PL. 22. *Ruddy Ducks*

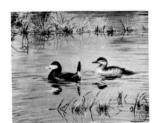

PL. 108. *The Stiff-tails: Ruddy Ducks*

Shoveler, Northern

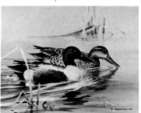

PL. 86. *Northern Shovelers*

PL. 109. *Ruddy Duck*

Snow (Blue) Goose

PL. 19. *Migrating Snow Geese*

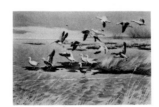

PL. 52. *Snow Geese*

Scaup, Lesser

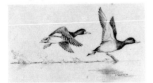

PL. 90. *Long, Sloping Takeoff: Lesser Scaup*

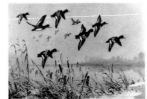

PL. 95. *Over the Point: Lesser Scaups*

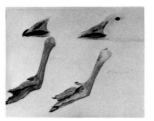

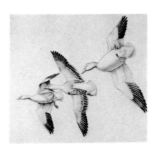

PL. 53. *Bills and Feet of Young and Adult Snow Geese*

PL. 54. *Snow Geese*

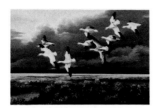

PL. 55. *Dark Sky: Snow Geese*

State Duck Stamps, *see PLS. 3, 82*

Swan, Trumpeter

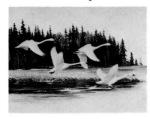

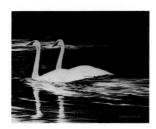

PL. 42. *Along the River: Trumpeter Swans*

PL. 43. *The Pair: Trumpeter Swans*

Swan, Whistling

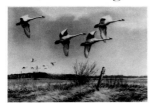

PL. 44. *Regal Flight: Whistling Swans*

Teal, Blue-winged

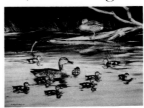

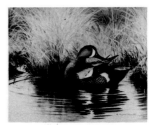

PL. 24. *Blue-winged Teal with Ducklings*

PL. 76. *Preening: Blue-winged Teal*

Teal, Cinnamon

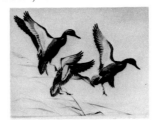

PL. 79. *Cinnamon Teal,* 1971 Federal Duck Stamp

Teal, Green-winged

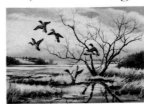

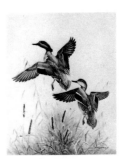

PL. 31. *The Willow: Green-winged Teal*

PL. 77. *Jumping Greenwings: Green-winged Teal*

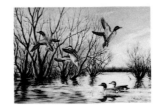

PL. 78. *Sunrise: Green-winged Teal*

Texas 1983 Duck Stamp, *see PL. 82*

Whistling Duck, Black-bellied

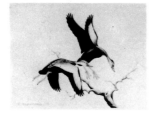

PL. 88. *Black-bellied Whistling Ducks*

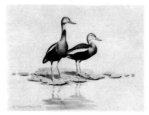

PL. 89. *Black-bellied Whistling Ducks*

Whistling Duck, Fulvous

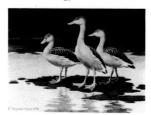

PL. 87. *Fulvous Whistling Ducks*

White-fronted Goose

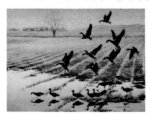

PL. 56. *Stubble Field: White-fronted Geese*

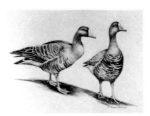

PL. 57. *White-fronted Geese*

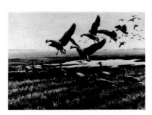

PL. 58. *Rendezvous: White-fronted Geese*

Wigeon, American

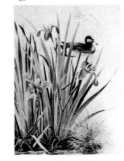

PL. 7. *Blue Flags and Wigeon*

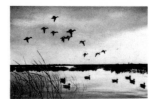

PL. 9. *Twilight: American Wigeon*

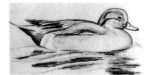

PL. 81. *Wigeon*

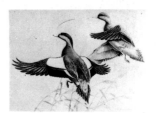

PL. 82. *American Wigeon*, 1983 Texas Duck Stamp

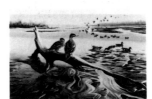

PL. 83. *Shallow River: American Wigeon*

Wood Duck

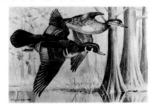

PL. 3. *Wood Ducks,*
1982 Arkansas
Duck Stamp

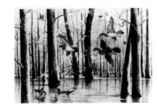

PL. 14. *Through the Trees:*
Wood Ducks

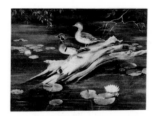

PL. 27. *Wood Ducks*

PL. 73. *Wood Ducks*

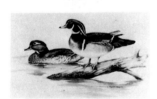

PL. 74. *Resting:*
Wood Ducks

PL. 75. *Timber:*
Wood Ducks